D

Books are to be returned on or before
the last date below.

LIBREX-

ART
THE GROUNDBREAKING MOMENTS

FLORIAN HEINE

PRESTEL
Munich · London · New York

CONTENT

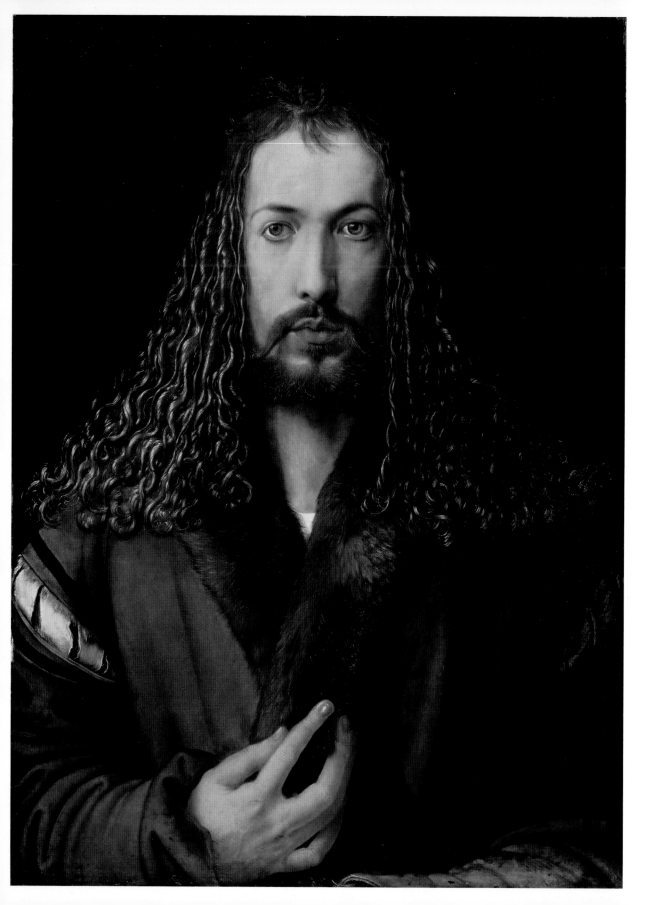

INTRODUCTION

In *Art: The Groundbreaking Moments* you will come across both world-famous paintings and those that are less well known but equally important. Often, the less well-known ones are the actual groundbreaking moments in painting, because it is in them that something occurs that has never before occurred in that way in painting. The first portrait of modern times is one example; the first still life, or the first painting to depict the artist's dreams, are others. Some of these paintings established a new genre or revived an old one, while others mark the beginning of a new style, and give it its name, too. The term "Impressionism," for example, derives from Claude Monet's painting *Impression, Sunrise* while "Cubism" arose from a small artwork by Georges Braque that had caused a stir because of its Cubist shapes. In this book, various facets of the development of these genres and styles are illuminated, from these and other "initial works" to the present day. Groundbreaking moments in art that are particularly famous, particularly interesting, or simply particularly good are the subject of the book.

Art: The Groundbreaking Moments is about the art of modern times, starting with the 14th century. There are several reasons for this. A considerable amount of knowledge from and about Antiquity was lost during the Middle Ages, in other words between the 5th century and the beginning of the 14th century. This was partly a result of the fall of the Roman Empire in Western Europe in the 5th century, partly because of the continuous dissemination and increasing preponderance of Christianity, and partly related to the confusion brought about by population migrations. Not until the beginning of the Renaissance, with its renewed interest in Antiquity and the resulting large body of research and many excavations, did a new understanding slowly emerge. This included the rediscovery in the 18th century of the cities of Herculaneum and Pompeii, destroyed by the eruption of Mount Vesuvius in the year AD 79.

The texts and the artworks in *Art: The Groundbreaking Moments* reveal fascinating events in the story of art and its development, the greater and lesser tales, ideas, strokes of genius, and coincidences to which we owe the many wonderful artworks in museums and churches throughout the world. The constraints and the limited space provided by such a volume make rigorous selection necessary. More than anything, however, its aim is to awaken the desire to see because, as Eugène Viollet-le-Duc wrote, "seeing is knowing."

ALBRECHT DÜRER, SELF-PORTRAIT | 1500
oil on linden | 67 x 49 cm | Alte Pinakothek | Munich.

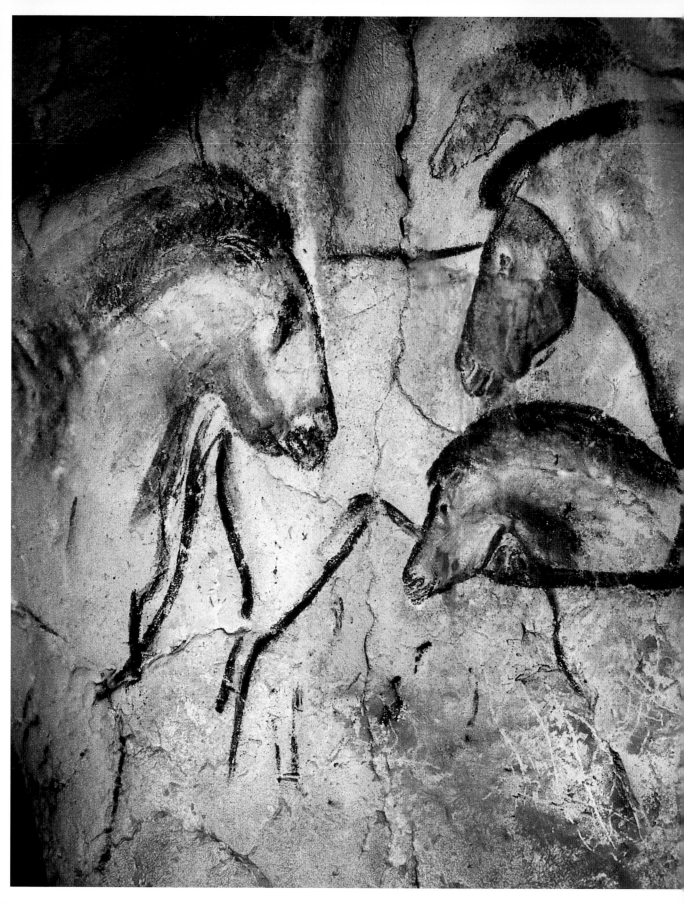

FROM CAVE PAINTINGS TO THE MIDDLE AGES

In 1994, in the gorges of the Ardèche in Southern France, Jean-Marie Chauvet discovered a cave that contained a sensational find: the walls of the cave were covered with more than 400 paintings depicting a great variety of animals. The paintings were estimated to be approximately 32,000 years old, making them the oldest surviving paintings in the world. This is where art originated. And it did not begin with awkward scribblings, but with wonderfully lifelike drawings of rhinoceroses, owls, bears, and horses (fig. p. 8). It is no longer possible to definitively answer the questions of who these first artists were and what purpose these paintings deep down in a dark cave had, because the worlds in which people lived then are too different from the world in which we live now. For conservational reasons, only a small number of people have so far had the opportunity to see humankind's first artistic self-expression in the original. In 2010, the German director Werner Herzog made 3-D film footage of the caves, which he released under the title *Cave of Forgotten Dreams* in 2011. Here, the most modern of recording techniques meets humankind's first artworks, making for a fascinating experience.

Whatever inspired or prompted the first artists to create their artworks, two motivations that can be traced through art history to the present day must have been among them: the desire for a pictorial representation of the world in which we live, and the power of pictures. In Ancient Egypt, the pharaohs were accompanied by pictures on their journey to eternity, and in Greek and Roman Antiquity, the stories of gods, goddesses, and heroes were told in pictures (fig. p. 10). In the 1st century AD, Pliny the Elder (*c*. AD 23–79) wrote the first history of art in his *Naturalis Historia*. His criterion for the quality of an artist was the resemblance of the picture to its natural model. This philosophy governed the art of the Classical world. Pliny described the development of Classical painting as a continuous improvement in the imitation of nature. In this vein, the Athenian painter Eumarum, who lived in the 6th/7th century BC, was the first to achieve a distinction between men and women in painting, and to achieve such a great likeness to the subjects of his depictions that it became unnecessary to inscribe the paintings with their names. Polygnotus of Thasos (4th century BC) was the first painter to depict a person's facial expression, but Pliny considered the fact that this painter could paint women in transparent gowns even more remarkable.

left——**Horses** | *c*. 32000 BC | painting on rock | Chauvet cave near Vallon-Pont-d'Arc | France.

10/11 | CAVE PAINTINGS TO MIDDLE AGES ··· **c. 13000 BC**—Climate warming begins ····································

c. 10000 BC—First human settlements ····································

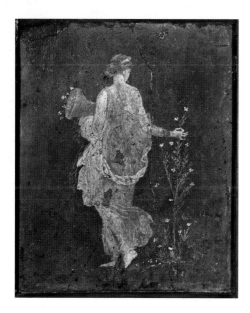

Apelles (4th century BC) was the greatest painter of Antiquity. None of his, or of his predecessors' paintings have survived to this day, but his skill was legendary and his praises were sung by poets. Apart from the representation of nature in all of its guises and his portraits—he was the only artist permitted to paint Alexander the Great—he also appears to have created, together with his colleague Protogenes, the first abstract painting. It is said to have shown three thin, barely visible lines, which the artists took turns in painting—and that was it. It was exhibited in Rhodes, and became more famous than all other works of art. Sadly, it was burnt in a fire in Caesar's palace on the Palatine Hill in Rome.

Antiquity was a golden age of painting. Portraits, still lifes, illusionistic pictures, and even an early form of perspectival representation were part of everyday life, at least for the wealthy (fig. p. 11). This changed with the rise of Christianity, which became the sole state religion of Rome in AD 391. In AD 476, this glorious phase of art history came to an end along with the Roman Empire: from then onwards, the Christian Church would determine what art should look like. In comparison with the painting of the Classical world, medieval art often appears stiff and clumsy to the modern viewer. And indeed, another art had been created, and it breathed a very different spirit. The culture of Classical Antiquity was temporal, whereas the material world was unworthy and sinful according to Christianity, despite the fact that it was God's creation. The religions of the Classical world were rooted in nature while Christianity was rooted in the eternity beyond. Understanding or even analyzing nature, as Aristotle had done, was considered to be contemptuous of and a threat to the truth, which was dictated by the absolute authority of the Church and holy scripture. In the process of explaining this world, the word (of the Bible) was privileged over the picture. The faithful reproduction of nature and of people was no longer in demand. The fact that people prayed to representations of saints in churches therefore came to be considered a problem and the Church wanted to suppress this cult of pictures, which originated in Antiquity. God and the saints, not pictures, were supposed to be venerated and prayed to. Over the centuries, there were numerous periods of aniconism, as well as discussions about whether pictorial representations should be allowed in churches or

above — **Flora with Cornucopia** | 1st century AD | fresco | Pompeii Museo di Capodimonte | Naples.
right — **Fresco from the villa of P. Fannio Sinistore in Boscoreale** | before 79 BC | Metropolitan Museum of Art | New York.

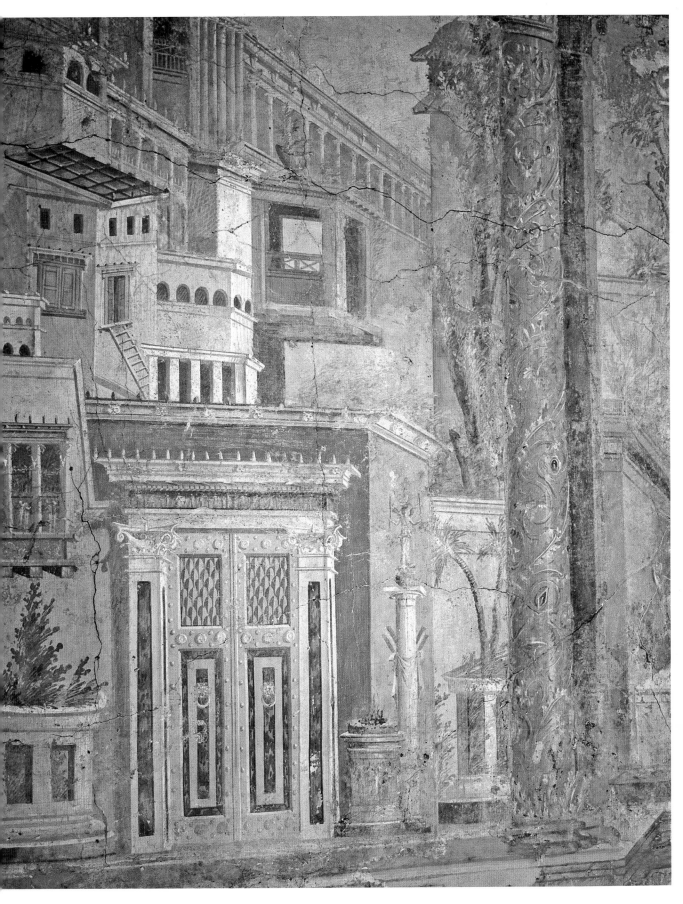

cipulis eius quia surrexit · & ecce preced&
uos ingalileam · Ibi eum uidebitis · ecce
predixi uobis ·

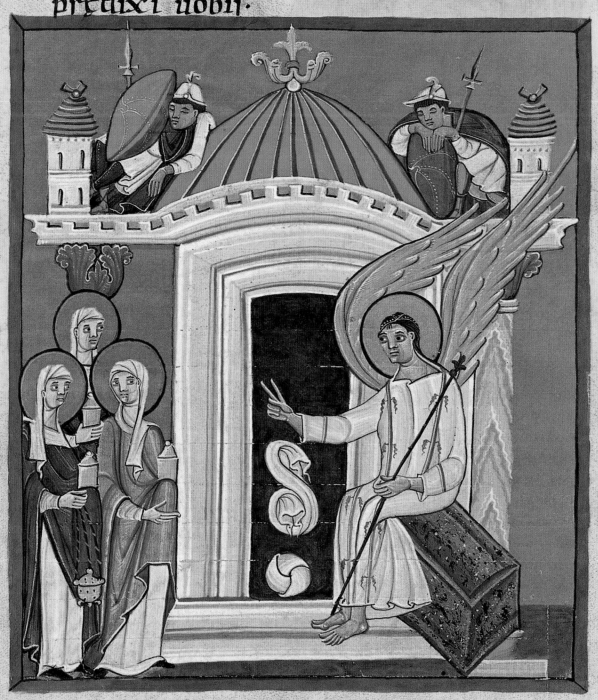

"In the Middle Ages images were considered as useful for making the Christian message of salvation accessible to those who could not read."

not. Pope Gregory the Great (540–604) recognized that pictures could be useful in the dissemination of the Christian message, however, because they made it possible to make the message of salvation accessible to those who could not read: "What the written word is to those who can read, the picture can achieve for those who cannot."

To achieve this aim, however, pictures had to be clear and unambiguous. Faithfulness to nature was no longer valued because artists were now expected to represent that which is holy and not-of-this-world, as well as its symbolic independence from place and time. They had to develop a simple and didactic pictorial language for abstract theological terms. All that was not essential was excised. Instead of an entire forest a tree was shown, and in place of an entire palace a few columns were depicted. The important figures, such as saints or rulers, were shown to be physically larger than other people because of their significance (see also *Giotto*, pp. 16–23) and recognizable scenery was often eschewed in favor of a gold background that symbolized the holy and the

eternal (fig. p. 12). The illusion of spatial depth thus became obsolete, too. Everything was reduced to the recognizability and clarity of the message. Medieval painting therefore often looks awkward. But it was precisely through this reduction that some medieval painters managed to increase the intensity and expressivity of their paintings (fig. p. 15).

Of course a certain amount of knowledge about the artistic techniques of the past was lost as a result of the dictates of the Church and the ways in which these were consequently put into practice over the centuries. But luckily, Classical knowledge was not entirely lost, and much of it was, paradoxically, preserved in monasteries. Through their efforts to collect, preserve, and copy texts and pictures, monasteries became custodians of the cultural traditions of the Greeks and Romans.

For people of the Middle Ages, there was no such thing as an artist in the modern sense of the word: the mosaic makers, painters of church art, and book illustrators were in the service of powerful families or were unknown monks whose work was valued less highly than that of the scribes because the latter had to be literate, at least. Those who created pictorial artworks were seen as craftsmen and remained anonymous. The work was of importance, but its creator was not. Their names have been handed down to posterity only in the rarest of cases, and the standing of

left — **THREE WOMEN IN FRONT OF THE EMPTY TOMB** | c. 1000–20 | painting on parchment | *Bamberg Apocalypse* | fol. 69v | Staatsbibliothek Bamberg.

"It was precisely through the reduction of painterly means that some medieval works of art possess a special intensity and expressivity."

these painters cannot be compared with that of the Classical masters.

A change began to take place in the 13th century. There was a new current in theology and philosophy—Scholasticism. This had its roots in the work of the great Christian thinker Albertus Magnus (*c.* 1200–80) and his pupil Thomas Aquinas (1225–74). Thomas Aquinas's theory created a significant prerequisite for the pictorial representation of nature that was to be discovered. For him, creation—and therefore nature—was a mirror of the divine order. It was his aim to bring together the temporal Greek philosophy of Aristotle and the Christian world view, detached as it was from this world. Both he and his teacher were of the opinion that there were two forms of knowledge: knowledge that is derived from theology, and knowledge of science. They advocated the division of science and faith, regarding theologians as experts in matters of faith and scientists as responsible for explaining temporal phenomena. As they believed that God is manifested in every part of creation, knowledge of God—and with it, faith—must grow as humankind learns and discovers more about nature. In order to counter the Church's fear of potential new findings before this could be raised, they argued that as everything in existence is God's creation, the human intellect, too, is part of His creation. And because this is the case, nothing that could be discovered, or thought, could counter the teachings of the Church.

The road to new discoveries was thus unobstructed. The Holy Roman Emperor, Frederick II (1194–1250), had already made use of this freedom to increase one's knowledge using one's own observations when he wrote his book on falconry (see also *Animals,*

pp. 42–49). The drawings and paintings in his book, and those of birds in particular, show that the illustrators were certainly able to depict nature accurately when required to do so.

The foundation of the mendicant orders of the Franciscans and Dominicans also took place during this time of innovation in the realms of religious philosophy. Together with the ideas of Scholasticism, St. Francis's close relationship with nature, and the erudition of St. Dominic created the basis for a reorientation of both religious and worldly art. The as-yet unknown Florentine painter Giotto di Bondone (*c.* 1266–1337) rang the changes with his paintings in the main church of the Franciscans in Assisi. It is therefore no surprise that Giorgio Vasari (1511–74), who could be described as the first art historian, ascribed the rebirth of art that followed the Middle Ages to the artwork and influence of Giotto. It was with him that the history of art began to become a history of artists, who created the groundbreaking moments that have made art what it is today.

right — **Utrecht Psalter** | AD 820–35 | ink on parchment Utrecht University Library.

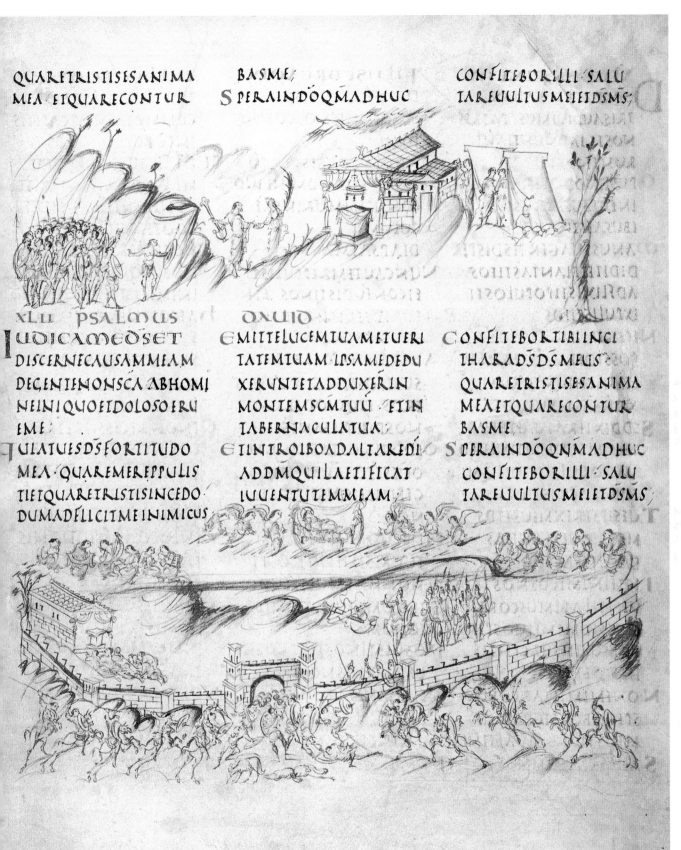

QUARETRISTISESANIMA
MEA ETQUARECONTUR

BASME:
SPERAINDOQMADHUC

CONFITEBORILLI SALU
TAREUULTUSMEIETDSMS;

XLII PSALMUS DAUID

IUDICAMEDSET
DISCERNECAUSAMMEAM
DEGENTENONSCA ABHOMI
NEINIQUOETDOLOSOERU
EME

EMITTELUCEMTUAMETUERI
TATEMTUAM IPSAMEDEDU
XERUNTETADDUXERIN
MONTEMSCMTUU ETIN
TABERNACULATUA

CONFITEBORTIBIINCI
THARADSDS MEUS
QUARETRISTISESANIMA
MEAETQUARECONTUR
BASME

TULATUESDSFORTITUDO
MEA QUAREMEREPPULIS
TIETQUARETRISTISINCEDO
DUMADFLLICITMEINIMICUS

ETINTROIBOADALTAREDI
ADDMQUILAETIFICAT
IUUENTUTEMMEAM

SPERAINDOQNMADHUC
CONFITEBORILLI SALU
TAREUULTUSMEIETDSMS;

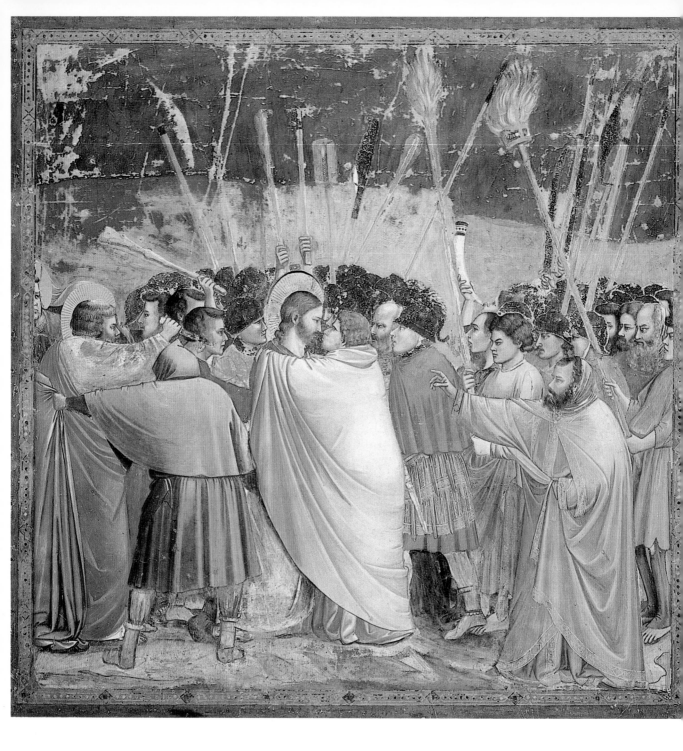

1266–1337 Giotto di Bondone

GIOTTO

"Once Cimabue [Giotto's teacher] seemed to hold full sure his own 'gainst all in art, now Giotto bears the palm, and this man's fame does that obscure," wrote Dante Alighieri (1265–1321) in his *Divine Comedy* (11th canto of "Purgatory"). This is the first time that a painter was described in such a remarkable way by a contemporary poet. Boccaccio (1313–75), too, appears to have been greatly impressed by the frescoes of Giotto di Bondone (c. 1266–1337), writing in his *Decameron*: "And the other, whose name was Giotto, had such a prodigious fancy, that there was nothing in Nature [...] but he could imitate it with his pencil so well, and draw it so like, as to deceive our very senses, making them imagine that to be the very thing itself which was only his painting."

What was so different and new about Giotto's art that these poets—and many others—rhapsodized and wrote such eulogies to him? The short answer is: everything. The longer answer is that Giotto was an artist who had new, revolutionary ideas. He made the leap from the two-dimensional, rigid-looking painting of the Middle Ages, which had become trapped in its pictorial traditions, to naturalistic, illusionistic painting. Giotto did not paint and draw from traditional models by Old Masters, as was standard practice at the time. Instead, he tried to depict his observations of nature in his painting. He gave his figures a new type of corporality and weight by modeling them with light and shadow. They stand firmly on the ground and do not "float," in the way figures often do in medieval paintings, with no sense of contact with the ground, on their tiptoes.

Giotto's figures have a lifelike appearance because they gesticulate and interact with each other through their gazes and gestures, and furthermore show emotions we can empathize with. Giotto loosened up the medieval frontal and profile views by turning and overlapping the figures, so that they can make dramatic use of the stage which the painter has given them. The combined effect is one of immediacy and of access to the stories depicted because they can be more readily experienced through Giotto's art. This sense of increased immediacy is heightened by the backgrounds. Giotto moved away from the traditional gold background and created more lifelike situations that make the scenes look more credible to the viewer.

Giotto created his first masterpieces in the Basilica of San Francesco d'Assisi. St. Francis, the mendicant and founder of the Franciscan Order, died in 1226 and

left — **GIOTTO, THE BETRAYAL OF CHRIST** | *c.* 1304 | fresco
c. 185 x 200 cm | Scrovegni Chapel | Padua.

c. 1290–1366 Taddeo Gaddi

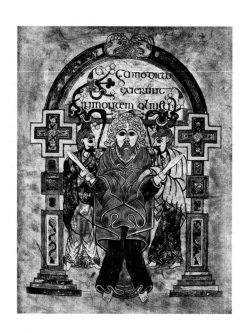

was canonized just two years later. The construction of the church began the very same year. The most important painters of the time took part in the decoration of the two-story church: Pietro Cavallini, Pietro Lorenzetti and Giotto's teacher Cimabue, amongst others. Giotto joined in 1296, and it was his responsibility to embellish the walls of the upper church with 28 scenes from the life of St. Francis. Here, Giotto proved his artistic abilities for the first time, developing the innovations for which he became so highly praised.

The fact that St. Francis was a "modern" saint may well have inspired Giotto to use such innovative representational methods. After all, why should such a talented painter not create a new form of painting when dealing with an entirely new subject? St. Francis had been dead for just 70 years when Giotto started on his frescoes. Many people in Assisi knew of the life of St. Francis, in some cases perhaps from the eye-witness accounts of parents or grandparents. St. Francis was therefore not a saint from a distant time and a distant world. He had been active in Assisi, and he had been one of them. Such a modern saint required a modern pictorial language, and Giotto was virtually predestined for such a task because of his extraordinary talent and his powers of observation. Giotto's depiction of a scene in which a simple man pays homage to St. Francis (fig. p. 19) is exemplary in

this respect. St. Francis approaches a temple in the company of his friends, and the man spreads out his coat in front of him. Both St. Francis's companions and those of the man are visibly surprised because the simple man has recognized St. Francis's holiness before the latter has actually become a saint: at this point, he is still Giovanni Battista Bernardone, the son of a wealthy family. Giotto has depicted him with a halo due to the fact that St. Francis had been canonized long before the painting was made. Giotto thought about where and how the scene might have taken place. He chose the Temple of Minerva on the main square of Assisi as the background. Everybody in Assisi knew this building, which still exists today, and in this way, Giotto made clear that this event really did take place here. In other words, he did not simply use a gold background to underline the holiness of the scene, and he did not just feature one or two pillars—sufficient for the representation of a temple or palace in medieval painting—but created

above — **THE ARREST OF CHRIST** | late 8th century | painting on parchment | 32.3 x 24.2 cm | *Book of Kells* | fol. 114v | Trinity College Library | Dublin.
right — **GIOTTO, HOMAGE OF A SIMPLE MAN** | *c.* 1300 | fresco *c.* 270 x 230 cm | San Francesco | Assisi.

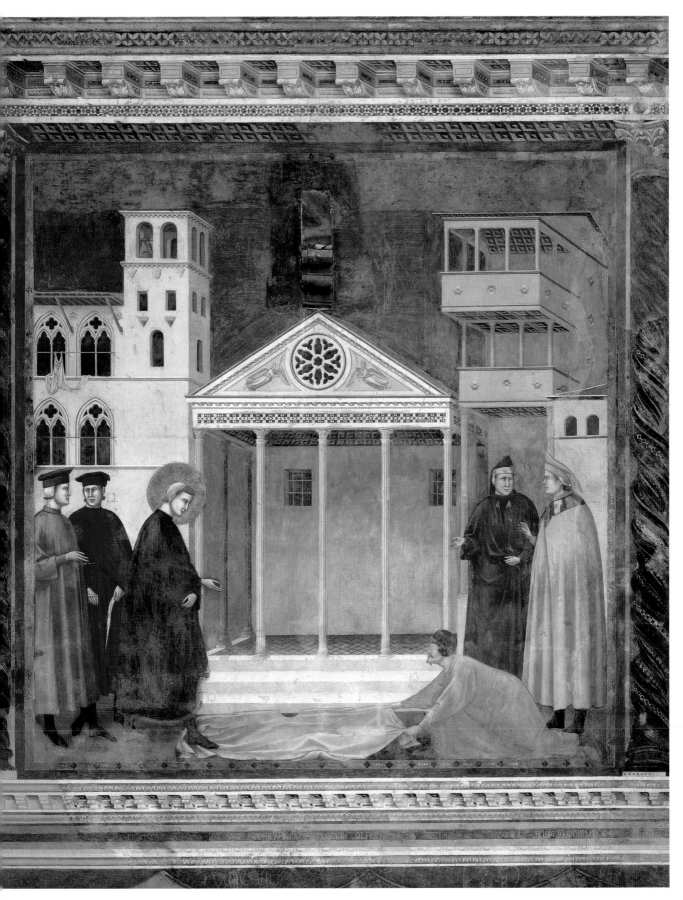

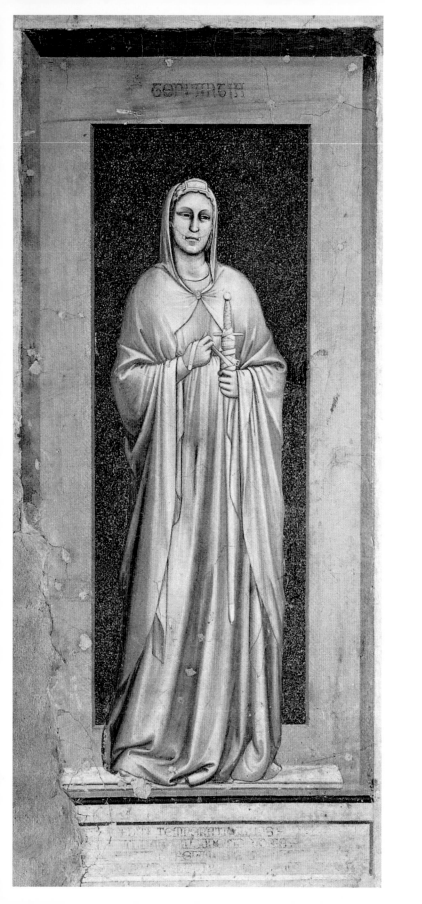

"Giotto demonstrated his ability to imitate nature convincingly in the grisailles panels of the Scrovegni Chapel in Padua."

what is in some ways an image of the historical setting.

Not only the determination of the specific location was innovative, however. The depiction of the people, too, is new. They stand on the ground, heavy and firm. They are no longer the ornamental symbols they had been in previous centuries, but are instead quite clearly people of flesh and blood. And they act accordingly: they gesticulate and react to one another. They move about freely on the stage which Giotto has given them. Furthermore, their proportions in relation to one another are accurate. All of this was entirely new in art, as was the composition of the frescoes. Giotto made a frame for each individual picture by creating a rhythmic arrangement of the architectural elements and figures. Although the cycle spreads across both church walls, each scene forms its own compositional unit. In this way, Giotto made it possible to imbue his paintings with drama. The innovations were suitable not only for "modern" histories of saints, but also specifically for traditional

Bible stories. Giotto showed this in his fresco cycle of 36 scenes from the lives of Mary and Jesus, which he created in the Scrovegni Chapel (also known as the Arena Chapel) in Padua between 1304 and 1306. *The Betrayal of Christ* (fig. p. 16) depicts the moment in which Judas identifies Jesus with his treacherous kiss, thus turning him in to the soldiers. A commotion between the disciples and the soldiers ensues. The high priest, who enters the scene from the right, orders the soldiers to arrest Jesus. On the left, Peter severs the ear of one of the soldiers. The confusion is emphasized by the lances and torches, which indicate that it is nighttime (see also *Night*, pp. 34–41). It is only at the center that the composition reaches a tension-filled calm. Judas envelops Jesus with his coat, and is clearly made nervous by Jesus's penetrating gaze. Jesus knows that this betrayal will result in his crucifixion, and appears to be sharing this knowledge with Judas.

Comparison with a page from the 8th-century *Book of Kells* (fig. p. 18) shows how far Giotto strayed from traditional forms of representation. Here, too, the moment of the arrest is shown. But this depiction is very different. The three figures are reduced to ornamental elements. Because of his holiness, Jesus is significantly larger than the henchmen. The arrest is signified only by the fact that the soldiers hold Jesus's arms. Nothing in this painting is natural: one cannot

left — **GIOTTO**, **TEMPERENCE [TEMPERANTIA]** | *c.* 1304 | fresco
c. 120 x 55 cm | Scrovegni Chapel | Padua.

22/23 GIOTTO ····**1320**—Declaration of Arbroath (Scottish Declaration of Independence)··**1337–1453**—Hundred Years' War between England and France

································**1323**—Destruction of the Lighthouse of Alexandria···········

1320–1368 Orcagna (Andrea di Cione)

make out the location, time of day, or any emotional response. The figures are virtually symmetrical within themselves and in their relationship to one another, and the soldiers are distinguished primarily through the positions of their hands.

Giotto's changes were so innovative, spectacular, and convincing that his paintings moved people in a hitherto unseen way. Just as St. Francis had wanted to touch people with his sermons in the Italian language, Giotto wanted to move away from pictography and towards a form that would allow viewers a more direct experience of holy scripture. One could say that Giotto depicted biblical events in the vernacular.

Giotto also demonstrated his ability to imitate nature convincingly, as the poets praised so highly, in the frescoes on the lower panels of the Scrovegni Chapel (fig. p. 20). He painted these figures in shades of grey (*grisaille*) to simulate sculptures symbolizing virtues and vices. He showed the possibilities opened up by his new approach through the illusion of spatial depth on a flat surface. This was so new to the viewers of his time that "men's visual sense is found to have been oftentimes deceived in things of his fashion, taking that for real which was but depictured" (Boccaccio).

Now that the first steps on this path had been taken—away from the more rigid painting of the Middle Ages—there was no reason for Giotto's colleagues and successors to be left behind by this development. Giotto was not an anonymous craftsman who pain-

ted, as his medieval colleagues had been, but was among the dignitaries of his hometown of Florence. He was appointed chief architect of the cathedral in 1334 and was responsible for the campanile of Florence Cathedral. Giotto was the first artist to be honored after his death with a state funeral.

For Giorgio Vasari (1511–74), the "Father of Art History," art was "reborn" with Giotto. He brought to an end the Middle Ages, that "clumsy, awkward period." Under Giotto, the history of art became a history of artists.

right — **GIOTTO, ADORATION OF THE MAGI** | *c.* 1304
fresco | *c.* 185 x 200 cm | Scrovegni Chapel | Padua.

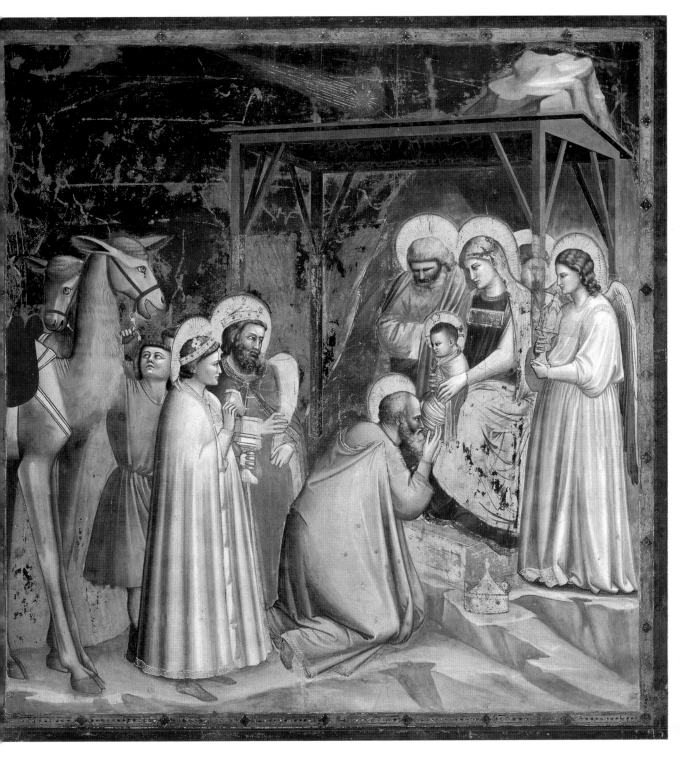

387 BC—Plato founds his Academy in Athens .. 69 BC—Birth of Cleopatra **24/25**

336 BC—Alexander the Great becomes king of Macedon··············

196 BC—Inscription of the Rosetta Stone ··············

PORTRAIT

The word "portrait" stems from the Latin *protrahere*, "to draw forth, bring to light." The aim of a portrait is thus to show a person's nature and what is characteristic about them. In Antiquity, portraits constituted an important part of the work of a painter. As one can see from Egyptian mummy portraits and excavations in Pompeii and Herculaneum, the quality of Classical portraiture was very high. "Ordinary" people were also the subject of portraits, although portraits of rulers were most common. Gaius Julius Caesar was the first to have his portrait embossed on coins (fig. right), in 44 BC. Portrait coins such as these were state symbols and contributed to the personality cults surrounding the rulers. In addition, the faces on the coins continually reminded soldiers who paid their *salarium*, and whom they served. The profile view became standard for portraits of rulers at this time.

After the fall of the Roman Empire and the rise of Christianity, the attitude towards portraits changed. According to Christianity, this world is nothing more than a thoroughfare on the path to eternal life. The representation of the individual thus became less important. The point of pictorial representations was no longer the depiction of a specific person, but of a signifier identified through particular attributes: a tiara, crown, or mitre identifying a pope, emperor, or bishop, for example. Individuals could no longer be distinguished from one another in these portraits. If necessary, names were inscribed, as a page from the manuscript by Herrad of Landsberg (c. 1130–95) shows to great effect (fig. p. 26 left).

left—**Diego Velázquez, Pope Innocent X** | 1650 | oil on canvas 140 x 120 cm | Galleria Doria Pamphilj | Rome.

right—**Denarius of L. Aemilius Buca with a portrait of Caesar** 44 BC.

26/27 PORTRAIT .. *c.* **150**—Ptolemy develops his geocentric cosmology ..

80—Completion of the Colosseum in Rome ..

c. **105**—Invention of paper in China ..

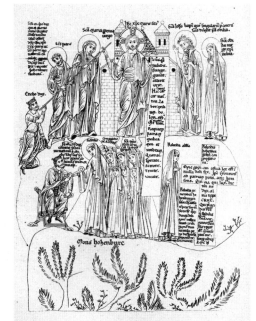

The first portrait after hundreds of years to show an individual person alone and for their own sake is to be found in the Louvre in Paris, the starting point of the museum's French painting collection. It is not simply the first portrait of modern times, but is also considered to be the earliest known French painting not to have been painted on a wall or in a book, but onto a wood panel. The painting (fig. above right), which was executed *c.* 1350, shows John the Good (Jean le Bon), who was king of France from 1350 until his death in 1364. Jean the Good is depicted without his royal insignia, which indicates that the likeness of the painting to the sitter must have been strong enough to allow viewers to recognize the real person in the portrait. And yet the way in which he is represented does make it clear that the subject must be a ruler. This is achieved both through the gold background and through the use of the profile view, which takes its cue from classical portraits of rulers. The name "Jean Roi de France" was added later. The unknown painter not only achieves what must be a portrait-like likeness, but also imbues the subject with a vitality that was new at the time by sculpting the face using light and shadow. This suggests that the artist was familiar with the innovations in paint-

ing that had been developed in Italy, primarily by Giotto, at the beginning of the 14th century. This is not particularly surprising as the papal court resided in the French city of Avignon from 1309 to 1376 and thus became an important intermediary between Italian and French art.

After the long period of "de-individualization" during the previous centuries, painting had rediscovered the individual as a subject, and painters had reacquired the skills necessary for portrait-like representations. The portrait soon became one of the most popular painting genres, although it was initially largely confined to the aristocracy and high clergy. Over time, different types of portraits developed. In Renaissance

above left——**HERRAD OF LANDSBERG, BOOK PAGE FROM THE HORTUS DELICIARUM** | *c.* 1185 | Bibliothèque Nationale | Strasbourg.
above right——**JEAN LE BON [JOHN THE GOOD]** | *c.* 1350 | tempera and gold on canvas on wood | 59.8 x 44.6 cm | Musée du Louvre | Paris.
right——**LEONARDO DA VINCI, MONA LISA** | 1503–06 | oil on poplar 77 x 53 cm | Musée du Louvre | Paris.

Italy, the classical tradition of the profile view was in fashion. Under the influence of Dutch painting, this increasingly gave way to the three-quarters view (see also fig. p. 86). The advantages were obvious: firstly, the subject can communicate, so to speak, with the viewer, and secondly, it simply shows more of the face. One of the most renowned paintings is an Italian Renaissance portrait is the so-called *Mona Lisa* by Leonardo da Vinci (1452–1519) (fig. p. 27). The portrayed gentlewoman is, quite literally, a multiple personality: more people have been and are thought to be the subject of this than just about any other portrait in the history of art. Two of the most important of their "identities" are Mona Lisa Gherardini del Giocondo, or Caterina Sforza, countess of Forlì and Imola.

Titian (*c.* 1488–1576) was the most important portrait artist of his time. He painted not only writers, doges, and popes, but also Emperor Charles V, who appointed him court painter and simultaneously raised him to the ranks of nobility. It was an honor for Titian to paint these people's portraits and also an honor for them to be painted by him. Charles V is even said, during a portrait sitting, to have picked up a paintbrush and handed it to Titian after the latter had dropped it, a great show of respect for the artist by the emperor. In the winter of 1547/48, Charles V summoned Titian to the Imperial Diet in Augsburg, where the painter executed a number of portraits. The painting with the most far-reaching consequences was the *Equestrian Portrait of Charles V* (fig. p. 28), in which Titian drew on the tradition of equestrian statues. The painting shows the emperor after the Battle of Mühlberg on April 25, 1547, when he had defeated the Protestant princes. Charles V rides out

976—Construction of St. Mark's Basilica in Venice ⋯⋯⋯⋯⋯⋯⋯⋯⋯ *c.* **1115**—Construction of Angkor Wat ⋯ PORTRAIT **28/29**

1010—First stone laying of St. Michael's Church in Hildesheim ⋯⋯⋯⋯⋯⋯⋯

1096—Beginning of the First Crusade ⋯⋯⋯⋯⋯⋯⋯⋯⋯⋯

of the forest and into the clearing in a victorious pose. The red of his helmet, sash, and saddlecloth signify that he is the leader of the Catholic Union, as does the lance, a reference to St. George. This new type of painting served as inspiration for many painters of portraits of rulers, including Rubens and Velázquez. Diego Velázquez (1599–1660) was a great admirer of Titian's art, which he was able to study intensively at the Spanish court. Like Titian before him, Velázquez was given the opportunity to paint a pope. During his second sojourn in Rome in 1649/50, Velázquez painted a portrait of Innocent X that made reference to the one Titian had painted of Pope Paul III. Velázquez had prepared his painting of the 75-year-old pope (fig. p. 24) in a series of sketches. It is said that Innocent X's physiognomy was so sinister that several people warned that he should not be elected pope during the conclave of 1644/45. Using his astute powers of observation, Velázquez was able to capture in a remarkable way the facial expression of the pope, who was described as choleric, suspicious, and power-hungry. When Innocent X first saw the completed portrait of himself, he appears to have recognized himself all too well, as he said: "Troppo vero!" ("Too true!") At first portraits were limited to the aristocracy, but soon ordinary citizens were also able to commission them. In these paintings, artists could stray from the conventions governing official portraits. In the Netherlands in particular, the private portrait played an

important role. Next to Rembrandt, the most notable artist in this respect was Frans Hals (between 1580 and 1585–1666). He created some of the most astonishing and unusual portraits of his time. In his group portraits, he opened up the conventional forms of painting to a certain extent, and even more so in his individual portraits. The subjects appear so at ease and his brushstrokes are so free that Hals's portraits look like painterly snapshots. The older Hals became, the more unrestrained his brushwork: *The Man in a Slouch Hat* (fig. above), from his late period, sits sideways on a chair and rests an arm casually on the backrest. Hals's brushwork, executed without a preparatory drawing, is so dynamic that the painting feels like a sketch. Hals developed the composition directly on the canvas without preparing it with underpainting. The spontaneity of the composition and the painterly technique in particular are reminiscent of the painting of the Impressionists, who were, significantly, enthralled by Hals's work.

Some highly intimate portraits resulted from the commissions of private individuals. This is clearly the case in the mourning portrait of *The Duchess of Alba* (fig. p. 31) by Francisco de Goya (1746–1828). Few portraits bear witness to a relationship as clearly as this one does. The duchess was considered to be one of the most beautiful women in Spain. It is not certain that the first lady of Spain after the queen and the

left——**TITIAN, EQUESTRIAN PORTRAIT OF CHARLES V** | 1548
oil on canvas | 332 cm x 279 cm | Museo Nacional del Prado | Madrid.

above——**FRANS HALS, THE MAN IN A SLOUCH HAT** | 1660–66
oil on canvas | 79.5 x 66.5 cm | Staatliche Kunstsammlungen | Kassel.

"Few portraits bear witness to a relationship between painter and patron as clearly as Goya's portrait of the duchess of Alba does."

best, most modern painter of Spain had an affair, but this is suggested by a number of pieces of evidence. (Not that their love for each other would have had a future as the difference between their positions in the social hierarchy was too great.) These include some very private drawings by Goya that were created during a joint stay at a country estate in Andalusia in the summer of 1796. In 1797, Goya painted the *Mourning Portrait of The Duchess of Alba*. The duchess points to the sandy ground, where the words "Solo Goya" are to be seen, as though she had written them in the sand herself. She wears two rings on her fingers, engraved with the names "Goya" and "Alba." It would hardly be possible for an artist to show affection more clearly in a portrait. This painting could also be interpreted as evidence of Goya's unrequited love for the duchess, reflecting his hope rather than reality. There was a final break following an argument. In her will, the duchess, who died in 1802, left Goya's son Javier an annuity for life, however. Goya never parted with this portrait and later gave it to his son.

The forms that portraits take are as varied as the people portrayed and the painters who portray them. *Arrangement in Grey and Black No.1* also called *Portrait of the Artist's Mother* (fig. p. 32) by James Abbott McNeill Whistler (1834–1903) is perhaps one of the most unusual titles for one of the most unusual portraits. Whistler took inspiration from Frans Hals's *Regentesses of the Old Men's Alms House* of 1644, and from its colors in particular. "To me it is interesting as a picture of my mother; but what can or ought the public to care about the identity of the portrait?" commented Whistler. The viewer should "concentrate on the composition and the beautiful gaps," he said.

At first Whistler's painting was highly controversial. It was basically considered a failure at the 1872 salon of the Royal Academy in London, but was acquired for the Louvre by the French state in 1891. It did not achieve its extraordinary fame until more than 40 years later, however, when Alfred Barr, the first director of the Museum of Modern Art in New York (founded in 1929), borrowed it from the Louvre and sent it on a traveling exhibition across the United States. Barr succeeded in making the painting exceedingly well known through a clever press campaign. The US was experiencing a great economic depression following the global economic crisis of 1929. Whistler's portrait of his mother appears to have struck a nerve during this time, strengthening

right——FRANCISCO DE GOYA, MOURNING PORTRAIT OF THE DUCHESS OF ALBA | 1797 | oil on canvas | 210 x 149 cm | Hispanic Society of America New York.

1618–1648—Thirty Years' War ·· 1939–1945—Second World War···PORTRAIT **32/33**

1776—Declaration of Independence in the USA···

1914–1918—First World War·········

1746–1828 Francisco de Goya 1834–1903 James McNeill Whistler b. 1958 Julian Opie

American patriotism. The simple fact that the French state had acquired the painting bestowed upon it the status of a masterpiece, and it was designated an American cultural treasure. When the painting was exhibited throughout the country from 1932 onwards under the slogan "America's most famous painting is coming home," it was transformed from a portrait of the artist's mother into the symbol of the mother of all generations. It became—in part as a result of press coverage—the symbol of American motherhood in general. The nation, in the midst of adversity, took comfort in this painting: comfort that only a mother can give. In 1934, a stamp bearing the image of "Whistler's Mother" was even issued for Mothers' Day. More than two million visitors saw the painting during its 18-month tour; on the last day of the exhibition in San Francisco alone, there were 25,000 viewers. The portrait of Whistler's mother became an icon of American painting.

As we can see in the work of Velázquez, Whistler, and many others, portraits are often very intricate character studies. For Whistler, for example, the portrait centered on the depth of emotion in his mother's face. The question is how little is actually necessary in order to depict an individual in a portrait-like way. The British artist Julian Opie (b. 1958) attempts to explore this in his portraits. He reduces faces as much as possible, and yet despite this high degree of "simplification," a particular individual is still recognizable in the painting, such as the portrait of the Formula One world champion Jacques Villeneuve. Astonishingly, the characteristics of some people actually appear to be highlighted by the extreme reduction.

left——JAMES ABBOTT MCNEILL WHISTLER, ARRANGEMENT IN GREY AND BLACK NO.1 also called PORTRAIT OF THE ARTIST'S MOTHER | 1871 oil on canvas | 143.3 x 162.4 cm | Musée d'Orsay | Paris.

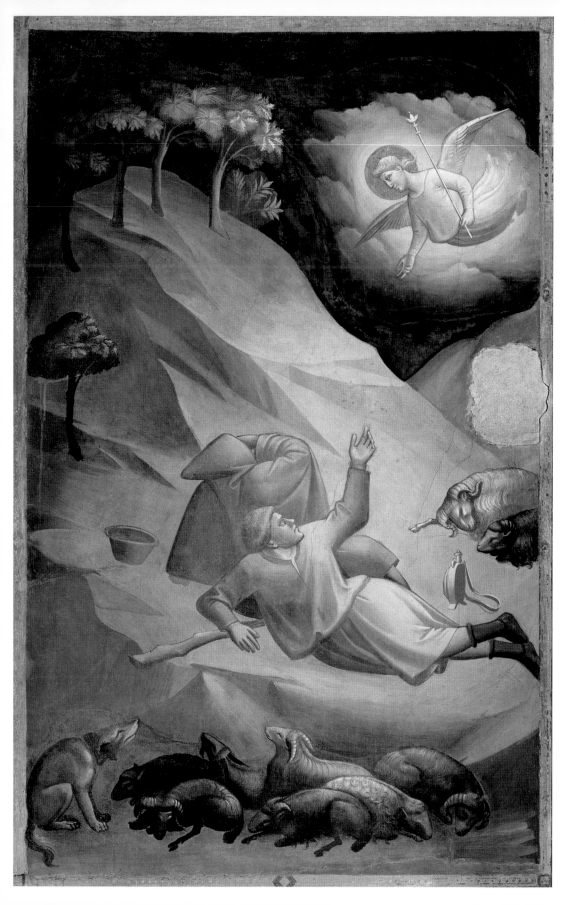

1010—First stone laying of St. Michael's Church in Hildesheim ·········· *c.* 1115—Construction of Angkor Wat··· **34/35**

1024—Completion of the Golden Gate in Kiev···

1096—Beginning of the First Crusade···

NIGHT

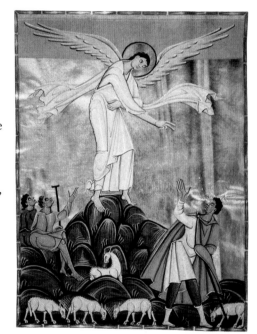

Although many biblical stories take place at night, the darkness of nighttime was not a subject until the end of the Middle Ages. Night was represented only symbolically, through sleeping people or animals, or through the moon and stars. During the Middle Ages, nighttime was considered to be the time of dangers and dark powers. Furthermore, there were religious concerns. St. Augustine described the night as the "mother of the godless" despite the fact that some of the most important Christian events, such as the birth of Christ and the annunciation to the shepherds, took place at night.

The first representation of the annunciation to the shepherds was created around 1012 for the Pericopes of Henry II, the Holy Roman Emperor (fig. right), and is a typical medieval take on the subject. An angel, larger than the humans, appears to the shepherds above the cliffs and proclaims the birth of Christ to them. Although nothing in this painting looks as it does in nature, least of all the light, one understands the story being told here: "And there were in the same country shepherds abiding in the field, keeping watch over their flock by night. And, lo, the angel of the Lord came upon them, and the glory of the Lord shone round about them" (Luke 2:8–9). Nighttime itself is not depicted in this scene in the Pericopes of Henry II, and this was to remain the case in art for a long time.

It was not until the innovations of Giotto that the development from medieval pictography towards a more realistic form of representation began to take

left——**Taddeo Gaddi, The Annunciation to the Shepherds** | *c.* 1328 fresco | Baroncelli Chapel | Santa Croce | Florence.

right——**Annunciation to the Shepherds** | *c.* 1012 | painting on parchment | Pericopes of Henry II | fol. 8v | Bavarian State Library | Munich.

c. **1200**—Creation of the *Song of the Nibelungs*................**1256**—Founding of the Augustinian Order ···

1206—Genghis Khan becomes Great Khan of the Mongol Empire ····································

1210—Founding of the Franciscan Order ······················

c. **1266–1337 Giotto di Bondone**

place. Light did not play a part in Giotto's painting, either, however. Although he imbued the figures in his paintings with corporality and weight by sculpting them using light and shadow, the position of the Sun, as it were, is always the same. It is just too bright, and neither a particular direction nor differing intensities of light are discernible, let alone a nighttime atmosphere (fig. p. 23).

Taddeo Gaddi (*c.* 1290–1366), Giotto's godson, pupil, and longtime member of his workshop, was the first to "step into the darkness." In 1328, Gaddi was commissioned to paint the chapel of the Baroncelli family in Florence's Franciscan Santa Croce church. One of the frescoes shows the annunciation to the shepherds (fig. p. 34), which had been depicted by the illustrator of the Reichenau manuscripts (fig. p. 35) 300 years before. However Gaddi's approach to and interpretation of the subject was very different.

Gaddi appears to have thought very carefully—as he had learned from Giotto—about what it might have looked like when the angel appeared to the shepherds as they watched their flocks by night. The shepherds here really are startled from their rest. The angel's light shines brightly onto the area in front of the shepherds, while the leaves and trunks of the trees on the hill are only partly lit. The sky is painted dark blue. Whereas the pictorial interpretation of the biblical narrative is symbolic in the medieval illumination, it

is almost naturalistic in Gaddi's work. A grayish tint dominates Gaddi's painting, giving way to a light, yellowish tone only in the areas lit up by the angel. Here Gaddi begins to anticipate the use of gray that would later become standard in representations of nighttime.

In around 1500, Leonardo da Vinci explained in his *Trattato della pittura* [*A Treatise on Painting*] what Gaddi had basically already understood and attempted to put into practice: "If you mean to paint a history [in the night], you must suppose a large fire, and those objects that are near it to be tinged with its color, and the nearer they are the more they will partake of it."

Paul, Jan, and Hermann Limburg already adhered to this principle in their depiction of the arrest of Christ (fig. left) in the book of hours *Les Très Riches Heures*, which they illuminated for the Duke of Berry between 1410 and 1416. It is highly probable that at least one of the brothers had seen Gaddi's fresco in person. If Gaddi's fresco appears dark as night when compared to the miniature in the Pericopes of Henry II, this is no longer the case when juxtaposed with the nighttime scene by the Limburg brothers. The Limburg brothers, too, depict a nighttime scene from the life of Jesus, the arrest in the Garden of Gethsemane (see also *Giotto*, p. 16). It really is nighttime here, and the scene would be entirely shrouded in darkness if the lanterns and torches were to go out.

Adam Elsheimer's *The Flight into Egypt* (fig. p. 37), executed in 1609, is an extraordinary painting of the night. Again, we are shown a scene from a biblical story which—although the Gospel of Matthew tells us that it took place at night (Matthew 2:14)—had never before been depicted as a nighttime scene. In addition to the masterful rendering of the various sources of light and the areas lit by each one of them, the night

1291—Founding of Switzerland············1347—Outbreak of the plague in Europe ······································· **NIGHT** **36/37**

1307–1321—Dante Alighieri writes the *Divine Comedy* ············

1337–1453—Hundred Years' War between England and France ·······························

c. 1290–1366 Taddeo Gaddi 1385–1416 Limbourg brothers

sky is of particular interest. This is the first time in the history of painting that such a large section of the composition has been dedicated to the night sky. There is a good reason for this. Elsheimer did not simply paint a sky covered with random white dots representing stars; instead, the painting depicts what the sky over Rome actually looked like in June 1609. One year before Galileo Galilei established in his treatise *Sidereus nuncius* [*Sidereal Messenger*] that the Milky Way is a cluster of thousands of stars, Elsheimer had already had the opportunity to look through a telescope and record his observations in this painting. Among the more than 1,200 stars shown, one can even make out the first representation of the constellation of the Big Dipper. Similarly, this is the first time that the Moon is shown not simply as a flat, even disc, but as the crater-marked satellite of the Earth we know today.

Pictorial representations of night became very fashionable indeed at the latest when, in the early 17th century, Caravaggio (1571–1610) created a stir with his *chiaroscuro* [light–dark] painting (see also *The Baroque*, pp. 130–137). The light from candles or torches became an active part of the painting. Figures appear three-dimensional against the darkness and are illuminated with a kind of spotlight. This new form of painting was particularly effective in the hands of a group of Dutch painters: Gerrit van Honthorst (1592–1656), Hendrick Terbrugghen (1588–1629) and Dirck van Baburen (*c.* 1595–1624) had come

left——**LIMBURG BROTHERS, THE ARREST OF CHRIST** | before 1416 painting on parchment | *Les Très Riches Heures du Duc de Berry* fol. 142v | Musée Condé | Chantilly.

above——**ADAM ELSHEIMER, THE FLIGHT INTO EGYPT** | 1609 oil on copper | 31 x 41 cm | Alte Pinakothek | Munich.

c. **1455**—Gutenberg invents the printing press ⋯⋯⋯⋯⋯⋯⋯⋯⋯⋯ **1517**—Beginning of Reformation (Martin Luther's 95 Theses)⋯

1492—Columbus's first voyage to America⋯⋯⋯⋯⋯⋯⋯

1510—Nicolaus Copernicus develops his heliocentric cosmology ⋯⋯⋯⋯⋯⋯⋯

1452–1519 Leonardo da Vinci | 1471–1528 Albrecht Dürer | c. 1488–1576 Titian | 1528–1588 Paolo Veronese

into contact with Caravaggio's painting in Rome in the early 17th century, and brought his ideas to the Netherlands. They are also known as the Utrecht Caravaggisti. The three painters competed with each other to create the most spectacularly lit scenes possible. In additional, genre scenes featuring figures of dubious origin, and thus contravening conventions governing appropriate subjects for art, were the group's trademark. Gerrit van Honthorst was a true master of this art. Because of his proclivity for these sorts of night scenes (fig. above left), and because of the fact that the majority of his paintings depicted them, the Italians called him Gherardo della Notte. Paintings of night scenes were now no longer confined to religious subject matter, and painters more often chose profane scenes through which to display their talents. Not so much the subject as the nighttime atmosphere was now central to the painting. Even if nighttime scenes became increasingly "normal" in painting, they were always charged with the mystical and spiritual connotations of the night (see also *Dreams*, pp. 124–129).

Paintings became conveyors of mood and emotion in Romanticism, as they were supposed to manifest the feelings of the artist. The works of Caspar David Friedrich are the epitome of Romantic painting: "The painter should not just paint what he sees before his eyes, but also what he sees within himself. If he does not see anything within himself, he should refrain from painting what he sees before his eyes" (Caspar David Friedrich). The night plays an important role in Friedrich's work, such as in his painting *Two Men Contemplating the Moon* (fig. above right). The two men—it is highly likely that they are Friedrich himself and one of his pupils—look from a mountain path across a landscape not visible to the viewer of the painting. The moon, veiled by a light haze, casts an almost monochrome light over the scene as could already be seen in Gaddi's first nighttime scene (fig. p. 34). The two men appear to be lost in thought. In addition to the Romantic moment, there is a political undertone in the painting: the cloaks worn by the two men, as astonishing as this may sound, were a sort of political statement. The painting was executed in 1819, that is during the time of the restoration after the Napoleonic Wars. According to the Carlsbad Decrees that came into force at that time, the German frock coat (worn by both men in the painting) was considered a symbol of opposition to the occupation of Germany by Napoleonic France. Asked what was represented here, Friedrich replied: "Demagogic machinations."

For Impressionist painting of the late 19th century, the night represented a particular challenge. "Mr. Vincent, an Impressionist painter, works, he tells us, in the evening by the light of the gas lamps on our

1578–1610 Adam Elsheimer 1592–1656 Gerrit van Honthorst

city were of great importance to van Gogh: "I always fall into a reverie when looking at the stars [...] Why, I ask myself, should the shining points in the firmament be less accessible to us than the black points on a map of France? Just as we ride on a train to get to Tarascon or Rouen, we take a ride with death in order to reach a star."

While van Gogh was interested in the painterly problems of depicting the night, Edward Hopper (1882–1967) was focused on people in the city during the night. He had simply painted "a restaurant on Greenwich Avenue, where two roads meet," Hopper said casually of one of the most famous nighttime scenes of Modernism, *Nighthawks* (fig. pp. 40/41), painted in 1942. At first glance, the bar appears as a haven in the darkness, but the neon light makes the protagonists look exposed, as though exhibited in a store window. There is no story, just as the four protagonists in the painting seem to have nothing to say to one another. The isolation of the individual in the hustle and bustle of the big city is the real subject of Hopper's painting. Hopper clearly had his finger on the pulse of the time when he depicted this feeling, which becomes even more pronounced at night, when the pace of life slows down: few other paintings of the 20th century became as popular as Hopper's *Nighthawks*. His painting became a symbol of the loneliness of people in big cities.

squares," reported a local paper in Arles on September 30, 1888. Vincent van Gogh (1853–90) was working on a new subject in his painting: the night: "I am intrigued by the problem of painting nighttime scenes or night effects at the time and in the place depicted." Van Gogh did not want to paint the night in the brown tones or just in black and blue, that had been common until then, but wanted to use the entire color palette for it, as the Impressionists had done. And van Gogh's *Café Terrace at Night* of 1888 is indeed one of the most "colorful" nighttime scenes of its era. The light of the gas lamps washes over the terrace and also illuminates the pavement. The stars above the

far left——GERRIT VAN HONTHORST, A SOLDIER AND A GIRL | 1625
oil on canvas | 82.6 x 66 cm | Herzog Anton Ulrich-Museum | Braunschweig.
left——CASPAR DAVID FRIEDRICH, TWO MEN CONTEMPLATING THE MOON | 1819 | oil on canvas | 35 x 44 cm | Galerie Neue Meister | Dresden.
above——VINCENT VAN GOGH, CAFÉ TERRACE AT NIGHT | 1888
oil on canvas | 81 x 65.5 cm | Kröller-Müller Museum | Otterlo.
next double page spread——EDWARD HOPPER, NIGHTHAWKS | 1942
oil on canvas | 84.1 x 152.4 cm | The Art Institute of Chicago | Chicago.

1776—Declaration of Independence in the USA ..

..1789–1799—French Revolution......................................

1724–1806 George Stubbs 1774–1840 Caspar David Friedrich

40/41

1832–1883 Édouard Manet **1853–1890 Vincent van Gogh** **1882–1967 Edward Hopper** **b. 1937 David Hockney**

1206—Genghis Khan becomes Great Khan of the Mongol Empire ························ **1323**—Destruction of the Lighthouse of Alexandria···

1307—Abolition of the Order of the Temple ································

42/43

c. 1266–1337 Giotto di Bondone *c.* 1290–1366 Taddeo Gaddi

ANIMALS

The 13th century was a time of change. Philosophical and scientific thought began to liberate itself from the rigidity of the Middle Ages. Alongside Thomas Aquinas and St. Francis of Assisi, Frederick II (1194–1250) of the House of Hohenstaufen was one of the main protagonists in this transition.

Frederick II was an inquisitive man who carried out research in a wide variety of areas, and his intellectual approach was quite revolutionary. He did not rely on traditionally accepted tenets but achieved insights through careful observation and experiments, which he was the first person to carry out. He engaged in lively exchanges with important thinkers of his time and was in frequent written communication with Arab princes and scientists. He was also known as *stupor mundi*, "the wonder of the world," because of his many-sided interests and astounding knowledge. Falconry was Frederick II's greatest passion. He wrote a book on the subject between 1241 and 1248 that remains relevant to this day. More than 900 depictions of more than 80 bird species can be admired in *De Arte Venandi cum Avibus* [*The Art of Hunting with Birds*]. It is probable that Frederick II made many of the drawings himself, or that they were created under his supervision. These are the first drawings representing birds in particular in a naturalistic manner that allows them to be distinguished from one another. Not only falcons and other birds of prey for breeding, training, and falconry are shown, but also many kinds of birds with their distinguishing features and behavior. Frederick was of the opinion that anybody who was interested in hunting with falcons must also acquire a basic knowledge of birds. And so the first part of his book on falcons is a general essay on ornithology. Storks, peacocks, sparrows, and even cockatoos (fig. above) are featured. Frederick II made many important observations and was, for example, the first to discover that birds do not hibernate, as most people thought at the time. He demonstrated the movements of migratory birds through his studies.

It is interesting to note that only the birds and the falconers' hand movements are drawn with precision and naturalism, while other people and landscapes continue to be drawn schematically, according to medieval convention (fig. p. 44 left). This is because Frederick was interested only in birds and how to handle them. In fact, the bird illustrations in his book on falcons are also evidence that medieval

left——**GEORGE STUBBS, WHISTLEJACKET** | *c.* 1762 | oil on canvas | 292 x 246.4 cm | National Gallery | London.

above——**COCKATOO** | *c.* 1248 | *De Arte Venandi cum Avibus* | Bibliothèque nationale de France | Paris.

illustrators were indeed able to draw "properly" when desired. But this was hardly ever the case. The way in which Frederick II acquired knowledge stood in opposition to the conventions of his time. He believed that one does not attain wisdom through listening to stories. He wanted to get to the bottom of things and used experiments, precise observation, description, and exact depictions of nature to this end. Frederick II wanted to "show things that are as they are." This meant that he challenged the authority of the Church, which was suspicious of these methods. He was not satisfied with the "word of the Lord": he wanted to discover things himself. *De Arte Venandi cum Avibus* is the first serious work of natural science, and its representations of animals became a benchmark for the further development of art and science.

Among artists, Albrecht Dürer (1471–1528) is considered to be one of the greatest observers of nature and animals. His *A Young Hare* of 1502 must be one of the best-known drawings of an animal and is a masterpiece of precise observation. But Dürer, too, made mistakes in the anatomically correct depiction of animals. This is evident in his famous woodcut, executed in 1515, of a rhinoceros (fig. p. 46): rhinoceroses do not have such richly decorated, scale-like carapaces or a second horn on the nape of the neck. Out of fairness to Dürer, one must point out that he had never

seen the animal, which had been a gift from King Manuel I of Portugal to Pope Leo X. He worked from a drawing and an eyewitness account. Dürer's rhinoceros woodcut was incredibly powerful all the same, inspiring a large number of copiers and informing many people's ideas of rhinoceroses into the 18th century.

Between 1741 and 1758, people all over Europe could see for themselves what a rhinoceros looked like. The Dutch captain Douwemout van der Meer brought a rhinoceros called Clara from India to Europe and took the exotic animal on tour through the Netherlands, Germany, Poland, Austria, Italy, Switzerland, France, and England. In 1751, this unusual group arrived for the carnival in Venice, as Pietro Longhi recorded in various paintings (fig. above right). Despite the enthusiasm for exotic animals, the horse remained the most important animal subject in art for centuries. It was both a means of transport and a status symbol, like cars are today. This explains why painters who were skilled in the depiction of horses became popular with the aristocracy. None could paint horses as George Stubbs (1724–1806) did. His precision in the representation of the physique and psyche of these animals was extraordinary. He did not simply paint pictures of horses but created veritable portraits of these animals. Stubbs knew horses better than most. He was not just a painter—he was

········**1555**—Peace of Augsburg, ending religious struggles during Reformation········ **1649**—Oliver Cromwell turns England into a Commonwealth··· **ANIMALS** 44/45

··············**1564**—Birth of Galileo Galilei·············

··············**1595**—Premiere of Shakespeare's *Romeo and Juliet*·············

an autodidact in that field—but had also studied anatomy, starting with that of humans and later focusing on that of horses. Just as Leonardo da Vinci had carried out autopsies on humans, Stubbs carried them out on horses. In 1766, he published a scientific book entitled *The Anatomy of the Horse*. Like so many painters who did not engage in historical painting, Stubbs struggled to achieve official recognition: as a "sporting painter," as he was described, he could not gain full membership of the Royal Academy of Arts. Stubbs became the best animal painter of his time all the same, as well as the favorite painter of the members of the rich upper classes interested in horse breeding and riding. Stubbs's painting *Whistlejacket* (fig. p. 42) shows the eponymous horse, one of the most famous of its time, owned by a two-time prime minister. The painting is considered one of the most well-known portraits of horses in the world. It is

unique in its exclusive concentration on the horse, and it comes across as more modern than any other animal painting of its time. There was evidence of the high regard in which Stubbs's paintings are still held today when his *Gimcrack on Newmarket Heath with Trainer, Jockey and Stable Lad* of 1765 was sold at auction for a record price of £ 22.4 million (c. $35.9 million) in July 2011.

Depictions of animals were and continue to be frequently employed to satirical ends. One finds the playful depiction of clichés such as stubborn asses, wily foxes, and wise owls. Here, animals take the position of humans in order to expose humans' weaknesses and open their eyes to their own, occasionally foolhardy, behavior. In *Satire on Tulip Mania* (fig. p. 47) by Jan Brueghel the Younger (1601–78), it is monkeys who act like humans during the tulip mania of 1635 to 1637 (see also p. 117). Dressed like humans, the monkeys haggle, weigh tulips, make price lists, and count money. One monkey sits, disappointed, on his supply while another is carried to his grave. In this unambiguous satire, Brueghel caricatures the greed of the speculators that was responsible for the first stock-market crash in history.

Animal painting was also always an exotic subject in art, however, as animals alone were not of particular importance. This hardly changed over the course of the centuries, as George Stubbs's difficulties in

far left——**A Knight on Falconry takes a Bath in a Pond**

c. 1248 | *De Arte Venandi cum Avibus* | fol. 115v | Bibliothèque nationale de France | Paris.

left——**Pietro Longhi, The Rhinoceros** | 1751 | oil on canvas 64.4 x 47 cm | National Gallery | London.

above——**Eadweard Muybridge, Horse in Motion** | 1878 photographs | George Eastman House | Rochester | New York.

above——**ALBRECHT DÜRER, THE RHINOCEROS** | 1515 | woodcut
21.2 x 30 cm | Albertina | Vienna.
left——**JAN BRUEGHEL THE YOUNGER, SATIRE ON TULIP MANIA**
c. 1640 | oil on canvas | 31 x 49 cm | Frans Hals Museum | Antwerp.
next double page spread——**WALTON FORD, LOSS OF THE LISBON
RHINOCEROS** | 2008 | watercolor, gouache, pencil and ink on paper
242.6 x 353.8 cm | courtesy the artist and Paul Kasmin Gallery.

·············1861–1865—American Civil War··1989—Fall of the Berlin Wall···················ANIMALS 46/47

···1933—Adolf Hitler seizes power···

···1969—Neil Armstrong lands on the Moon·····································

1853–1890 Vincent van Gogh 1904–1989 Salvador Dalí b. 1960 Walton Ford

gaining official recognition as a painter showed. Fascination with animal painting, however, did not change, either, as the paintings of Walton Ford (1960–) show. In the style of the nature painting of the 18th and 19th centuries, "one of the most unmodern of modern painters" (Bill Buford) creates precise and detail-rich depictions of animals in enormous watercolors, the peculiarities of whose contents are not always immediately apparent. Ford's subjects are based on diaries, reports of expeditions and the descriptions of journeys. The subject of his 3.5-meter-wide watercolor, *Loss of the Lisbon Rhinoceros* (fig. pp. 48/49), is the story of the rhinoceros Albrecht Dürer had depicted in his highly popular woodcut 500 years before, and which had drowned during a shipwreck on the way from Portugal to Italy in 1516.

Not even the great painter of horses George Stubbs could solve one problem in the depiction of animals: What does the position of a horse's legs look like when it gallops? This question intrigued many during the 19th century, including Leland Stanford (1824–93), railroad magnate, horse lover, and founder of the university named for him. He commissioned the British photographer Eadweard Muybridge (1830–1904) to investigate the matter. In 1878, the latter made the

first photographic sequences of a galloping horse by connecting twelve cameras in series and attaching string to their shutter-release buttons (fig. p. 45). The horse tore the strings as it galloped past and in this way triggered the shutters. For the first time one could see that all four of a horse's legs are in the air during one phase of the gallop, and that they come together under the stomach rather than—as shown in many paintings—the front legs extending towards the front and the hind legs towards the back.

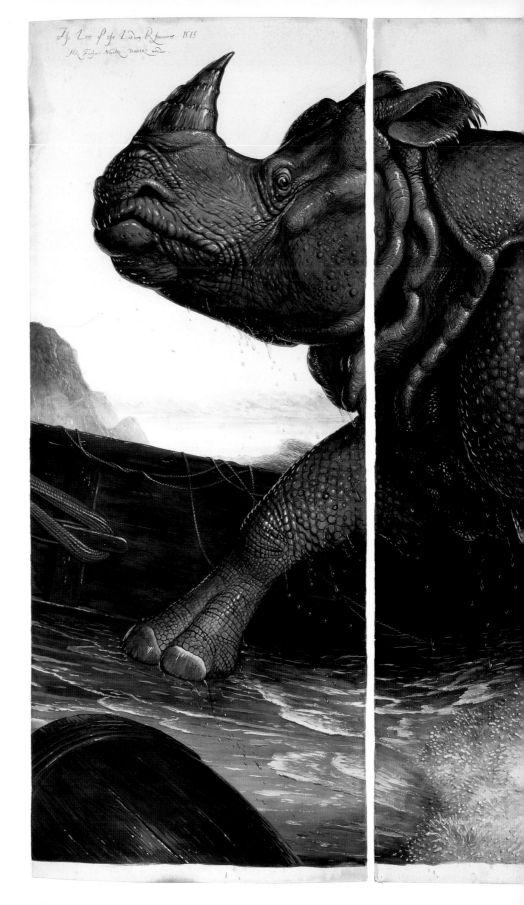

Rhinoceros . Rhinoceros unicornis

Imperator Cæsar Diuus Maximilianus
Pius Felix Augustus

1453—Fall of Constantinople 1492—Columbus's first voyage to America
c. 1455—Gutenberg invents the printing press
1478—The Spanish Inquisition is established

50/51

c. 1440–1516 Jacopo de' Barbari 1471–1528 Albrecht Dürer 1475–1564 Michelangelo Buonarroti

GRAPHIC ARTS

"On whichever day you look into the face of St. Christopher, you will not die a terrible death on this day." This statement is to be found on the so-called Buxheim St. Christopher of 1423, the oldest extant dated woodcut (fig. p. 54 left). It was named for the place in which it was discovered, a monastery near the Swabian town of Memmingen in Germany. Particularly in a time when Europe was ravaged by famines and plague epidemics, people looked to pictures of saints for comfort. The desire for private devotion increased, and with it the demand for pictures of saints, which were also affordable to the less-well-off.

A printing method that had been in use for the printing of fabrics for centuries was particularly suitable for the production of such pictures: the woodcut. The use of woodcuts made it possible to distribute the pictures of saints, for which demand was so high, at a low price.

Woodcut is a so-called relief-printing technique in which the design to be printed is raised, as on a rubber stamp. A drawing is transferred to a woodblock and all the areas that should stay white in the printing process are cut away. The remaining raised lines are inked and transferred to a piece of paper through the application of pressure. A mirror image of the desired drawing is cut into the woodblock so that the resulting printed image is the right way around.

This first printing method was developed around 1400 and represented a revolutionary innovation that soon became widespread. For the first time, a drawing could be reproduced. Churches and monasteries recognized this as a potential source of income, and began selling pictures of saints.

The first woodcuts were relatively coarse and were frequently colored in order to satisfy the increased desire for faithfulness to reality. This changed when artists such as Jacopo de' Barbari (c. 1440–1516) and Albrecht Dürer (1471–1528) began to work with this new technique, which led to its first flourishing.

In 1500, Barbari created a bird's-eye view of his hometown of Venice, composed of six blocks. Every single building in the city is depicted with great attention to detail. The map is so precise that one can still use it to find one's way around Venice today (fig. pp. 52/53).

Without the invention and mass production of paper the graphic arts would not have been conceivable. In the 12th century, paper was brought to Europe via the Orient and Africa and slowly began to replace the expensive parchment that had been in use until

left—ALBRECHT DÜRER, MAXIMILIAN I
1519 | woodcut | 41.4 x 31.9 cm.

········1506—First stone laying of St. Peter's Basilica in Rome···

························1510—Nicolaus Copernicus develops his heliocentric cosmology···

······························1517—Beginning of Reformation (Martin Luther's 95 Theses)··

1503–1540 Parmigianino **1528–1588 Paolo Veronese** **1571–1610 Caravaggio**

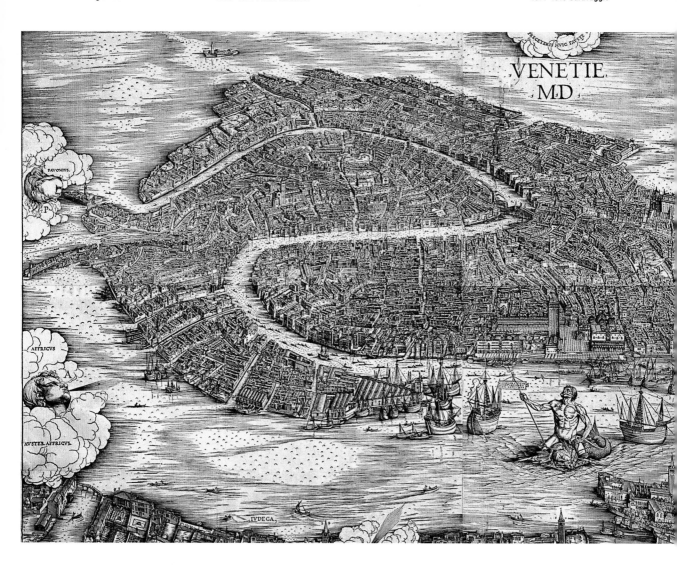

above——**Jacopo de' Barbari** | **View of Venice** | 1500
woodcut on six blocks | 135 x 282 cm | Museo Correr | Venice.

c. 1600—Beginning of the Baroque period · · · · · · · · · · · · · · · · 1632—Construction of Taj Mahal · GRAPHIC ARTS 52/53

1618–1648—Thirty Years' War ·

then. Paper production began in Italy in the mid 13th century. In 1390, the Nuremberg merchant Ulman Stromer launched the mass production of paper in the first paper mill north of the Alps.

The best and arguably most famous woodcuts were made by the Nuremberg resident Albrecht Dürer. He developed what had been a craft into an independent art form. In addition to single-leaf woodcuts such as *The Rhinoceros* of 1515 (fig. p. 46), he published several series of woodcuts as books, including *The Great Passion*, *Life of the Virgin,* and *Apocalypse.* Dürer published the *Apocalypse* in 1498, making it the first book to be produced. Even Emperor Maximilian I commissioned a woodcut portrait from Dürer, distributing it throughout the empire to increase his popularity (fig. p. 50).

In *c.* 1450, Johannes Gutenberg invented movable-type printing. Woodcut was the ideal method for illustrating books printed using movable type. In 1493, the *Nuremberg Chronicle* initiated by Hartmann Schedel was published in his hometown. It was one of the most elaborate productions of early book printing: more than 100 people worked at 25 printing presses in the workshop of Anton Koberger, who was the most important printer of his time. Dürer was among the many artists and block cutters, learning and working, in the workshop of Michael Wolgemut, which was responsible for the over 1,800 woodcuts.

1685—Birth of Johann Sebastian Bach ···································· 1726—Jonathan Swift publishes *Gulliver's Travels*.·················· 1769—Invention of the steam engine ················

1689—Bill of Rights in England·

1696–1770 Giambattista Tiepolo 1720–1778 Giovanni Battista Piranesi 1746–1828 Francisco de Goya

The young Dürer also worked as an illustrator on the most successful book of the Reformation period: he created a large number of drawings for Sebastian Brant's moral satire *The Ship of Fools*, published in 1494. This constituted the first peak of woodcut printing. After this, its importance decreased and it was replaced by a new printing method: copperplate engraving. It was not until the end of the 19th century and, most importantly, the Expressionist period, that the woodcut achieved fame once again. The bold lines of the woodcut were an ideal means of expression, particularly for the members of the artists' group Die Brücke [The Bridge], which was founded at the beginning of the 20th century. Painters such as Ernst Ludwig Kirchner, Karl Schmidt-Rottluff, and Erich Heckel were members (fig. p. 55).

The copperplate print was the first intaglio printmaking technique. The drawing can be made with much greater precision than in woodcuts because it is cut into the matrix or plate, rather than the intermediate spaces having to be cut away. Once the plate has been engraved in this way, ink is applied and wiped off the surface of the plate, remaining in the incised grooves. A dampened sheet of paper is then pressed against the plate with great force. This technique allowed artists to create *chiaroscuro* effects using drawing methods such as cross-hatching.

Copperplate printing was used for many different purposes and had a considerable influence on the development of art. The first copperplate engravings were used for more profane purposes, however: they were used to print playing cards (fig. above right). Albrecht Dürer may well have been acquainted with the method of engraving from his father's goldsmith's workshop. The origin of copperplate engraving can be traced to the crafts of the goldsmith and armorer, who used it to decorate their work. With his engravings *Knight, Death, and the Devil* (1513), *Melencolia I*, and *St. Jerome in his Study* (both from 1514), Dürer created the most important works using this technique as well, and became a well-known graphic artist throughout Europe by means of the sale of his engravings through art dealers and fairs. Erasmus of Rotterdam, whose portrait Dürer painted twice, wrote about the latter's art: "He even depicts what cannot be depicted, fire, rays of light, thunder, sheet lightning, or, as they say, the 'clouds on a wall': all the sensations and emotions; in fine, the whole mind of man as it reflects itself in the behavior of t he body, and almost the voice itself. These things he places before the eye in the most pertinent lines—black ones, yet so that if you should spread on pig-ments you would injure the work." Dürer's famous signature played an important part in this. It was more than simply a way of protecting his work

1776—Declaration of Independence in the USA ⋯⋯⋯⋯⋯⋯ 1848—Revolution in Europe ⋯⋯⋯⋯⋯⋯ GRAPHIC ARTS 54/55
⋯⋯⋯ 1789–1799—French Revolution ⋯⋯⋯
1815—Congress of Vienna ⋯⋯⋯

1774–1840 Caspar David Friedrich 1808–1879 Honoré Daumier 1859–1891 Georges Seurat

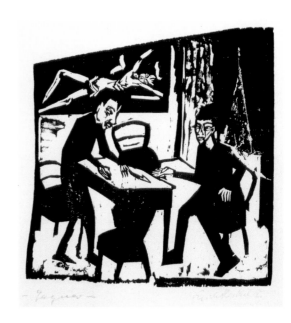

(borne out by the adjudication of the Nuremberg council): it was a guarantee of exceptional quality. This was recognized as far away as Italy, which led to a not entirely positive state of affairs for Dürer. The Italian engraver Marcantonio Raimondi (1475–1534) became famous for engravings of Raphael's paintings, and was one of the first practitioners of the reproduction of illustrations. He earned his living through reproductions of famous works of art, which he distributed as copperplate engravings. Raimondi also copied Dürer's work, and created the impression that his copies were originals through the inclusion of Dürer's signature. When Dürer heard of this, he launched the first copyright case in history in Venice. Raimondi was allowed to continue to disseminate Dürer's work, but was not allowed to include the signature in his reproductions.

The technique of copperplate engraving thus gave artists the ability to distribute their artworks worldwide. This led to a completely new exchange of artistic ideas in Europe. Some paintings achieved great fame and influence precisely through the prints made by means of copperplate engraving. Adam Elsheimer's *The Flight into Egypt* of 1609 (fig. p. 37) is just one example. Some artists, such as Rubens and Canaletto, sent out catalogues featuring engravings of their work to attract new clients. Copperplate engravings were also very important in the training of young artists. Many artists collected engravings of famous paintings by their colleagues, which their pupils had to copy in order to improve their drawing technique.

Despite its many advantages, the art of engraving remained a very labor-intensive one. The engraving of the plate was very time-consuming (Dürer spent more than three months on his engraving *Knight, Death, and the Devil*), and commissioning an engraver added an intermediate stage that stood in the way of artistic freedom. These disadvantages were sidestepped by the invention of a new technique. This, too, sprang from the armorer's craft and was first applied by Daniel Hopfer the Elder (c. 1470–1536) in Augsburg in about 1500. The technique is that of etching.

Etching differs from engraving in that the the plate is "carved" not by mechanical but by chemical means. The plate is covered in etching ground made of wax,

far left—**Buxheim St. Christopher** | 1423 | woodcut 20.8 x 28.7 cm | John Ryland Library | Manchester.

left—**Master of the Playing Cards, Queen of Wild Men** c. 1430/40 | copperplate engraving | 13.5 x 8.8 cm | Bibliothèque nationale de France | Paris.

above—**Erich Heckel, Adversaries** | 1912 | woodcut 24.8 x 24.3 cm | Museum of Modern Art | New York.

····1861–1865—American Civil War ·· 1939–1945—Second World War···GRAPHIC ARTS 56/57
··· 1917—October Revolution in Russia ·································
··· 1925—Invention of television···································

1883–1970 Erich Heckel 1904–1997 Willem de Kooning b. 1932 Gerhard Richter

"Etching, first applied in about 1500, remained the most important artistic printing technique into the 20th century."

resin, and asphalt. The artist creates the drawing on the etching ground, leaving the plate itself intact but cutting into the etching ground. The plate covered in the etching ground is subsequently dipped into acid, which erodes the sections of the plate that are exposed.

This new method is much easier and faster than copperplate engraving because one does not have to engrave the plate but rather one draws on the thin etching ground. Furthermore, it is easy to make corrections by applying a new etching ground and in so doing touching up flaws. Most importantly, the freer drawing method makes the artistic expression more clearly visible. One of the first and outstanding masters of this technique was the Dutchman Rembrandt (1606–69) (see also p. 90), who achieved painterly effects by exposing the plates to acid for different lengths of time. Rembrandt transformed the art of etching into an artistic means of expres-

sion—as Dürer had done with the woodcut—and perfected it to a degree not achieved by many others. By varying the length of the acid biting and working on different stages of the various plates, new effects can be achieved again and again, increasing the intensity of the prints, as one can see in the etchings of Giovanni Piranesi (1720–78). In his *Carceri* series he shows nightmarish prison architectures that become increasingly dark and threatening with each state (fig. p. 56).

Aquatint joined these other techniques in the middle of the 18th century, so that, in addition to lines, whole areas could be etched in different shades of gray. Francisco de Goya (1746–1828), who was undoubtedly one of the greatest etchers, took this technique to previously unparalleled heights of expressiveness with the series *Caprichos* (1793–99) and *Disasters of War* (1810–14). The etching *The Sleep of Reason Produces Monsters* of c. 1797/98 from the *Caprichos* series is one of the most impressive examples of this (fig. p. 127).

Because of their great expressiveness and because they could be combined with others, etching remained the most important artistic printing technique into the 20th century.

left—**Giovanni Piranesi, Carceri VII** | 1761 | etching | second state
55.3 x 41 cm | Staatliche Kunsthalle | Kupferstichkabinett | Karlsruhe.

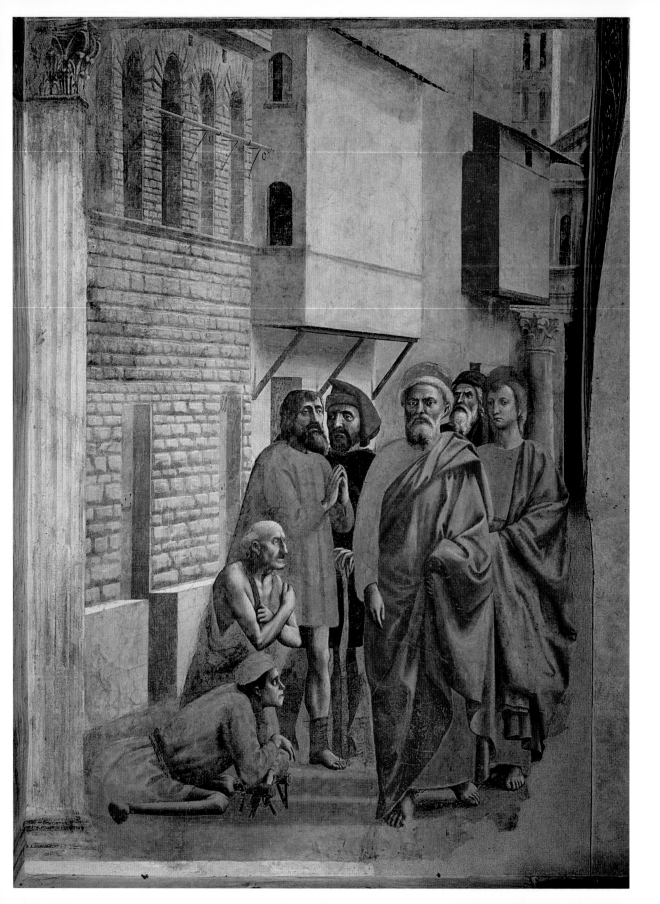

c. 1410—Creation of the illustrations for the *Très Riches Heures* **1478**—The Spanish Inquisition is established··· 58/59
1453—Fall of Constantinople ·················
c. **1455**—Gutenberg invents the printing press ·················

1401–1428 Masaccio 1452–1519 Leonardo da Vinci *c.* 1488–1576 Titian

SHADOW

It is always there, but its "presence" is taken for granted to such a degree that it can easily be forgotten in representations of our world: it is the shadow. More than anything else, it makes objects and people in paintings appear realistic. If one believes the story told by the historian of the classical world Pliny the Elder (AD 24–79), the shadow was instrumental in the invention of painting. According to this account, the daughter of the ancient Greek potter Butades of Sicyon loved a man who had to leave for a faraway place. In order to have a keepsake of him, she followed her father's suggestion to position him in front of a lantern and trace his profile, which was cast as a shadow on the wall [...] and so painting was born (fig. p. 62 left).

Generally speaking, two types of shadow are used in painting. One is the so-called form shadow, the type of shadow that is to be seen on the bodies themselves when light shines upon them. The form shadow can be traced through art from Antiquity to the present day, almost without interruption. Classical Greek and Egyptian painting, as well as the art of the Far East, are among the exceptions. Form shadows lend bodies

plasticity and depth by sculpting them. In the Middle Ages, when painting looked more like pictography, they played a negligible role, so that the paintings of the time appear flat, and the figures seem strangely disembodied. The admiration for Giotto's frescoes in Assisi and Padua was all the greater because he reintroduced form shadows into art and thus created figures with bodies that appear to be three-dimensional and that impart a sense of physicality. This provides them with their much-lauded air of naturalness (see also *Giotto*, pp. 16–23).

There is another type of shadow, which Giotto did not depict: it is known as the cast shadow. This is the type of shadow that is cast by a body on its surroundings on the side of the body that is not turned towards the light. It is dependent on the position of the body in relation to the source of light. The smaller the angle between the source of light and the object, the longer the shadow will be; and the more focused the source of light, the more defined the shadow will be. Cast shadows were already depicted in classical Roman painting and mosaic art, but disappeared entirely in medieval painting, which was also related to religious considerations. In the Middle Ages, saints were considered to be holy beings of another realm and subsequently not subject to natural optical laws. When the theological and scientific paradigms began to shift as the Middle

left——MASACCIO, ST. PETER HEALING THE SICK WITH HIS SHADOW
c. 1425 | fresco | *c.* 240 x 180 cm | Santa Maria del Carmine | Florence.

1492—Columbus's first voyage to America ⋯⋯⋯⋯⋯⋯⋯⋯⋯⋯⋯⋯⋯⋯⋯⋯⋯⋯⋯⋯⋯⋯⋯ 1555—Peace of Augsburg, ending religious struggles during ReformationReformationszeit ⋯

1570—Birth of Guy Fawkes ⋯⋯⋯⋯

1503–1540 Parmigianino 1560–1609 Annibale Carracci 1571–1610 Caravaggio

Ages gave way to the modern age, and the desire for more realistic paintings had manifested itself, this had an effect on the depiction of shadows. It was reasoned that, if the saints were not beings of an ideal, transcendental world, but part of the physical world, they must also be subject to the optical laws of the real world, and must therefore also cast shadows. It is not possible to determine just who reintroduced cast shadows into painting, but it is known that the Florentine painter Masaccio (1401–28) was one of the first to depict them. He decorated the Brancacci Chapel in the Florentine church of Santa Maria del Carmine with scenes from the life of St. Peter between 1423 and 1428. Masaccio depicts a story which focuses on the shadow, and which could not be satisfactorily depicted without it: St. Peter healing the sick with his shadow (fig. p. 58). "Insomuch that they brought forth the sick into the streets [...] that at the least the shadow of Peter passing by might overshadow some of them" (Acts 5:15). This is the scene depicted by Masaccio: St. Peter and his companions walk along a row of houses in Jerusalem, which in Masaccio's fresco looks remarkably similar to Florence. Four men can be seen outside the houses. Those who have already been brushed by St. Peter's shadow can stand up once again, while the cowering man is still waiting for the healing effect. Peter's shadow is on the left, which also corresponds to the illumination of the chapel, where the only window is to be found on the right-hand side above the fresco. Another aspect of Masaccio's fresco is of significance: the shadow shows precisely where St. Peter is positioned at that moment. The shadow starts at the exact point where his foot is placed firmly on the ground—and this is new in painting. If one looks at earlier paintings from the Middle Ages, or even by Giotto, one discovers that the figures in them appear almost to float. They are grounded by the introduction of the cast shadow, which nails them to the ground, so to speak. Masaccio roots the saint in the real world by making him cast a shadow, because any real physical presence must cast a shadow. Interestingly, only the people in Masaccio's frescoes in the

............**1595**—Premiere of Shakespeare's *Romeo and Juliet* | **1649**—Oliver Cromwell turns England into a Commonwealth··· **SHADOW** 60/61

..**1618–1648**—Thirty Years' War·················**1644**—Beginning of the Qing Dynasty in China··

betw. 1580 and 1585–1666 Frans Hals 1606–1669 Rembrandt 1628/29–1682 Jacob van Ruisdael

above——**Robert Campin, The Annunciation** | center panel of the triptych of the Mérode Altarpiece | *c.* 1425 | oil on wood | 64.1 x 63.2 cm Metropolitan Museum of Art | New York.

Barnacacci Chapel cast shadows: the houses and the trees do not.

A painting by the Dutch artist Robert Campin (c. 1375–1444) confirms that plants and inanimate objects certainly could cast shadows at this point in time. The Netherlands, like Florence, was a center of artistic development during the 15th century. Unlike the painters in Florence, who were masters of pictorial construction in search of the ideals of Antiquity, the Dutch were masters of observation and of detail. The desire for detail-rich paintings benefited from the introduction of oil paint, whose invention was ascribed by Giorgio Vasari (1511–74) to Jan van Eyck (c. 1390–1441), who was famous even beyond the borders of his country. His colleague Robert Campin, a master of shadows, was no less brilliant. His triptych depicting the Annunciation, known as the Mérode Altar (c. 1425), shows clearly that shadows in particular appear to fascinate Campin, although it does not yet feature central perspective (fig. pp. 60/61).

The two sconces above the fireplace cast shadows, as do the bench, window shutters, the towel and the kettle in the niche in the back wall. Looking more closely, we can see that most of the objects cast two shadows. The explanation for this is to be found in the two windows on the left wall. Campin assumed that two shadows are necessary if there are two sources of light. The three-dimensionality that he

achieves in this way was quite unprecedented at the time. And yet there are a number of inconsistencies in Campin's work: if the two windows act as the source of light, why does the bench cast a shadow onto the back wall, and what is the source of illumination of the window shutter? Did Campin think that there would be a further source of light in the space in which the altar would be displayed? This would explain these shadows. But why are the vase and the candlestick on the table without shadows?

Shadows became particularly important in the painting of still lifes, which often aim to deceive the eye of the beholder. The casting of shadows, which supplies the objects in the paintings with a remarkable appearance of realism, was essential to this effect. While it was also present in other painting genres, it was seldom more important than it was in the still life. This was to change in the Baroque period, during which the sense of drama in paintings was heightened through the increased use of *chiaroscuro*. Caravaggio (1571–1610) was a master of the direction of light. In his *The Calling of Saint Matthew* of c. 1598, both light and the accompanying shadow play an important role (fig. above right). Jesus steps into Matthew's custom house from the right. The source of light is located above Jesus, outside the painting. With the effect of a spotlight, the light shines on the group at the table at whose head

1774–1840 Caspar David Friedrich 1803–1847 Grandville 1839–1906 Paul Cézanne

Matthew is counting money. Most of the scene takes place in the shadow, which is emphasized by the use of a single shaft of light, which falls directly on the future apostle. Matthew gazes at the divine light and, with it, his calling. The light follows the gaze and the movement of Jesus's hand through the entire room, grazing the faces of those present and hitting Matthew, who has been chosen but pretends that none of the action has anything to do with him. For the sake of concentrating the beam of light even more directly on the tax collector, the shutter of the blind window at the back is slightly open, casting a shadow on the left side of the wall. Caravaggio achieves an entirely new sense of drama and dynamics in his paintings through his light direction. Leonardo da Vinci (1452–1519) had advocated the avoidance of hard light and the resulting shadows in his treatise on painting: "Light separated from shadow with too much precision has a very bad effect." Caravaggio shows that the opposite can be correct and convincing. The latter's *chiaroscuro*, or *light-dark*, would have a profounder and more lasting effect on painting than most other painting styles (see also *The Baroque*, pp. 130–137, and *Night*, pp. 34–41).

As anybody who has ever attempted to play shadow games using their hands knows, shadows can have a life of their own: they can take on forms that do not correspond to the objects from which they "originate." Artists, such as the French graphic artist Jean Ignace Isidore Gérard, known as Grandville (1803–47), have often taken advantage of this. His caricature of the members of the French cabinet depicts shadows that reveal the "true form" of the politicians walking along a wall (fig. above). Seen in the "right light," the dignitaries are transformed into turkey, pig, devil, and somebody who is clearly an alcoholic. For a long time, shadows were usually painted as lighter or darker grey areas. Shadows are seldom gray, however, taking on different hues as a result of the contrast with their various surroundings. Leonardo da Vinci already knew that the colors of objects vary according to their environments (see also p. 36). This realization was therefore not new, but the Impressionist painters were the first to put it into practice by painting colorful shadows. This is the very reason for which many Impressionist

far left——EDUARD DAEGE, THE INVENTION OF PAINTING | 1832
oil on canvas | 176 x 135.5 cm | Nationalgalerie | Berlin.
left——CARAVAGGIO, THE CALLING OF ST. MATTHEW | c. 1598
oil on canvas | 328 x 348 cm | San Luigi dei Francesi | Rome.
above——GRANDVILLE, "THE FRENCH CABINET – THE SHADOWS"
in *La Caricature* | 1830.

paintings appear as realistic and lifelike as they do (see also *Impressionism*, pp. 160–165). The connection between the color of a shadow and its surroundings is perhaps best seen in a sunlit snowy landscape such as that captured by the American painter Rockwell Kent (1882–1971) in his painting *The Trapper*, executed in 1921 (fig. above).

"There are more enigmas in the shadow of a man who walks in the sun than in all the religions of the past, present and future," wrote Giorgio de Chirico (1888–1978). Many of de Chirico's early paintings show town squares bathed in the summery light of the south. This lightness, already virtually palpable, is amplified by the heavy shadows cast on the bright, light ground. *Mystery and Melancholy of a Street*, painted in 1914, is a typical example of *pittura metafisica*, whose founder de Chirico is considered to be (fig. p. 65). The painting is characterized by the stark contrast of light and shadow. While the building on the left is brightly lit, that on the right fades into dark shadow. The sunlight cleaves a bright path between the houses. All that is visible of a girl who plays with a hoop is a shadowy silhouette against the bright ground. She is running towards the square on which a large shadow is visible. A trailer whose doors are open is parked in front of the shadowy building on the right. To whom does the shadow on the square belong? Is it a man or a statue?

Has the child seen him, or is it engrossed in the game it is playing?

De Chirico creates the tension with the steep and warped perspectives of the buildings and the strong light-dark contrasts. It appears not to be possible to resolve the situation, nothing is clear, and both everything and nothing appear to be possible. Although shadows are natural and omnipresent, it is this very fact that makes them so inconspicuous. Only if one concentrates on them do they step into the foreground. And they are not present in art until artists become aware of the possibilities inherent in shadows.

above——**ROCKWELL KENT, THE TRAPPER** | 1921 | oil on canvas 84.5 x 108.9 cm | Whitney Museum of American Art | New York.
right——**GIORGIO DE CHIRICO, MYSTERY AND MELANCHOLY OF A STREET** | 1914 | oil on canvas | 87 x 73 cm | Private collection.

c. 1410—Creation of the illustrations for the *Très Riches Heures* ·············· c. 1450—Gutenberg invents the printing press ·············

1436—Completion of the dome of Florence Cathedral ·············

1453—Fall of Constantinople ·············

66/67

1401–1428 Masaccio

1431–1506 Andrea Mantegna

CENTRAL PERSPECTIVE

The desire to depict nature in an increasingly precise and realistic manner increased exponentially as a new age for artists was ushered in by Giotto's frescoes, following the end of the Middle Ages. A fundamental problem for "correct" depiction was—and still remains—the transposition of a three-dimensional world onto the two-dimensional surface of paper, canvas, or a wall. Artists attempted to back up their observations scientifically, and to establish scientific-theoretical rules for painting from nature correctly. The sculptor and architect Filippo Brunelleschi (1377–1446) took an interest in this problem, and discovered the rules of central perspective in pictorial representation. At some point between 1410 and 1420, he stood in the entrance of the cathedral in Florence and painted a picture of the baptistry opposite the cathedral as he saw it from that position. A special apparatus allowed the viewer to look at the reflection of the painting in a mirror in such a way that the sky above the Baptistry was visible at the same time

(fig. above). Those who observed the Baptistry with Brunelleschi's contraption realized that there is little difference to the eye between the real object and a representation of it drawn or painted according to the rules of central perspective. Unfortunately, the painting has not been preserved and all one can do is work out from various reports what it might have looked like.

How did Brunelleschi come up with the idea? When looking down a road, it looks as though all of the lines extending into the distance meet at a central point.

left——MASACCIO, HOLY TRINITY | c. 1427/28 | fresco | 667 x 317 cm Santa Maria Novella | Florence.

above——Filippo Brunelleschi's mirror experiment with the San Giovanni Baptistry in Florence, painted according to the rules of central perspective.

1492—Columbus's first voyage to America ················· 1510—Nicolaus Copernicus develops his heliocentric cosmology ·····················

··························· 1506—First stone laying of St. Peter's Basilica in Rome·····················

··························· 1517—Beginning of Reformation (Martin Luther's 95 Theses) ·····················

c. 1488–1576 Titian 1503–1540 Parmigianino 1560–1609 Annibale Carracci

All objects become smaller in proportion to their distance from the observer. The first to formulate a theoretical description of the principle was the Italian art theorist and architect Leon Battista Alberti (1404–72), who discussed it in his book *De Pictura* [*On Painting*], published in 1435. He compared the aforementioned effect with a view through a window, showing a particular segment of a room. If one looks from a fixed position with just one eye open through the pane of glass, every point of the room or of the object to be depicted comes to be superimposed on a particular place on the pane of glass. The lines in the room that are parallel to the pane are also parallel on the pane. The lines extending into the distance appear foreshortened on the glass pane and cross at a particular point on the pictorial surface, the so-called vanishing point. Connecting the points and lines on the pane results in a perspectival picture.

Having understood the principles of perspectival construction, one can transpose every building and every object onto a two-dimensional pictorial surface, achieving the correct proportions. It also makes it possible to construct illusory spaces that can look as real as if they actually existed. Of the two, this second aspect was of greater importance to the artists of the early 15th century. In order to construct such a space correctly, one must first determine the horizon line, or the height from which the space will be viewed. The vanishing point is located on this line. If the vanishing lines are drawn in as reference lines, the height and position in space—and thus in the picture—of every object or person can be precisely determined.

And this is precisely what Tommaso di Ser Giovanni Cassai, better known by the name of Masaccio (1401–28), did in the church of Santa Maria Novella in Florence. In about 1425, he created the first fresco to be painted according to the rules of central perspective (fig. p. 66) and therefore an unprecedented form of painting. One feels as though one is looking into a real space that appears to open up in the church wall. The inhabitants of Florence must have been astounded when they saw it and believed that a new chapel must have been built. A barrel-vaulted chapel

above ——Giovanni di Paolo, St. Jerome Appearing to St. Augustine | *c.* 1465 | 38.9 x 49.9 cm | Gemäldegalerie | Berlin.
right——Andrea Mantegna, The Lamentation Over the Dead Christ | *c.* 1480 | oil on canvas | 68 x 81 cm | Pinacoteca di Brera | Milan.
next double page spread——Paolo Uccello, The Battle of San Romano | *c.* 1438 | egg tempera on poplar | 182 x 320 cm | National Gallery | London.

1571—Birth of Johannes Kepler **1632**—Construction of Taj Mahal............................. CENTRAL PERSPECTIVE **68/69**
1618–1648—Thirty Years' War.................................

1571–1610 Caravaggio 1606–1669 Rembrandt

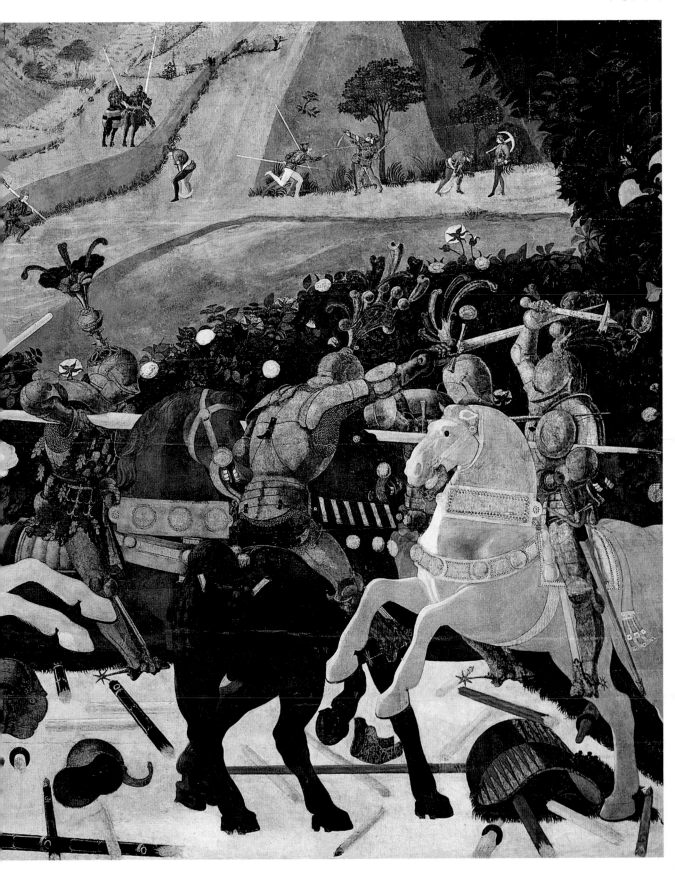

with a panelled ceiling opens up in two levels over a pedestal in front of which are a sarcophagus and a skeleton. A depiction of Jesus on the Cross can be seen in the center of the chapel, and behind him God the Father stands on an altar-like elevation, holding the cross in his hands. A white dove, symbolizing the Holy Spirit, is depicted between God and Jesus. This triumvirate of God, Jesus, and Holy Spirit constitutes the Trinity, for which the fresco is named. The Disciple John and Mary stand beside the cross. The husband and wife who commissioned the fresco are depicted kneeling on a step in front of the chapel. It is very likely that Brunelleschi had supplied the model for this architecture because it is an example of the modern Renaissance architecture of the time,

whose "inventor" Brunelleschi is considered to be. Masaccio's Trinity fresco is the first instance of a pictorial representation in which all proportions coincide with those in real life, whereas the people in Giotto's frescoes, for example, were still much too big in relation to their surroundings. This marks the end of medieval conventions governing perspective, which were based on relative importance and depicted important people as larger in size than others. Masaccio makes people the focal point: space is defined in relation to them. Each person depicted is assigned a particular place by the architecture. The benefactors kneel on the steps outside the chapel, and are thus not part of the sacred events that are taking place inside. The viewer, too, is assigned a

·1726—Jonathan Swift publishes *Gulliver's Travels*...........................1776—Declaration of Independence in the USA ··· CENTRAL PERSPECTIVE 72/73
.........................1752—Benjamin Franklin invents the lightning rod...
.........................1756—Birth of Mozart...........................1774—Goethe writes *The Sorrows of Young Werther*...........................

1732–1806 Jean-Honoré Fragonard 1775–1851 Willam Turner 1798–1863 Eugène Delacroix

particular place by the fact that the spatial effect of the fresco looks correct only from a particular place in the real-life church, approximately five meters from the center of the painting. We, the viewers, essentially become part of the pictorial construction because the scene refers to us, both in terms of content and in terms of physical space. What Masaccio shows here is in some ways the leap from a theocentric to an anthropocentric view of the world.

Soon, central perspective became the norm and a plethora of treatises were written dealing with its geometric foundations, with its many possibilities, and with the correct application thereof. A painting by Giovanni di Paolo (c. 1403–82) of c. 1465 (fig. p. 68) shows that not all painters were able to put this idea into practice accurately.

The Florentine painter Paolo Uccello (1397–1475) was so thrilled by central perspective and its potential that he could barely go to sleep. "Oh, what a sweet thing [Ital. *dolcezza*] is perspective," he is said to have replied to his wife when she called to him to join her in bed; *dolcezza* is the poet's word for the beloved. Uccello created a famous example of the consistent application of perspective in the three-part painting cycle called *The Battle of San Romano*, which he painted in c. 1438 (fig. pp. 70/71). Uccello created a grid on which he positioned the figures. The lances on the ground have not been scattered haphazardly, but actually follow precisely the lines that lead towards the vanishing point. The felled knight in the foreground lies precisely on the construction net and is depicted in the foreshortened manner specified by the new method's rules. The painting feels primarily ornamental because Uccello did not aim to create a realistic battle scene; he wanted instead to exploit the possibilities of his new "beloved," also known as "central perspective."

A variety of different instruments were developed to help the artist perfect the art of perspectival foreshortening, including Dürer's grid of lines and the camera obscura, a precursor of the photographic camera.

The application of the rules of perspective to the human body was a particular challenge. Whether the foreshortening with which this was depicted was accurate or not was often considered an indicator of the quality of a painter. *The Lamentation Over the Dead Christ*, painted in about 1480 by Andrea Mantegna (1431–1506), is a magnificent example of this (fig. p. 69). The viewer of this painting essentially stands directly in front of the soles of the unshod feet of the dead Christ's body, a highly unconventional representation. Here, one can see the soles of the feet and into the nostrils of the Son of God: Mantegna has eschewed the representative conventions of the typical Lamentation scene. This artistic trick, which was made possible only by the application of perspective, transforms the Son of God into the human he was when he died on the Cross. He is identified as Jesus by the stigmata on his hands and feet, as well as by his halo. Such a close-up was almost considered an affront, an indecency. And yet Mantegna was able to turn it into a great artwork on the subject of the Passion. The viewer is brought into close proximity to the scene by the extreme close-up that compresses the broken body. Andrea Mantegna was also the first to paint an illusionistic ceiling (see also *Illusionistic Ceiling Painting*, pp. 104–113). As Masaccio had shown in his Trinity fresco, it was possible to create the illusion of architectural spaces through the

right——**PAOLO VERONESE, MURAL IN THE VILLA BARBARO** | Maser 1561/62.

above——**WILLIAM HOGARTH, SATIRE ON FALSE PERSPECTIVE** | 1754 engraving.

1827—First photographs

1876—Invention of the telephone

1883—First petrol-engined automobile

1889—Completion of the Eiffel Tower

1832–1883 Édouard Manet

1853–1890 Vincent van Gogh

1881–1973 Pablo Picasso

"Magritte often uses classic methods such as central perspective in order to call them into question."

consistent application of perspective. This was particularly popular in the decoration of palaces. Paolo Veronese (1528–88) created illusionistic architecture, passages, and rooms for the confusion and delight of contemporary visitors (and the continued astonishment of visitors to this day) in the Villa Barbaro built by Andrea Palladio (1508–80) (fig. p. 72).

Florence was one of the centers of new developments in art at the beginning of the 15th century. The Netherlands was the other. Here, painters in the circle around Jan van Eyck achieved results similar to those of the Florentine painters, although they used a different approach: their paintings were not created on a geometric foundation, but instead depicted every single detail, no matter how small. Painters in the Netherlands had not yet achieved in their paintings the internal coherence of the spaces constructed by the Italians: the rules of perspective had not yet been discovered here. As a result, the effects in the Netherlandish paintings are different from those created by the Italians. In Italian paintings, one stands "in front of" the painted rooms, or in front of the window, as Alberti described it. The viewer is even assigned a precise position in front of the painting from which the correct perspective is achieved. One becomes part of the pictorial construction. In Netherlandish art, by contrast, one feels drawn into the painting. Although many painters repeatedly

deviated from the rules of correct perspectival representation, it remained a foundation of their training and work. In 1754 an instruction manual was published, advertised in the following terms: "Being an attempt to make the art of perspective easy and familiar, to adapt it entirely to the arts of design, and to make it an entertaining study to any gentleman who shall choose to engage in as polite an amusement." The frontispiece is by the English painter and printmaker William Hogarth (1697–1764), and illustrates just about every mistake that can be made if perspective is not used accurately (fig. p. 73). At first glance, it appears to be a simple landscape featuring a few people. Looking more closely, one discovers a plethora of small mistakes: the fishing rod of the man in the foreground reaches all the way behind the other fisherman; the sign of the public house appears to be affixed to two different buildings, and extends to the trees in the field; and on the hill, a man's pipe is lit by a woman who looks out of the window of a house in the middle distance, to name just a few examples. Hogarth, who was famous for his sharp wit and satirical prints, wanted this image to serve as a warning: "Whoever makes a design without the knowledge of perspective will be liable to such absurdities as are shown in this frontispiece." Central perspective remained one of the most important foundations of painting and drawing until the

1914–1918—First World War ⋯⋯⋯⋯⋯⋯⋯⋯⋯⋯⋯⋯ 1969—Neil Armstrong lands on the Moon ⋯ CENTRAL PERSPECTIVE 74/75
1931—Completion of the Empire State Building ⋯⋯⋯⋯⋯⋯⋯⋯⋯⋯⋯
1939–1945—Second World War ⋯⋯⋯⋯⋯⋯

20th century. This did not change until the appearance of Cubism, when the painting was no longer seen as an illusionistic pictorial space, but as what it is: a flat canvas. Despite this thoroughly modern approach, it did not spell the end of representation according to the rules of linear perspective. "Absurdities"—albeit intentional ones—make further appearances, particularly in 20th-century art, notably in the confusing drawings of the Dutch artist M. C. Escher (1898–1972). Although our modes of viewing have expanded alongside the development of painting, some images continue to call them into question. Because we know how big objects are, and what their proportions are in relation to one another, it confuses us when things are juxtaposed in a way that does not make sense. The Surrealist René Magritte (1898–1967), for example, illustrates this in his painting *The Listening Room* (fig. above) of 1958: does it depict an enormous apple, or a normal apple in a doll's house? One automatically tends towards the first of these explanations as the size of the room is considered to be a given. Magritte often uses classic methods such as central perspective in order to toy with our modes of viewing, and to call them into question.

above——RENÉ MAGRITTE, THE LISTENING ROOM | 1958 | oil on canvas 38 x 46 cm | Kunsthaus | Zurich.

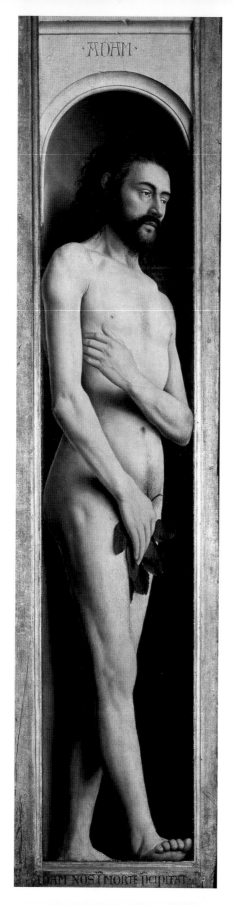
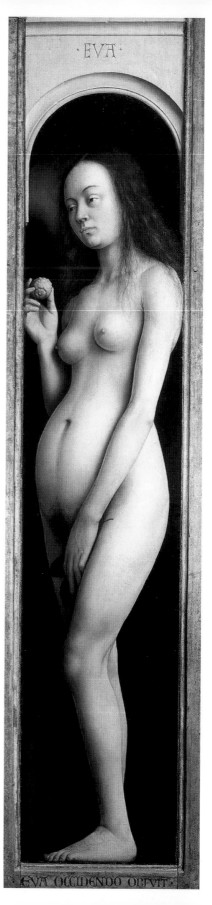

· ADAM · · EVA ·

ADAM NOS IN MORTE PCIPITAT EVA OCCIDENDO OBFVIT

1306—First public post-mortem dissection····· 1323—Destruction of the Lighthouse of Alexandria
1307–1321—Dante Alighieri writes the *Divine Comedy*
1320—Declaration of Arbroath (Scottish Declaration of Independence)

76/77

THE NUDE

The acceptance of nude painting has always been in flux, and is always dependent upon the moral values of the period in question. In Antiquity, the nude as an ideal of beauty was not subject to any moral restrictions. This changed radically with the rise of Christianity. Nudity became a sin, starting just after the creation of humankind. Adam and Eve became aware of their nakedness, which had not bothered them until then, once they had eaten from the Tree of Knowledge. Now, however, they were able to tell good from bad, and nakedness was obviously bad. This was particularly true of women, who acquired the role of the seductress through Eve.
The uptight approach of Christianity to nudity, had a direct influence on art because the painters of the Middle Ages no longer oriented themselves with reference to nature. Over time, they did not know how to draw the naked human body anymore, occasionally leading to idiosyncratic representations (fig. p. 78 right). Exceptions prove the rule, however, as one can see on a page from a book of hours from the 14th century (fig. above).

In the 13th and 14th centuries, theology changed as a result of Scholasticism and, consequently, so did the image of humankind and the pictorial representations of people. Science played an important part in this. The first public autopsies took place in 1306 in Bologna, resulting in the publication of the first book of anatomy in history.
And yet more than a hundred years would pass before the first artistic drawings after a living, nude model would be made. These were executed by Antonio di Puccio Pisano, known as Pisanello (1395–1455), who was one of the most successful painters of his time. Pisanello drew indefatigably, taking on a wide variety of subjects in his sketchbooks. Around 1425, he became the first artist of modern times to draw a nude female model in various positions (fig. p. 78 left). As is common practice in courses on anatomical drawing

left——JAN VAN EYCK, ADAM AND EVE, GHENT ALTARPIECE | 1432
oil on wood | 204 x 33 cm each | St. Bavo | Ghent.
right——EROTIC SCENE IN THE MARGIN OF A TEXT | 2nd quarter of the 14th century | The Morgan Library & Museum | New York.

1381—Peasants' Revolt in England ⋯⋯⋯⋯⋯⋯⋯⋯⋯⋯⋯⋯⋯⋯⋯⋯⋯ *c.* 1410—Creation of the illustrations for the *Très Riches Heures* ⋯⋯⋯⋯⋯⋯⋯⋯⋯⋯⋯⋯⋯⋯⋯⋯⋯⋯⋯

1420–1436—Construction of the dome of Florence Cathedral⋯⋯⋯⋯⋯⋯⋯⋯⋯⋯

c. 1390–1441 Jan van Eyck 1395–1455 Pisanello Mid-14th *c.*–*c.* 1410 Master Wenceslaus

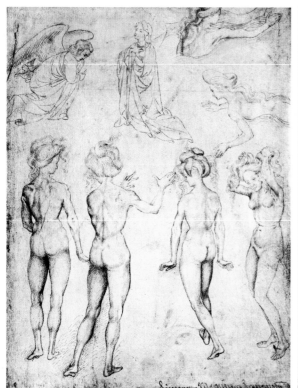

these days, Pisanello depicts the woman with various arm and leg positions. The naturalness that emanates from the drawings was new and was not adopted across the board for some time. At the art academy in Paris, for example, drawing from nude female models was not allowed until 1759. Until then, only men were drawn (officially, at least), and were given female attributes.

Nude painting became common practice more quickly in Italy, as a result of the reception of works of art from Antiquity. In his seminal book *De Pictura* [*On Painting*], which was published in 1435, Leon Battista Alberti recommended drawing naked people because, he stated, the study of naked people alone would allow artists to depict clothed people with accuracy.

In the Netherlands, too, which became the most important center of art alongside Italy, some artists focused on nude painting. It was here that Hubert van Eyck (*c.* 1370–1426) and Jan van Eyck (*c.*

1390–1441) created a "miracle of painting" and "the pride of the town of Ghent" with the Ghent Altarpiece, which was erected in *c.* 1432. The first life-size nudes of modern times, in the form of Adam and Eve, painted from nature, are depicted on the inside of this polyptych (fig. pp. 76 and 79). As Hubert van Eyck died in 1426, Jan van Eyck can be credited with the creation of these figures.

above right——**ADAM AND EVE** | *c.* 950 | Ms & II. 5 f 18 | Real Biblioteca San Lorenzo de El Escorial

above left——**ANTONIO PISANELLO, NUDE STUDIES** | *c.* 1425 | ink on parchment | 22.2 x 16.6 cm | Museum Boijmans Van Beuningen | Rotterdam.

right——**JAN VAN EYCK, GHENT ALTARPIECE** | *c.* 1432 | oil on wood | 335 x 229 cm | St. Bavo | Ghent.

.............**1453**—Fall of Constantinople ...

....................................**c. 1455**—Gutenberg invents the printing press ...

1471–1528 Albrecht Dürer **c. 1488–1576 Titian**

1555—Peace of Augsburg, ending religious struggles during Reformation··········· *c.* 1600—Beginning of the Baroque period······

1564—Birth of Galileo Galilei···

1595—Premiere of Shakespeare's *Romeo and Juliet*·······

1577–1640 Peter Paul Rubens 1606–1669 Rembrandt

While in Italy artists aspired to the ideal image of humankind according to models from Antiquity, Jan van Eyck depicted two entirely individual people, on whom he performed a virtual painterly autopsy using his exceptional powers of observation. This can be seen most clearly in the representation of Adam. Adam is shown covered by a fig leaf, so that Van Eyck clearly represents him after the Fall. But van Eyck has not painted the biblical figure of Adam, but the very man who served as his model: he has painted the hands and head darker than the rest of the body. But were Adam and Eve not entirely naked before the Fall, and would that not mean that the skin on every part of their bodies would be the same color? Jan van Eyck's subject was Adam, but he painted a man of his time, whose body was usually covered by clothing and who was tanned only where he his clothes did not protect his skin: his hands and face.

Jan van Eyck's nudes became so famous that the entire altarpiece was for a long time known as the Adam-and-Eve altarpiece. Upon seeing *Eve* on a visit to Ghent in 1521, Dürer, who had painted Germany's first life-size nudes (*Adam and Eve,* 1507, Museo Nacional del Prado, Madrid), waxed rhapsodic. The two panels disappeared in 1781, however, while the Holy Roman Emperor, Joseph II, took offense at their unambiguous nudity. They did not reappear until 1861.

Once painting had rediscovered the human body, artists tried to systematize its proportions, and the erotic became an important subject. As it was not yet possible to paint nude people without a story, they made use of biblical and mythological subjects. The biblical story of Susanna (Daniel, chapter 13) was particularly popular. Two judges were guests in the house of a respected man. When his wife Susanna

· **1618–1648**—Thirty Years' War .. **1689**—Bill of Rights in England··· NUDE 80/81

1632—Construction of Taj Mahal··

1685—Birth of Johann Sebastian Bach·······························

1628/29–1682 Jacob van Ruisdael

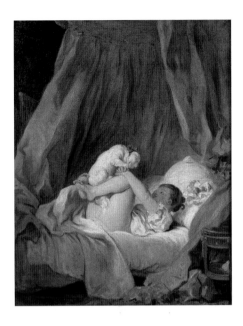

bathed in the garden, the men secretly observed her and "gradually began to desire her." They put pressure on her to have sex with them and said that they would claim that she had committed adultery with a young man if she did not acquiesce. The story has a happy ending, and gave many painters a welcome alibi for a voyeuristic nude painting (fig. p. 80).

In addition to the Bible, artists often turned to classical texts such as Ovid's *Metamorphoses*. One need only think of the numerous amorous adventures of Zeus or of Venus, goddess of love, which supplied countless opportunities for painting nudes. The most famous painting of Venus must be Titian's *Venus of Urbino*, executed in 1538 (fig. p. 82). The painting was a marriage present from the Duke of Urbino to his son. A number of the details in this painting indicate that it is a sort of allegory of married love: the chest, which traditionally held the wife's dowry; the dog, a symbol of fidelity; and the roses that are a sign of love make this abundantly clear. It might seem rather strange to modern viewers that a nude such as this

would have been hung in the marital bedroom. However, it was thought at the time that women would give birth to more beautiful children if they looked at a beautiful body during conception. Mark Twain had a completely different take on this painting. In his view, it was "the foulest, the vilest, the obscenest picture the world possesses." No matter how he reached this conclusion, it does not change the fact that Titian's *Venus* inspired countless artists.

The nudes of 18th-century France were much more frivolous. Here, eroticism played the most important part. François Boucher (1703–70) and his student Jean-Honoré Fragonard (1732–1806) were masters of this genre, and enjoyed great success with it. The majority of their paintings were intended only for private use, however. Many, including *Girl with Dog* (fig. above), were not allowed to be exhibited in public, and engravings of them were not allowed to be sold to the general public.

The approach to nude painting became increasingly rigid over the course of the 19th century, although certain liberties were regularly taken in the privacy of people's homes. It was still necessary to find a suitable mythological pretext for such paintings, which feels slightly hypocritical when one examines them. Alexandre Cabanel (1823–89) exhibited his painting *The Birth of Venus* (fig. p. 83) in the Paris Salon of 1863. A young woman reclines lasciviously

left——**TINTORETTO, SUSANNA AND THE ELDERS** | 1557 | oil on canvas 146.6 x 193.6 cm | Kunsthistorisches Museum | Vienna.

above——**JEAN-HONORÉ FRAGONARD, GIRL WITH DOG** | *c.* 1770 oil on canvas | 89 x 70 cm | Alte Pinakothek | Munich.

"A number of the details in Titian's Venus of Urbino indicate that it is a sort of allegory of married love."

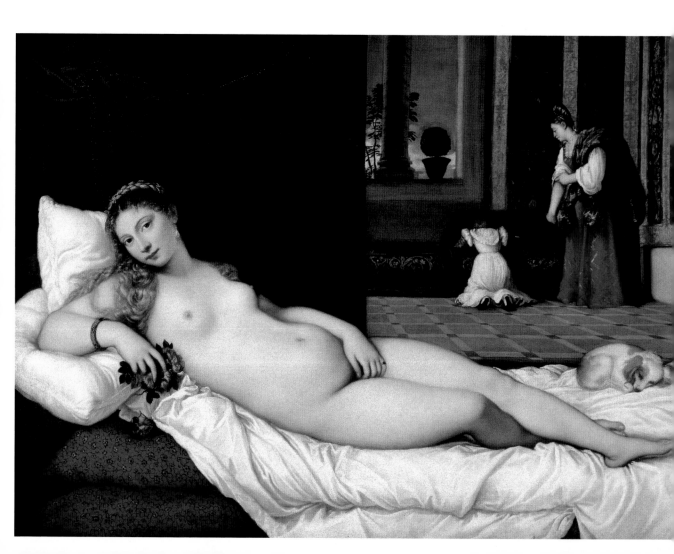

1769—Invention of the steam engine ·········· 1815—Congress of Vienna ········· 1848—Marx and Engels publish *The Communist Manifesto*··· NUDE

········ 1776—Declaration of Independence in the USA ·········

1789–1799—French Revolution·········

82/83

1823–1889 Alexandre Cabanel 1832–1883 Édouard Manet

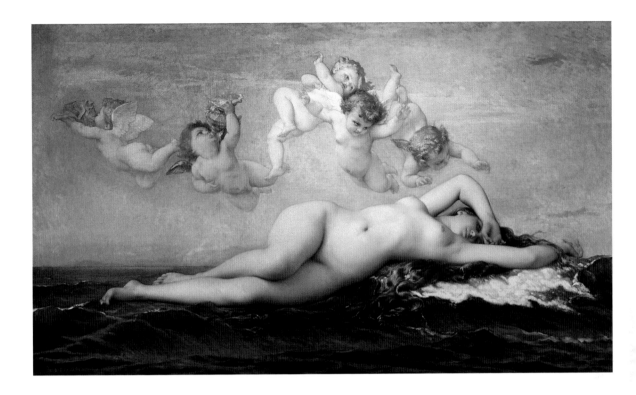

among the waves, accompanied by *putti* made of "vanilla pudding from the workshop of fashionable art confectioners" (Émile Zola). One might consider it a little too provocative, and imagine that it could have been criticized as offensive. But this was not the case at all, because it was, after all, entitled *The Birth of Venus*. Emperor Napoleon III bought it immediately. There was a scandal two years later, however, when Édouard Manet (1832–83) exhibited his *Olympia* (fig. p. 84), executed the same year as Cabanel's *Venus*. The visitors were so shocked that they attacked the painting with sticks. It had to be protected from the enraged crowds by police officers. What makes Manet's nude so different from those of his respected precursors?

At first glance, Manet's painting appears to be considerably less lascivious and in many ways far less salacious. Manet's painting drew on, or even copied, Goya's *The Nude Maja* and Titian's *Venus*. But, in addition to the painting style (which was repeatedly criticized), the combination of the title and the painting itself constituted the main problem: "Olympia" was, significantly, a common name for prostitutes in Paris at the time. Manet had depicted a prostitute, and the object of desire upon whom men gazed for centuries, looked back at them, nonchalant, challenging, and confident. The viewer was thus positioned as a potential customer. The painting's "obscenity" was highlighted by attributes such as the black cat—in place of Titian's loyal dog—arching its back on the bed. Black cats in general stand for all that is evil and, in addition, the French term *la chatte* not only refers to the animal, but is also a vulgar expression for the vagina. The orchid that Olympia wears in her hair is considered a symbol of sexual desire, and Titian's two maids have here been transformed into a black servant who has clearly brought in a bunch of flowers from the next customer. And yet nude painting has enjoyed uninterrupted popularity to this day, perhaps only in part because many artists are searching for perfect proportions. One of the most

left—**TITIAN, VENUS OF URBINO** | 1538 | oil on canvas | 119 x 165 cm
Galleria degli Uffizi | Florence.

above—**ALEXANDRE CABANEL, THE BIRTH OF VENUS** | 1863
oil on canvas | 130 x 225 cm | Musée d'Orsay | Paris.

1861–1865—American Civil War ... 1900—Sigmund Freud publishes *The Interpretation of Dreams*

1886—Completion of the Statue of Liberty ...

1914–1918—First World War

1922–2011 Lucian Freud b. 1937 David Hockney b. 1938 Georg Baselitz

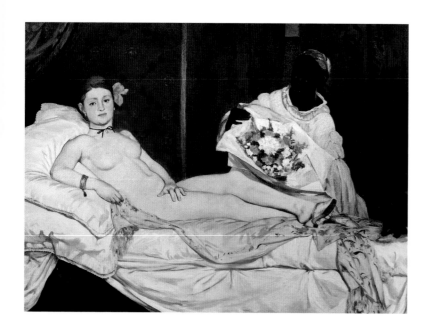

famous painters of the 20th century focused much of his energy on painting nudes, both female and male: the British artist Lucian Freud (1922–2011). His strikingly naturalistic nudes, which he painted with remarkable tenacity from the 1950s onwards, made him—together with his work as a portrait painter—famous. This is even more surprising considering that he depicts his models and all of their irregularities in a highly sculptural and exact manner. Freud does not present ideal beauty, with which we are confronted constantly in the form of advertisements, in his nudes. Instead, he shows us entirely normal people, and the vulnerability and transience of the human body.

His most famous painting—apart from a rather controversial portrait of Queen Elizabeth II—is entitled *Benefits Supervisor Sleeping* and was executed in 1995 (fig. p. 85). Like his predecessors Titian and Manet, Freud shows a naked woman, asleep on a bed.

But that is where the similarities end. The woman in question is Sue Tilley, an employee of a London job center (hence the title of the painting), and his model for many years. Freud is interested in her and in the sculptural representation of her very corpulent body, and provides no attributes that could indicate anything more about her. This painting was the first nude to have made it onto the cover of the *Financial Times*. This was not so much because of a newly discovered interest in nude paintings of the economics-focused newspaper, but because it had been bought at auction by the Russian billionaire Roman Abramovitch for $ 33.64 million. *Benefits Supervisor Sleeping* thus became the most expensive painting by a living artist. Not bad for a nude.

above——**Édouard Manet, Olympia** | 1863 | oil on canvas 103.5 x 190 cm | Musée d'Orsay | Paris.
right——**Lucian Freud, Benefits Supervisor Sleeping** 1995 | oil on canvas | 151.3 x 219 cm | Private collection.

1939–1945—Second World War ... 2002—Introduction of the Euro··· NUDE 84/85

1968—Assassination of Martin Luther King ..

1989—Fall of the Berlin Wall ...

b. 1958 Julian Opie

"Lucian Freud does not present the ideal beauty of advertisements, but the vulnerability and transience of the human body."

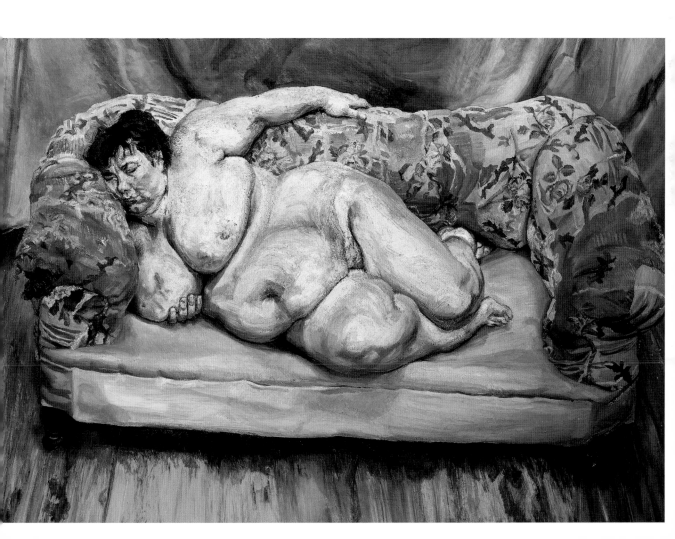

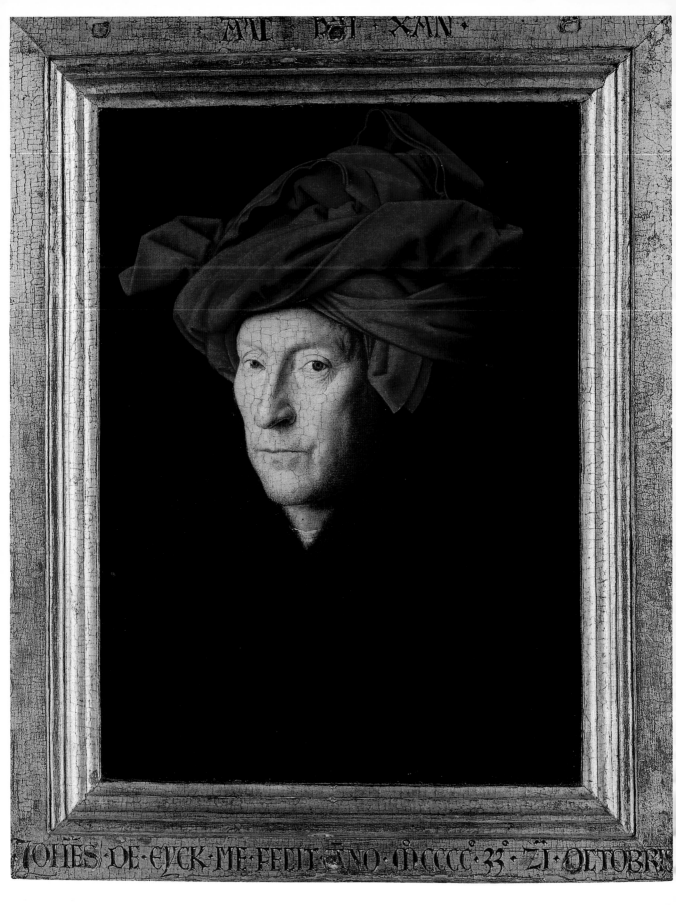

c. 1410—Creation of the illustrations for the *Très Riches Heures* ⋯⋯⋯⋯⋯⋯⋯⋯⋯⋯ **1492**—Columbus's first voyage to America⋯

1436—Completion of the dome of Florence Cathedral⋯⋯⋯⋯⋯⋯⋯⋯⋯⋯⋯⋯⋯⋯⋯⋯⋯⋯⋯

c. **1455**—Gutenberg invents the printing press ⋯⋯⋯⋯⋯⋯⋯⋯⋯⋯⋯⋯

86/87

THE SELF-PORTRAIT

From an art-historical point of view, portraits that artists create of themselves are a relatively young genre. Nowadays, we no longer know the medieval artists who made book illustrations, wall paintings, and mosaics; their names have not been passed down in history. Their work was important, but who it was by was considered irrelevant. Art was not yet autonomous but served exclusively to represent the notion of the divine and its "representatives," such as popes, kings, or emperors. We differentiate between the *artes liberales* and the *artes mechanicae* at this time. From late Antiquity onwards, the "Seven Liberal Arts"—grammar, rhetoric, dialectics, arithmetic, geometry, music, and astronomy—comprised those practised by "free citizens." The *artes mechanicae* were those practised as crafts by "unfree citizens," and were considered inferior. Painters were also in the latter category as they were viewed as simple craftsmen.

This distinction began to dissolve in the Renaissance. The social image of the artist and the artist's status changed with the strengthening of the notion of the individual and the changing challenges of the time. Giotto was one of the first artists to begin to ascend to the intellectual strata of society. Art also became a history of artists, who cemented and attested to their new position in society with their self-portraits.

The Dutch artist Jan van Eyck (*c.* 1390–1441) was one of the first painters to turn himself into the subject of a painting. He had long before stepped out of the shadowy existence of a medieval painter. In 1430 he was made city painter of his hometown of Bruges, *valet de chambre* to the Burgundian Duke Philip the Good, and fulfilled secret diplomatic missions that took him as far away as Portugal. He completed the famous Ghent Altarpiece (see also p. 79) in *c.* 1432, and bought a house for himself and married in 1433. He was at the peak of his career and was one of the dignitaries of his town. And it was precisely this status as a wealthy and important citizen that he wanted to document in a portrait. As he happened to be the best painter in town, he commissioned himself, so to speak (fig. p. 86).

A Dutch inscription in pseudo-Greek letters at the top of the original frame reads "I do as I can," and that at the bottom of the frame says "Jan van Eyck made me on 21 October 1433" in Latin lettering and language. The words appear to have been incised into the frame, but have actually simply been painted on. We find ourselves faced with a 43-year-old man with

left——Jan van Eyck, Portrait of a Man (Self-Portrait?) | 1433 | oil on oak | 26 x 19 cm (33 x 26 cm with frame) | National Gallery | London.

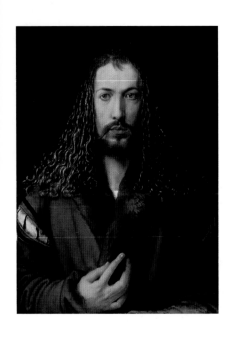

"Renaissance painters show in their self-portraits their new social status as artists."

a fur coat and red headdress. He is shown in three-quarter profile and appears to examine the viewer sternly. This was an innovation in portraits which, until then, were usually painted in profile. The three-quarter profile was a necessity as van Eyck had to look at his reflection in a mirror while painting. In fact, he is therefore not observing the viewer, but observing his own face in the mirror. Although the face in this painting is just eight centimeters high, the finest wrinkles and even beard stubble are visible. The chaperon, the turban-like headdress, was a trademark of van Eyck, making it possible to recognize him in his various paintings: it was in some ways his signature.

It looks as though artistic self-confidence and the desire to document this in portraits were in the air: a large number of self-portraits were created both in the Netherlands and in Italy. The artists in Italy enjoyed a higher status than their colleagues in the north. This can be traced back to the literature of Antiquity praising painters such as Apelles, Phidias, and Zeuxis on the one hand, and to the fame of Giotto—who was celebrated in Dante's *Divine Comedy* and honored by being accorded the first state funeral for an artist—on the other. Whether Giotto, too, painted a self-portrait is a contested issue; that none has survived if he did is undisputed, however. A letter by Albrecht Dürer (1471–1528) shows how

different the situation of painters in Italy was from that of those in the north. During his second sojourn in Venice, in 1506, he wrote: "How I shall freeze after the Sun; here I am a gentleman, at home a parasite." But it was in fact Dürer who managed to catapult himself to a new social stratum, as one can see in his various self-portraits in general, and the one he painted in 1500 in particular (fig. above). In this portrait, Dürer presents himself to the viewer entirely symmetrically and from the front. The coat with the fur collar is testament to his economic success and his elaborate curls highlight his confident nature. His gaze is at once stern and relaxed. The cross of a window frame is to be seen in his left eye, indicating that the eye is the "window to the soul." The hand, depicted in a remarkably delicate fashion, stands for the tool of the creative spirit. Dürer presents himself as one of these creative spirits in this painting, assuming a pose that had been used exclusively for representations of Christ until this time.

above——**ALBRECHT DÜRER, SELF-PORTRAIT** | 1500 | oil on linden 67 x 49 cm | Alte Pinakothek | Munich.

right——**MAX BECKMANN, SELF-PORTRAIT IN TUXEDO** | 1927 | oil on canvas | 141 x 96 cm | Harvard Art Museums/Busch-Reisinger Museum | Cambridge | MA.

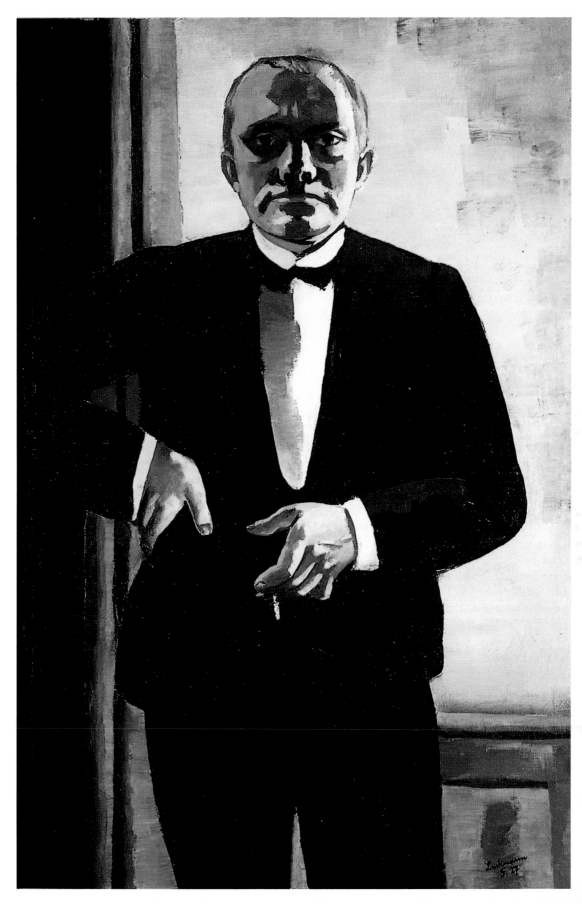

1618–1648—Thirty Years' War··· **1685**—Birth of Johann Sebastian Bach··

1689—Bill of Rights in England·····························

1697–1768 Canaletto 1699–1779 Jean-Baptiste-Siméon Chardin

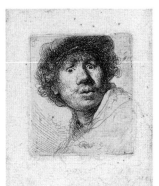 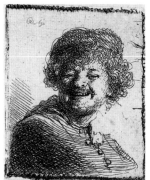 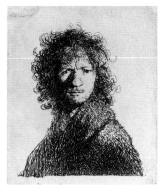 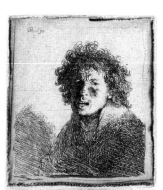

In this way, Dürer depicts himself, in the words of Italian theoretician Leon Battista Alberti (1404–72), as a "divine" artist, "a re-creator" of God in the "re-creation" of His creation by means of painting.

The first self-portraits were used primarily to confirm and bolster social status. The self-portrait has retained this function to this day. In 1927 the German painter Max Beckmann (1884–1950) created the *Self-Portrait in Tuxedo*, which is the modern equivalent to the Dürer portrait. Beckmann depicts himself as a cosmopolitan citizen who is aware of his position as an important artist (fig. p. 89). "What are you? What am I?—These are the questions that pursue me and torment me unceasingly [...] Because the self is the greatest and obscurest secret in the world," as Max Beckmann wrote in 1938. This also applies to numerous painters before him, many of whom tried to get to the bottom of the question in their self-portraits: Who am I?

One feels as though one can read an autobiography in pictorial form into the more than 90 self-portraits by Rembrandt (1606–69): from the confident, young, successful painter to the disillusioned old man. He not only examined himself , but also used them as practical exercises and experimented with different facial expressions, grimaces, and light distribution (figs. above). One of the most well-known paintings by Vincent van Gogh (1853–90) is his *Self-Portrait with Bandaged Ear*, which he painted after his infamous clash with his colleague Paul Gauguin (1848–1903) (fig. p. 91). On Christmas Eve 1888, a great argument erupted between the two painters, leading to Gauguin's departure from Arles. Van Gogh was so distraught following this that he appears to have wanted to punish himself by cutting off his right earlobe. He was admitted to hospital in Arles, where he painted himself as soon as he had regained his strength. This was a form of therapy for van Gogh, who was of the opinion that "... working on my paintings is actually necessary for my recovery." Van Gogh had mental health problems and appears to have been severely afflicted by alcoholism. He was plagued by suicidal thoughts, and he finally died of the consequences of a suicide attempt two years later. But that lay in the future: "Every day, I follow the incomparable Dickens's prescription against suicide. It consists of a glass of wine, a piece of bread with cheese, and a pipeful of tobacco." Van Gogh probably saw himself as being on the path to recovery in this self-portrait.

above——**Rembrandt, Four Self-Portraits** | *c.* 1630 | etching
J. de Bruijn Collection.

right——**Vincent van Gogh, Self-Portrait with Bandaged Ear**
1889 | oil on canvas | 64 x 50 cm | Kunsthaus | Zurich.

1712—Saint Petersburg becomes the capital of Russia

1827—First photographs··· SELF-PORTRAIT 90/91

1776—Declaration of Independence in the USA

1789–1799—French Revolution

1815—Congress of Vienna

724–1806 George Stubbs 1732–1806 Jean-Honoré Fragonard 1798–1863 Eugène Delacroix

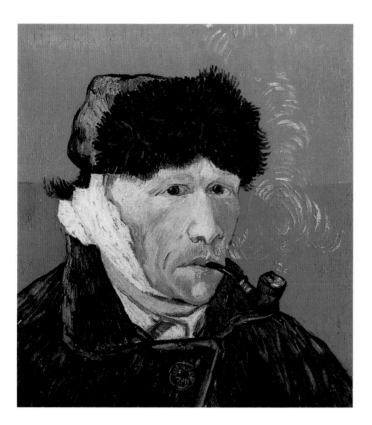

Through his self-portraits and, most importantly, because of his constantly frustrated attempts to establish himself as an artist, van Gogh became the prototype of the artist who can only create true art as a result of personal crisis. The self-portrait sometimes also served as a job application with which artists solicited new commissions. Painters could use them to prove their ability in both conception and painterly skills, unconstrained by convention. The Italian Francesco Mazzola, known as Parmigianino (1503–40), made an exceptional example when he arrived in Rome, the center of the art world at the time, from Parma. Instead of the usual canvas, he commissioned a convex wooden panel, onto which he painted his portrait (fig. p. 92). Parmigianino's face is visible at the center of the spherical surface and, surrounding it, the room, distorted by the curvature of the wood. Parmigianino used this device to simulate a convex mirror in which the room appears to be reflected. His hand, for example, is shown to be larger than it would be in a flat reflection, in keeping with what one would see in a convex reflection.

Parmigianino did not want to depict himself as an honorable citizen, but as a talented artist who had unusual ideas and who, most importantly, was able to put them into practice. He was clearly successful in this endeavor: Pope Clement VII, to whom he showed his "object," immediately gave him a couple of commissions, so that the young painter from the provinces had achieved his goal.

Although some of them achieved great fame during their lifetimes, women who took up the paintbrush as a profession are less well known than their male colleagues. They include Sofonisba Anguissola (c. 1531–1625), Artemisia Gentileschi (1593–1652), Rosalba Carriera (1675–1757) and Angelika Kauffmann (1741–1807). Women were largely excluded from academic training until the 19th century, which resulted in considerable limitations to the subjects they could paint. Most women learned from their fathers and engaged primarily in portrait painting. The French artist Élisabeth Vigée-Lebrun (1755–1842) was one of the most successful painters of her time, and her portraits of members of the

aristocracy were a great success throughout Europe. She, too, learned to paint from her father and, as a young woman, became Queen Marie Antoinette's painter. Vigée-Lebrun had to flee France because of the French Revolution in 1789, and spent the next 12 years travelling from Italy via Vienna to Saint Petersburg, where she remained for six years. Here, as in the many other cities in which she lived, she painted portraits of the international aristocracy and became rich and famous. Nowadays, her portraits tend to look a little bit too sweet and saccharine. Her paintings were comparatively sober for their time, however, and focused on the subjects themselves, without too many additions. This was in keeping with contemporary tastes. The self-portrait of 1782, which shows her at the age of 27, was an opportunity for the young painter to present herself to her clients (fig. p. 93). We see a confident young woman, whose beauty was celebrated by her contemporaries, in the bright light of a summer's day, which is reflected in her straw hat. She faces the viewer openly and naturally, without powder or a wig, which was unusual at the time. The boldly painted feather on her hat is considered a symbol of the imagination of painting. Vigée-Lebrun's self-portrait was thus also seen as an allegory of painting itself.

Since its "discovery," the self-portrait has been one of the most important genres for painters. It is important not only to cement their social position, to explore facets of themselves, for practice or as a job application; it was and still is important as a painting to be sold to collectors, considered as it is as the most personal expression of the artist. The differences between artists' self-portraits are as great as those between their personalities. This will never change, no matter which media artists use to present themselves to the world.

above——PARMIGIANINO, SELF-PORTRAIT IN A CONVEX MIRROR
1523/24 | oil on convex wood panel | diam. 24.4 cm | Kunsthistorisches Museum | Vienna.
right——ÉLISABETH VIGÉE-LEBRUN, SELF-PORTRAIT IN A STRAW HAT
after 1782 | oil on canvas | 97.8 x 70.5 cm | National Gallery | London.

1323—Destruction of the Lighthouse of Alexandria .. 1381—Peasants' Revolt in England 94/95

1337–1453—Hundred Years' War between England and France

1347—Outbreak of the plague in Europe

1377–1446 Filippo Brunelleschi c. 1390–1441 Jan van Eyck

LANDSCAPE

It is astonishing to think that the first landscape painting to portray a real landscape in a recognizable way is fairly recent. This form of landscape representation was not a genre known to Antiquity or the Middle Ages, when landscapes were shown in an idealized form, or symbolically represented by small sections (see also *Night*, pp. 34–41).

The Florentine painter Cennino Cennini (*c*. 1370–1440) wrote one of the most important technical handbooks on painting in the late Middle Ages, *A Treatise on Painting* [*Trattato della pittura*], in *c*. 1400. In this book, he gives advice on the training and profession of the artist, as well as information about various techniques and materials. In one chapter, Cennini suggests that one should take "a few big, rough, unworked stones and paint them according to nature, using light and shadow." He also teaches artists to paint those mountains that are further away in darker colors, which is the polar opposite of the way in which we perceive things in reality.

It never occurred to the painters of the time to paint nature faithfully as they observed it. And this was hardly necessary because the pictorial narratives from the Bible were usually painted against a gold or precious blue background to symbolize the divine sphere. Nature itself was not a subject for art in the Middle Ages. It was either a "workplace" or quite simply the wilderness and it was considered sinful despite the fact that it had been created by God.

With the new assessment of nature by Scholasticism, and with the painting of Giotto (which was also based on the observation of nature), these conditions began to change. And yet in Giotto's work, too, nature as represented in painting continued to consist only of individual, stylized components, as Cennini described.

One initial step towards landscape painting was made in the form of an artwork in the Palazzo Pubblico in Siena. Ambrogio Lorenzetti (*c*. 1290–1348) was commissioned by the town council to paint an allegorical representation of good and bad governance in his hometown, and the consequences of both on town and country. For the *Effects of Good Government on Town and Country*, Lorenzetti created between 1337 and 1339 an enormous, 14-meter-wide panorama of the environs of Siena, painted as it were from the center of the town (fig. p. 96). The hills, fields, and populated areas continue to be primarily symbolic, it remains far removed from a true likeness of reality, but it represents a temporal landscape that no longer needs a religious background.

left—**KONRAD WITZ, THE MIRACULOUS DRAUGHT OF FISHES** | 1444
oil on wood | 132 x 154 cm | Musée d'Art et d'Histoire | Geneva.

.......... **1453**—Fall of Constantinople **1510**—Nicolaus Copernicus develops his heliocentric cosmology
.......... *c.* **1455**—Gutenberg invents the printing press
.......... **1492**—Columbus's first voyage to America

1431–1506 Andrea Mantegna **1471–1528 Albrecht Dürer** *c.* **1480–1538 Albrecht Altdorfer** **1503–1540 Parmigianin**

By the way: the first depiction of a snowball is also to be found in the Palazzo Pubblico in Siena, in the Sala dei Novi. The seasons are represented symbolically in the lunettes above the frescoes of the *Effects of Good and Bad Government*. Lorenzetti painted winter in the form of a man in a flurry of snow, wrapped in a coat, and wearing a hat. In his hand, he holds the first snowball in art history. But it is as though nobody has worked out what to do with it yet—at least not in painting. Almost 70 years later, in *c.* 1405, this question is answered: a room in Buonconsiglio Castle in Trento is also decorated with representations of the seasons and months. Here, the painter Master Wenceslaus has created the first snowball fight in the history of art as a representation of winter. Wenceslaus's winter landscape is also part of the first "monumental" representation of the months, which had until then been a subject for book illumination alone.

The first truly portrait-like landscape that remains recognizable even to this day was created in Geneva in 1444 by the Swiss painter Konrad Witz (*c.* 1400–46). *The Miraculous Draught of Fishes* from the panel of the St. Peter Altarpiece of St. Peter's Cathedral in Geneva tells the story of the resurrected Christ, who appeared to Peter and the other disciples at the Sea of Galilee (John 21). Of course the faithful knew the story, and yet none of them would ever have seen a representation like the one by Witz: it was confusingly new. Witz did not repeat traditional patterns, but showed viewers the landscape that they saw before their own eyes: Lake Geneva and its surroundings. The stilt houses are recognizable, as are Mont Salève, the ridge of the Voirons, and the distant, snow-covered *massif* of Mont Blanc in the background. Suddenly the story does not take place in faraway lands and times in the distant past, but has a direct relationship with the people and their surroundings—the Gospel has authority and is applicable to all times and all places. Witz created a milestone in art that would have far-reaching consequences.

Witz, too, still needed a biblical narrative as justification for his landscape painting. It was not until *c.* 1500 that a landscape became the sole subject of an art-

above——**Ambrogio Lorenzetti, Effects of Good Government** (**detail from the fresco cycle Allegory of Good and Bad Government**) | 1337–39 | fresco | approx. 14 m wide | Palazzo Pubblico Siena.

right——**Albrecht Dürer, View of the Arco Valley** | *c.* 1495 | watercolor and opaque pigment on paper | 22.1 x 22.1 cm | Musée du Louvre Dép. des Arts Graphiques | Paris.

1564—Birth of Galileo Galilei··· **1618–1648**—Thirty Years' War··· **LANDSCAPE** 96/97

1595—Premiere of Shakespeare's *Romeo and Juliet*

***c.* 1600**—Beginning of the Baroque period

1560–1609 Annibale Carracci··· 1606–1669 Rembrandt

work created without an additional "alibi." The two protagonists were German painters: Albrecht Dürer (1471–1528) and Albrecht Altdorfer (*c.* 1480–1538). In the autumn of 1494, the young Dürer set off for his first journey through Italy, which would take him as far as Venice. It seems that he painted a watercolor whenever a landscape caught his attention and he had some free time on his journey there and back (fig. above). This type of souvenir was entirely new and for some time Dürer remained the only painter to create these kinds of works. In his depictions, he did not stray far from the landscapes before his eyes, so that it is still possible to trace his route using these watercolors. And yet, Dürer was no landscape painter. For him, these pictures were memories, practice pieces, and a fund of landscape motifs that he could use for his prints and paintings, in order to make them even more realistic.

In *c.* 1520, Albrecht Altdorfer painted the *Danube Landscape with Castle Wörth near Regensburg* (fig. p. 98). In doing so, he created the first painting to have nothing but a landscape as its subject, requiring neither religious nor historical references. But what is so new about it, and why is it so different from Dürer's painting *Arco*, which was executed years before, *c.* 1495, and in which there is clearly no narrative, either? In contrast to Dürer, Altdorfer captures not only the landscape in his painting, but also the

mood that pervades the landscape. While Dürer describes the landscape as though it were an object, without establishing its relationship to the whole, Altdorfer is interested in atmospheric unity. The entire landscape is bathed in evening light. The aerial and atmospheric perspective employed here connects the different layers of the painting. In contrast to Cennini's description in his textbook of 1400, the background becomes lighter rather than darker, and takes on a blueish hue, in keeping with the way that we really do perceive landscapes. Furthermore, the sky becomes an important part of Altdorfer's painting, whereas Dürer pays scant attention to it. While Dürer analyzes the landscape, Altdorfer "feels" it, and thus takes landscape painting in an entirely new direction. In Altdorfer's painting, nature is no longer in any way hostile, but—quite the contrary—is characterized by an almost lyrical atmosphere. A similar perception of nature was shared by a few other painters, including Wolf Huber (*c.* 1485–1553) and Lucas Cranach the Elder (*c.* 1472–1553). Huber, Cranach, and Altdorfer are considered members of the Danube School, whose works are characterized by precisely this romantic, fairy-tale-like atmosphere.

In the 17th century, innovations took place in landscape painting, particularly in the Netherlands. One explanation for this is linked to the Calvinist

1628/29–1682 Jacob van Ruisdael 1696–1770 Giambattista Tiepolo

Church's hostility to religious pictures. Painters had to find new spheres of activity, as a result of which landscape painting, as well as portraits, genre paintings, and still lifes underwent a boom. It also served as the affirmation of territorial expansion of the Netherlands, which had become wealthy through overseas trade.

A painting by Adam Elsheimer (1578–1610), a German painter living in Rome, had a particularly strong influence on Netherlandish landscape painting. *The Flight into Egypt* (fig. p. 37) enjoyed extraordinarily wide distribution as a copperplate engraving after Elsheimer's death. In addition to the unique representation of the night sky, this small painting's specialness and novelty lies in its composition. It had been common practice to divide landscapes into foreground, middle distance, and background, staggered parallel to the picture plane. Elsheimer, however, creates a sort of diagonal, or triangular, composition, while the lowest point in the landscape is also the most distant.

This form of pictorial composition became a veritable trademark of Netherlandish landscape painting. It made it possible to suggest vast expanses with a low-lying horizon. Whereas the Italians and the French, such as Claude Lorrain, tended to paint narratives embedded in ideal landscapes in the 17th century, the description of the real landscapes surrounding them, and of the particular atmosphere with which they were imbued as a result of proximity to the sea, was the focus of painters in the Netherlands.

Jacob van Ruisdael's *Tower Mill at Wijk bij Duurstede* is one of the most successful landscape paintings of its time, and it is typical of Netherlandish landscape painting (fig. above). Ruisdael (c. 1628–82) used a triangular composition like that of Elsheimer in which the land is inserted like a wedge between the water and the sky. He also imbues the pictorial space with rhythm using diagonals and creates a dynamic that reaches its climax in the windmill. Despite a highly complex composition, Ruisdael creates a spatial impression of unity in which water, land, and sky are in harmony with one another, bound together by means of the light that falls on different parts of the landscape through the gaps between the clouds. "This painter is in fact a thinker, and in each of his works one recognizes a sophisticated creation," said Eugène Fromentin (1820–76). Ruisdael masterfully solves the landscape painter's challenge which lies in

left——ALBRECHT ALTDORFER, DANUBE LANDSCAPE WITH CASTLE WÖRTH NEAR REGENSBURG | *c.* 1520 | oil and opaque pigment on parchment | mounted on birch | 30.5 x 22.2 cm | Alte Pinakothek | Munich.

above——JACOB VAN RUISDAEL, TOWER MILL AT WIJK BIJ DUURSTEDE *c.* 1670 | oil on canvas | 83 x 101 cm | Rijksmuseum | Amsterdam.

1774–1840 Caspar David Friedrich 1776–1837 John Constable 1798–1863 Eugène Delacroix

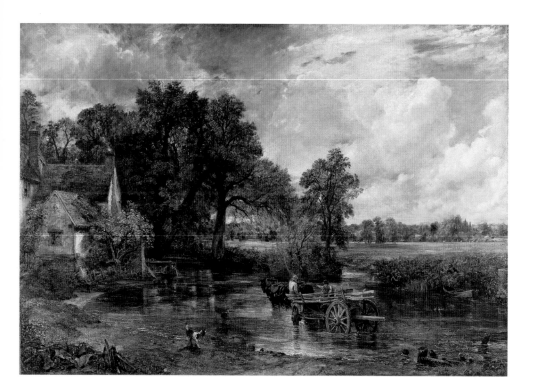

selecting a segment of the boundless landscape, and in creating the composition in such a way that this landscape forms an entity in itself. The mill did exist in reality, and the castle and church steeple are still extant today. Ruisdael composed the different pictorial elements in such a way that they essentially formed an idealized interpretation of the real landscape.
In the Romantic period, Caspar David Friedrich (1774–1840) did something similar. Spurned at the end of his lifetime, he is now perhaps the most well-known representative of this epoch (see also *Night*, pp. 34–41). *Wanderer above the Sea of Fog*, executed c. 1817, is probably his most famous painting (fig. p. 101). It shows a landscape that does not exist in this form, but that appears realistic in its own way all the same. By bringing together realistic pieces, different elements that he came across in the Elbe Sandstone Mountains, Friedrich created a purely subjective and poetic—in other words a Romantic —truth.
The English painter John Constable (1776–1837) introduced a new aspect to landscape painting. His use of color in particular was innovative: his predecessors and contemporaries were of the opinion that a meadow should have the "warm gold hue of a violin."

According to legend, Constable is said to have placed a violin in a green meadow before the eyes of an advocate of this view to demonstrate to him the difference between theory and practice. Of course other painters also used the color green, but not in the same way that Constable did. "Constable says that the superiority of the green results from the fact that it is composed of many different greens. The green of common landscape painters looks so lifeless and dull because they usually paint it using just one single tone. What he [Constable] says about grass-green can also be applied to all other colors" (Eugène Delacroix). By mixing his paint and using more white, Constable's palette became lighter, which made his paintings look more realistic and livelier than those of his colleagues. For a long time Constable had a difficult relationship

above——**JOHN CONSTABLE, THE HAY WAIN** | 1821 | oil on canvas 130 x 185 cm | National Gallery | London.
right——**CASPAR DAVID FRIEDRICH, WANDERER ABOVE THE SEA OF FOG** c. 1817 | oil on canvas | 94.8 x 74.8 cm | Kunsthalle | Hamburg.

1827—First photographs 1848—Revolution in Europe 1876—Invention of the telephone

1883—First petrol-engined automobile

1914–1918—First World War

1839–1906 Paul Cézanne 1853–1890 Vincent van Gogh

"In the 20th century, landscape painting remained a popular genre within which new points of view were constantly developed."

with the Royal Academy of Arts in London because of his passion for landscape painting. Because landscape painting was still considered by many to be an inferior, even a dishonorable genre, 16 years passed between Constable's first application and his admission. Constable remained a steadfast advocate of landscape painting, and eventually the situation changed. In 1824, Constable's painting *The Hay Wain* (fig. p. 100) was awarded a gold medal at the Paris Salon and in 1827 the London *Times* described him as the best landscape painter in England. In 1829, he was finally voted into the Royal Academy.

The next leap in the development of this genre took place in France, when the Impressionists in the circle around Claude Monet (1840–1926) showed an entirely new form of landscape painting, which was, however, initially considered a failure by the critics (see also *Impressionism*, pp. 160–165). Impressionism was the highpoint of landscape painting characterized by perspective and verisimilitude to nature, and it simultaneously signaled the beginning of a new era.

In the 20th century, landscape painting remained a popular genre within which new points of view were constantly developed. One of the most famous landscape paintings in the US, *Christina's World* (fig. p. 103), was created by Andrew Wyeth (1917–2009). If the Impressionists' painting style was too wild and forceful for the tastes of the critics of the Impression-

ists' time, Wyeth's style was criticized for the very opposite during his. He was derided for his realism, his narrative approach, and his emphasis on technical skill; *Christina's World* was, after all, painted at the very time that the Abstract Expressionism of a certain Jackson Pollock was celebrating its first successes. *Christina's World* cannot be grasped fully at first glance. Like many of Wyeth's artworks, it has repeatedly been the cause of heated debate. The initial romantic mood is disrupted only when the viewer discovers that the woman in the foreground, Christina Olson, suffered from polio and could not walk. This makes Wyeth's painting disturbing, while simultaneously expressing a tremendous sense of yearning.

right——**ANDREW WYETH, CHRISTINA'S WORLD** | 1948 | tempera on gessoed panel | 81.9 x 121.3 cm | Museum of Modern Art | New York. © 2012. Digital image | The Museum of Modern Art | New York/Scala | Florence

1917–2009 Andrew Wyeth **1928–1987 Andy Warhol** **b. 1937 David Hockney**

1431–1506 Andrea Mantegna | 1475–1564 Michelangelo Buonarroti | c. 1489–1534 Correggio

ILLUSIONISTIC CEILING PAINTING

The "invention" of central perspective opened up new possibilities for artists, facing them with a new challenge: the ceilings of churches and palaces, until then a relatively neglected area, were absolutely ideal for perspectival designs. Until that point, while the walls of churches and palace rooms had been decorated with splendid paintings, people had not paid attention to the ceilings. In churches, it was generally considered sufficient to embellish the ceilings with a starry-sky motif if there was not an open truss or paneled ceiling, as became fashionable during the Renaissance. In late-medieval churches, the post-and-lintel wood roofs were occasionally decorated with iconographic representations, but the images were not related to the space they occupied in the church. Only a small number of these beamed ceilings remain, including that of St. Michael in Hildesheim, Germany.

The first painter to make use of the possibilities offered by central perspective to create the illusion of an upwards extension of an architectural space was Andrea Mantegna (1431–1506). He had already created an unusual interpretation of the subject of

The Lamentation Over the Dead Christ (fig. p. 69) thanks to the exceptional application of central perspective. As court painter to Ludovico Gonzaga, Marquis of Mantua, Mantegna was responsible not only for painting the portraits of the members of the aristocratic family, but also for their artistic needs and prestigious paintings. He was responsible, one could say, for the "image" of the court.

The room in the castle of the Gonzaga family known as the Camera degli Sposi, or "wedding chamber," is not (as one might assume) a bedroom, but an impressive reception room of sorts. Entering this room, one has the impression of being on some sort of terrace because the entire space is surrounded by arcades that appear to offer views of the surrounding countryside (fig. p. 106). Members of the Gonzaga family and important members of their entourage stand between the arcades. These turn into arches that cover the entire ceiling and are embellished with stucco decorations. An opening in the ceiling that provides a view of the sky, similar to the hole in the cupola of the classical Pantheon in Rome (which was presumably an inspiration for Mantegna's design) constitutes the zenith. The opening at the center of the dome in the Pantheon is real, however, while that in the Camera degli Sposi is painted—like all of the other elements of the interior design of the room. The entire room, and the ceiling in particular, is a

left——ANDREA MANTEGNA, DECORATION OF THE CAMERA DEGLI SPOSI IN THE PALAZZO DUCALE | Mantua | before 1474 | ground area of the room: *c.* 8 x 8 meters | height of ceiling: *c.* 7 meters.

···1517—Beginning of Reformation (Martin Luther's 95 Theses)··············· 1555—Peace of Augsburg, ending religious struggles during Reformation···············

1564—Birth of Galileo Galilei···········

1595—Premiere of Shakespeare's *Romeo and Juliet* ···········

1528–1588 Paolo Veronese 1571–1610 Caravaggio

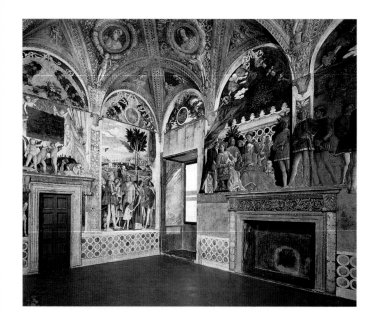

masterpiece of illusionistic painting. This is the first example of a ceiling decorated with illusory architectural embellishments. Unlike Masaccio's Trinity fresco, one cannot examine the painting up close. As a result of what is, at approximately seven meters, an exceptionally high ceiling for a relatively small room (which measures approximately eight by eight meters), the painting is removed to a distance at which it can no longer be "grasped," thus heightening the illusionistic effect.

The opening in the ceiling is surrounded by a balustrade, creating the impression that one is looking up at a roof terrace. Ten *putti* gallivant around the balustrade, which is painted according to the principles of central perspective as though viewed from directly beneath it; a flower-pot balances precariously on top of it, and a peacock has also alighted here. Five young women who appear to delight in the goings-on taking place in the room below are visible, too. While even the subjects of the frescoes in the Camera degli Sposi create a restrained atmosphere, the party on the illusory roof terrace appears to be enjoying itself. The *putti* clambering around seem even to be poking fun at the Gonzaga family's claim to power: one *putto* holds an apple, symbolising the *globus cruciger* [orb surmounted with a cross], in his hand; the one next to him holds a little wooden stick, a scepter; and the third holds a laurel wreath over his own head. Such

a relaxed approach to the insignia of power was considered the sign of good governance.

In the Camera degli Sposi, Mantegna created a new type of interior decoration. It would later not only be found in palaces, but would also point the way to a completely novel approach to the decoration of churches. Antonio Allegri, simply known as Correggio (c. 1489–1534) after his hometown, pursued this new path, creating one of the first illusionistic cupola frescoes. Correggio, too, created an opening in a ceiling using painterly techniques, but did so in an entirely different way from his predecessor Mantegna. Between 1526 and 1530, Correggio created in Santa Maria Assunta, the cathedral of Parma, a cupola fresco that provides a view of the sky unlike any other (fig. p. 107). The cupola rises above the crossing of the cathedral. It is barely discernible as an architectural element because the Virgin is in the process of ascending into the heavens that open above the octagonal tambour. A host of angels accompanies her from the

above——**Andrea Mantegna, Decoration of the Camera degli Sposi in the Palazzo Ducale** | Mantua | before 1474 | ground area of the room: *c.* 8 x 8 meters | height of ceiling: *c.* 7 meters.

right——**Correggio, cupola fresco in Santa Maria Assunta** Parma | 1526–30.

c. **1600**—Beginning of the Baroque period ·················· **1632**—Construction of Taj Mahal ·················· ILLUSIONISTIC CEILING PAINTING **106/107**

1618–1648—Thirty Years' War

1599–1660 Velázquez **1606–1669 Rembrandt** **1627–1678 Samuel van Hoogstraten**

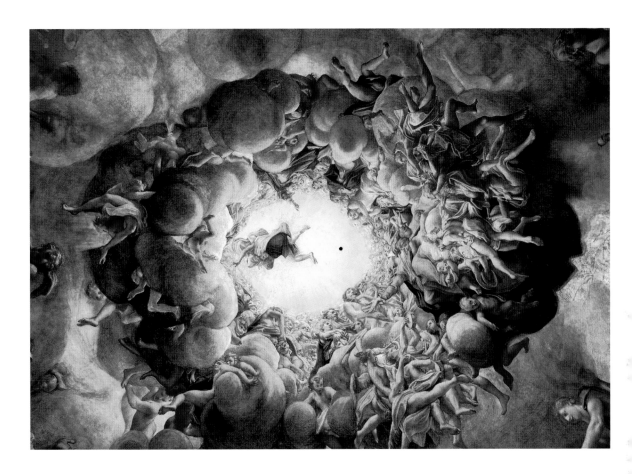

balustrade, from where the apostles follow her with their gaze, to heaven. Jesus appears to rush towards her with a dramatic gesture, before ascending towards the brightest light together with her. Correggio does not simply open the cupola to create an illusionistic effect such as that achieved by Mantegna, but also to grant the faithful a glimpse of heavenly paradise. The light spheres and dynamic movement towards eternity mean that Correggio's work became one of the precursors of Baroque art. Giorgio Vasari (1511–74) praised him highly: "Had he only traveled beyond his birthplace and visited Rome, he would have performed miracles and caused great consternation to those who were considered great during his time."

In Rome, however, another artist had already "performed a miracle," and was considered "great" for this among other things—Michelangelo Buonarroti (1475–1564). In Rome, Michelangelo had actually been tasked with the decoration of the ceiling of the Sistine Chapel with paintings of the Twelve Apostles; the chapel had been completed in 1483, having been commissioned by Pope Sixtus IV (hence the chapel's name). Michelangelo received the commission from Pope Julius II, by whom the artist had already been commissioned to create a monumental tomb with more than 40 sculptures. In fact, Michelangelo saw himself as a sculptor and was extremely disappointed that he could not start work on the tomb. The pope insisted on the painting of the Sistine Chapel, however. If he was going to be coerced into painting, he was determined to paint whatever pleased him, at the very least! And he wanted to create something unique. The result was one of the greatest artworks in the world, and its subject is the creation of the world (fig. pp. 108/109). Michelangelo did indeed create a new world—in art—between 1508 and 1512. Michelangelo first divided the chapel ceiling, 41 meters long and more than 13 meters wide, into smaller

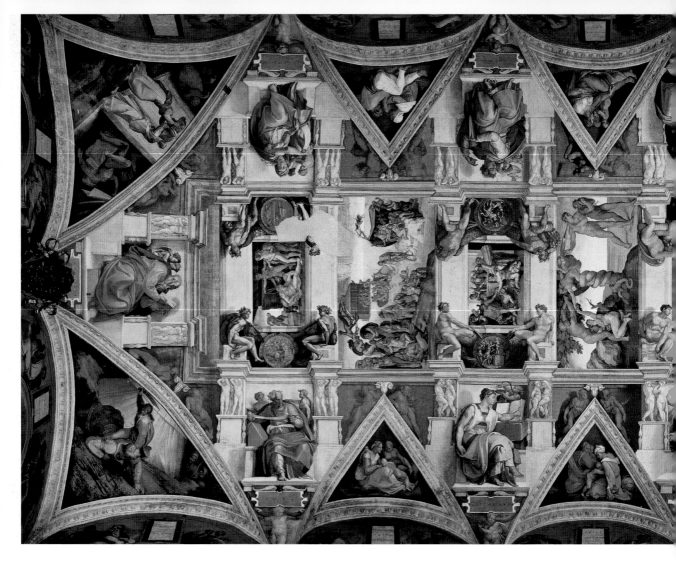

compartments using transverse arches, and these were then supplemented by four spandrels in the corners and lunettes along the longitudinal sides. In this way, Michelangelo created an illusionistic, architectural framework within that he illustrated his main subject: from the creation of the world and the creation of humankind via the Flood to the drunkenness of Noah (Genesis 1:9). The nine subjects that form the narrative arc and that are shown in the nine central areas of the fresco are complemented with a series of prophets and sibyls and the biblical ancestors in the lunettes. And, as though that were not enough, in the empty spaces Michelangelo painted naked figures holding medallions depicting densely populated scenes. The richness of the painted architecture and of the figures is unparalleled. The imaginative power

that allowed Michelangelo to give each of the more than 250 figures an individual appearance and to tell the stories passed down from generation to generation in the Bible in a novel manner is also unequalled. Michelangelo's method is interesting: he did not paint in the "chronological" order specified in the Bible but proceeded the other way around: from the entrance to the chapel to the section depicting the creation of the world, which is positioned above the altar wall. And Michelangelo painted the frescoes in two segments. The first five bays (from the prophet Zechariah to the creation of Eve in the center) were painted between 1508 and 1510. After the first half had been completed, the scaffolding was removed and it was not until this point that Michelangelo discovered that he had made a big mistake: he had

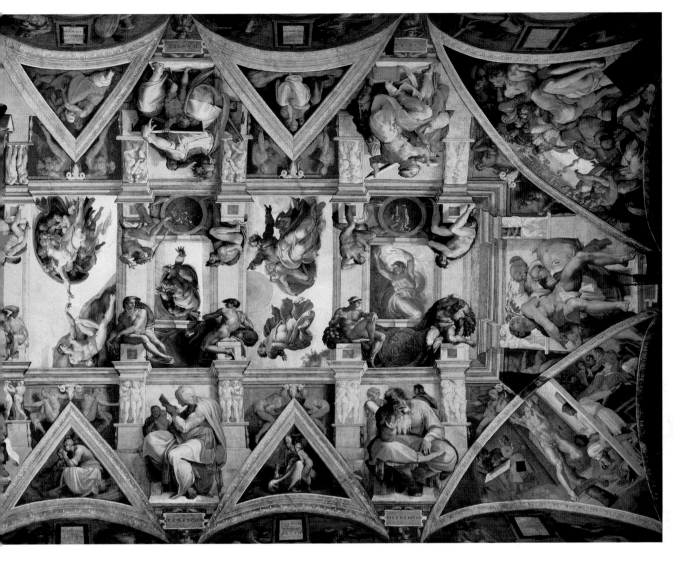

painted too many people in the main scenes, and they were too small. With a ceiling height of more than 20 meters, the figures could only be made out with difficulty, particularly because of the insufficient lighting in the Sistine Chapel.

Following a break of six months, Michelangelo started work on the second part, which he completed in 1512. His artistic concept for the figures in the main scenes was fundamentally different this time. It was now that he found the style and the artistic greatness that make the frescoes exceptional to this day. He concentrated

on a small number of concomitantly larger figures. This was also when he began to conceive of the pictorial creations that continue to fascinate people the world over. The most famous example and one of the best-loved scenes in art anywhere in the world is the creation of Adam (fig. pp. 110/111). The first human, in the flawless form of a top athlete, lies on the Earth. God sweeps down, wrapped in a wide gown and surrounded by *putti*. His finger almost touches Adam, who weakly extends his hand towards God. In the next moment, which is not shown here, God will breathe life into the formerly limp figure of Adam. This scene and the entire ceiling became a place of pilgrimage for many artists, who wanted to learn from Michelangelo's magnificent artwork.

Decorating such large surfaces in a coherent man-

above—**Michelangelo Buonarroti, ceiling frescoes of the Sistine Chapel** | Rome | 1508–12 | 41 x 13.4 m.

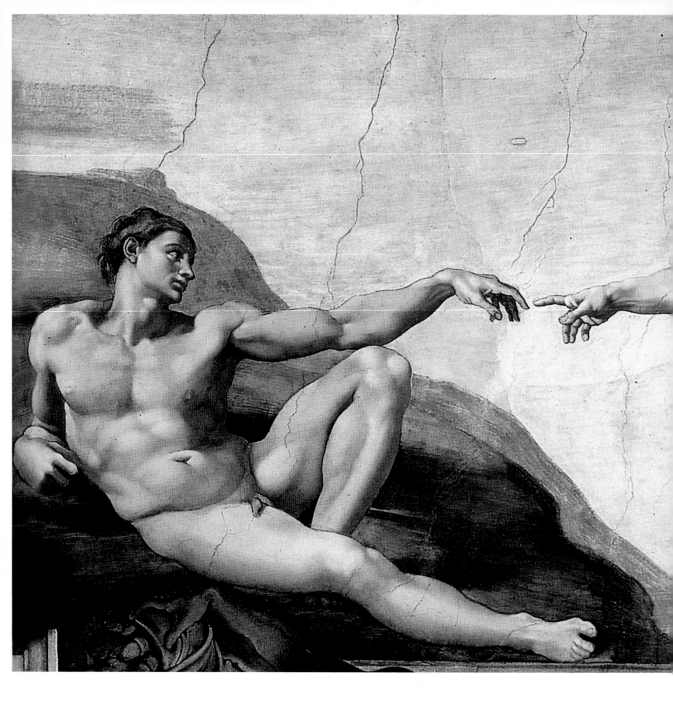

ner was a tremendous challenge. Architecturally subdividing the space, as Michelangelo did, was one option. The other was to cover the entire ceiling with just one painting. The Venetian painter Giambattista Tiepolo (1696–1770) chose the latter strategy for the staircase of the Würzburg Residenz palace in Germany. In 1750, Tiepolo was initially summoned to Würzburg by Prince Bishop Carl Philipp von Greiffenclau (1690–1754). He was tasked with the decora-

tion of the ceiling of the so-called Kaisersaal room with a fresco. The prince bishop was so delighted by the result that he assigned the embellishment of the enormous ceiling over the staircase to Tiepolo, too. The staircase and its ceiling, almost 700 square meters large and constructed without supports, is an architectural tour de force by Balthasar Neumann (1687–1753). It was transformed into an even more significant masterpiece by the addition of Tiepolo's

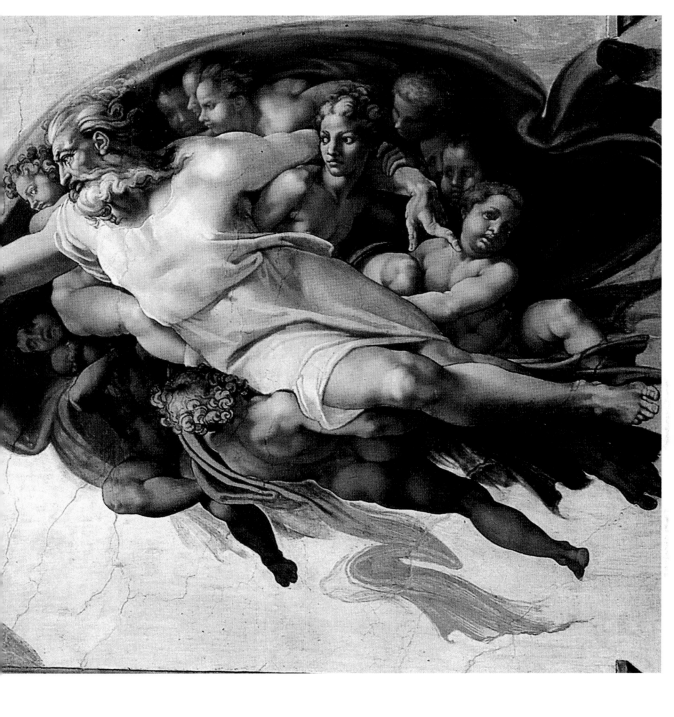

illusionistic painting. He turned it into the largest continuous ceiling fresco in the world (fig. p. 112). There is a big difference between seeing a reproduction and seeing the original when it comes to panel paintings. This is even truer of the works of Man-

tegna, Michelangelo, and Tiepolo discussed here. In Tiepolo's fresco in particular, the architecture (Neumann's staircase) is an essential element. Due to the spatial constraints on a painting of this size, it unfolds before the eye as one walks up the stairs: from the bottom to the first landing to the gallery on the upper level, from where one can finally see it in its full glory. As the borders of the plastered surfaces painted each day can easily be seen up close, it has

above——MICHELANGELO BUONARROTI, THE CREATION OF ADAM | 1511 fresco | 4.8 x 2.3 m | Sistine Chapel | Rome.

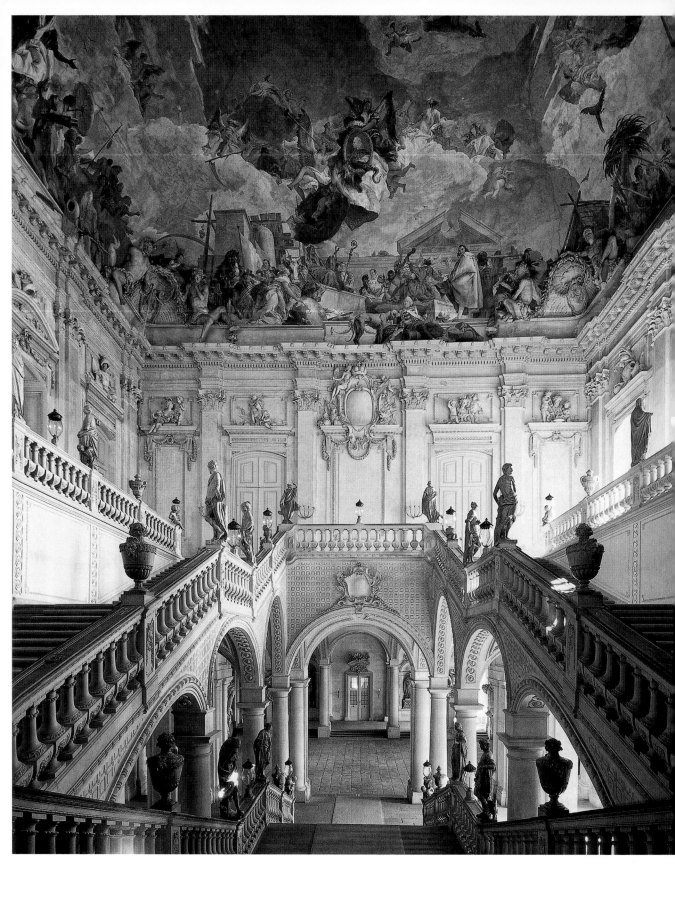

1689—Bill of Rights in England ···································· 1769—Invention of the steam engine··· **ILLUSIONISTIC CEILING PAINTING** **112/113**
1726—Jonathan Swift publishes *Gulliver's Travels* ·····························
1752—Benjamin Franklin invents the lightning rod ··

1696–1770 Giambattista Tiepolo | **1699–1779 Jean-Baptiste-Siméon Chardin** | **1746–1828 Francisco de Goya**

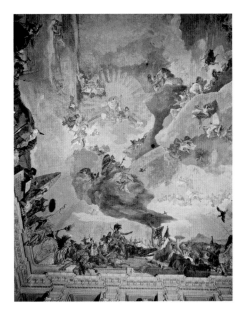

"In the fresco technique the paint is applied onto the fresh (Ital. fresco) plaster and bonds with the plaster in the course of the drying process."

been possible to establish that Tiepolo needed 219 work days for the enormous ceiling fresco.

Fresco painting is an intricate and complicated technique that requires artists to be very confident in what they are doing: the possibilities for correcting mistakes are extremely limited. The paint is applied onto the fresh (Ital. *fresco*) plaster and bonds with the plaster in the course of the drying process. This means that the paint cannot peel off, and lasts for a long time. The preparations for fresco painting are very laborious. First, the lime plaster is applied to the wall surface that is to be painted on that particular day. Next, either a simple preparatory drawing is made or the artist uses a cartoon onto which the design for the fresco, in its original size, is drawn. This can be impressed onto the plaster, or the contours of the drawing are perforated and traced onto the wall surface using soot. Once the preparatory drawing has been transferred onto the wall, the artist can start to paint. This section has

to be completed within one day as the plaster dries within this time period. Because of the complexity of the technique and the numerous different steps that it involves, it is virtually always the case that several people are involved in the painting of a fresco. It is therefore no more than a legend that Michelangelo completed the entire ceiling of the Sistine Chapel by himself. In terms of the organizational requirements alone, this would not have been possible. Tiepolo, too, was helped when he decorated the staircase of the Würzburg Residenz. One of his helpers was his son Giandomenico (1727–1804).

Michelangelo depicted the creation of the world in the Sistine Chapel, and Tiepolo decorated the Würzburg Residenz with what were thought to be the four continents, using allegorical images. Australia had been discovered as early as 1605, but was in Tiepolo's time not yet considered to be a continent in its own right. The radiant sky, home to the gods, opens over the frieze of the four corners of the earth, bringing forth Apollo, the god of light and of the arts. Tiepolo's painting is lighter and less restrained than that of Michelangelo in the Sistine Chapel. This is not the work of a "painting sculptor," subduing masses of figures. This is the work of a subtle artist imbued with the lightness of the late Baroque period. But his fresco is no less monumental for all that.

left and above—**GIAMBATTISTA TIEPOLO, CEILING FRESCO ABOVE THE STAIRCASE OF THE WÜRZBURG RESIDENZ** | 1752/53.

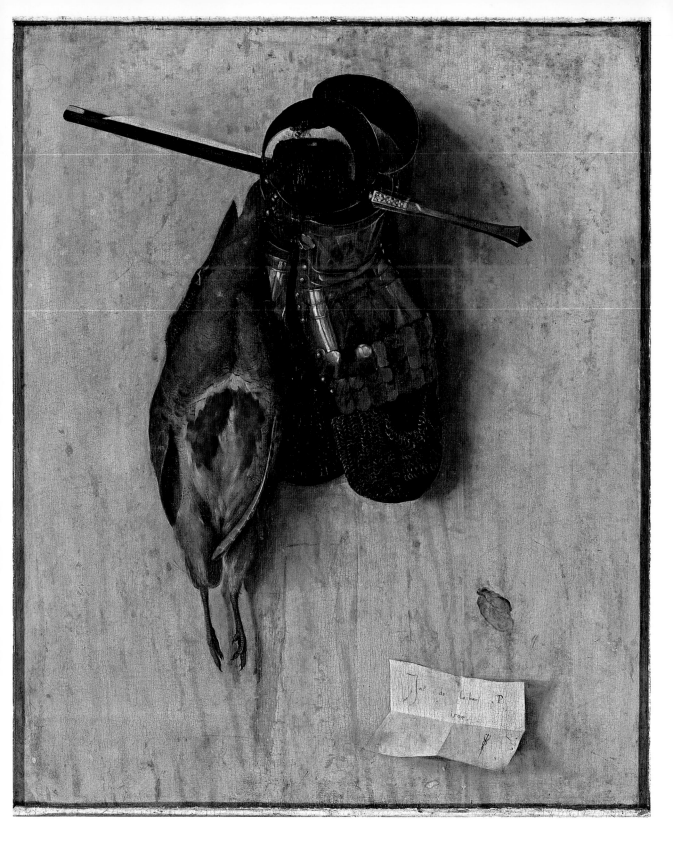

c. 1455—Gutenberg invents the printing press ································· 1506—First stone laying of St. Peter's Basilica in Rome···

1478—The Spanish Inquisition is established·································

1492—Columbus's first voyage to America·····························

114/115

c. 1440–1516 Jacopo de' Barbari 1452–1519 Leonardo da Vinci 1471–1528 Albrecht Dürer

STILL LIFE

Painting is illusion. What we see is paint on a canvas. If this is masterfully applied, however, we can give in to the illusion and believe that what is to be seen on the canvas is real. Still lifes are among the types of paintings to have achieved, at times, the greatest and most convincing of illusions. The term "still life" derives from the Dutch *still-leven* and simply means that "still" things are depicted in these paintings: inanimate objects, fruits, and dead, or at least motionless, animals that have been arranged in an artistic way, used by artists to celebrate materiality, form, and the play of light and shadow.

Still lifes play an important role in Antiquity, which was a time of interest in temporal things. They were often part of interior decoration, sometimes in the form of floor mosaics representing an unswept floor. Those artists who were able to recreate nature with the greatest degree of accuracy were considered to be the best. A famous contest between Zeuxis and Parrhasius, two of the best painters of Antiquity, took place on this subject in Greece around the year 400 BC. Zeuxis painted a bowl of grapes that are said to have looked so natural that birds attempted to peck at them. When he went to see his competitor, he believed the latter's picture to be covered by a curtain and wanted to pull it back. In that moment, he noticed that the curtain was nothing but a painting. He admitted defeat because, while he had fooled birds, Parrhasius had managed to fool a human being with his illusion.

In the Middle Ages, still lifes were no longer of importance. As this world was thought of as a veil covering the divine, "real" world, the illusionistic depiction of worldly objects was not of interest. The first to take up still life painting after this hiatus was the Venetian painter Jacopo de' Barbari (c. 1440–1516). His background virtually predestined him to take this courageous step. He was familiar with the rules of central perspective, as can be seen in his "aerial shots" of his hometown (see fig. p. 52/53). Furthermore, he knew about the painting of the north because he had been employed as court artist at the courts of Maximilian I in Nuremberg and, from 1503, at the court of Frederick III of Saxony. He had also become acquainted with Albrecht Dürer (1471–1528) during the latter's first sojourn in Venice. It is highly likely that he had seen Dürer's still-life-like drawings and watercolors. But even Dürer did not not go beyond drawing: he did not create any paintings of simple objects.

left——Jacopo de' Barbari, Still Life with Partridge and Gauntlets | 1504 | oil on wood | 49 x 42 cm | Alte Pinakothek | Munich.

1555—Peace of Augsburg, ending religious struggles during Reformation
1564—Birth of Galileo Galilei
1571—Birth of Johannes Kepler

1571–1610 Caravaggio 1577–1640 Peter Paul Rubens

This step was taken by Jacopo de' Barbari in 1504. He painted the first still life of modern times (fig. p. 114). The painting was probably part of the decoration of one of Frederick III's hunting rooms. In it, a dead partridge, a pair of gauntlets and a bolt for a crossbow are depicted hanging from a wooden wall. A note, a *cartellino,* appears to be affixed in the right-hand corner. On the one hand, it features Barbari's signature and his symbol, a caduceus (the staff of Hermes), as well as the year of execution, 1504. This indicates that Barbari thought of the painting as an independent artwork, despite the fact that it was part of the room decoration. On the other hand, the note is part of the illusion because this is not simply the first still life, but also the first trompe l'œil, or "eye deception," of modern times. When a hunting party entered the room, they saw what appeared to be the spoils of Frederick's hunt on the wall. Only when they stepped closer did they realize that they had fallen prey to a deception. Should any of them have attempted to remove the note, they would have realized that this, too, is nothing but "oil on wood"—but not on real wood, of course, as this, too, is part of the painting. Although today we find it hard to perceive this still life as a deception, the illusion worked at the time. In fact, it probably worked perfectly because the people of the time were simply not used to being deceived by a painting.

This is one aspect of this first still life; the other relates to its content: still lifes often have a deeper meaning that is not visible at first glance. This, too, was introduced by Barbari. The partridge may be a reference to a story from Greek mythology: the great painter, sculptor, and inventor of Antiquity, Daedalus, who created the minotaur's labyrinth amongst other things, had a nephew who was also his best pupil. The latter invented such important things as the saw, the potter's wheel, and compasses (the last of which was to be of such great importance to painting). Daedalus became so jealous of his nephew's talent that he pushed him off a cliff. Athene saved the nephew by changing him into a partridge so that he could fly away. The nephew was called Perdix, and as a result of this story, the scientific name of the grey partridge is *perdix perdix.* Perhaps Barbari is raising the question of the relationship between art and power (symbolized by the gauntlets and crossbow bolt) in this painting.

The golden age of the still life did not arrive until 100 years after Barbari, when it flourished in the Netherlands in particular. It was here that the Protestant teachings of John Calvin had led to a prohibition of altar pictures and other religious representations in the 17th century. Because the Church lost its role as one of the most important patrons for art, painters had to find private clients. Still lifes played an important role in this context because they allowed painters to demonstrate all their skill. They specialized in particular subjects, which led to the development of a variety of types, including still lifes with fruits, breakfast still lifes, still lifes with weapons, still lifes showing scenes of splendor, and still lifes with different animals or with flowers, among them the very popular tulip still lifes.

The tulip was introduced to Holland in the 1570s and soon became a status symbol. The Dutch achieved wealth through overseas trade, and many invested in

above——**The unswept Floor, Copy by Heraclitus of a Mosaic in Hadrians' Villa** | 2nd century AD | detail of a mosaic | 405 x 405 cm Musei Vaticani | Rome.

right——**Christian Thum, Vanitas Still Life** | c. 1670 – 80 oil on canvas | 68.5 x 84 cm | Nationalmuseum | Stockholm.

1595—Premiere of Shakespeare's *Romeo and Juliet* ·· 1632—Construction of Taj Mahal ·· STILL LIFE **116/117**

·················· *c.* **1600**—Beginning of the Baroque period ···

·······················**1618–1648**—Thirty Years' War ·······························

1599–1660 Velázquez 1601–1678 Jan Brueghel the Younger 1606–1669 Rembrandt 1627–1678 Samuel van Hoogstraten

tulips. As demand remained strong not only during the tulip season, but continued throughout the year, tulip bulbs became the objects of speculation (see also pp. 45–47). This was one reason—in addition to the desire to measure one's skill as a painter against nature at its most beautiful—for the profusion of flower still lifes in which flowers that do not actually bloom at the same time as each other are depicted together. It was a way of showing clients which flowers grew from which bulbs, and so a lot of the paintings also in some ways functioned as sales catalogues. To counteract the possible charge of pomposity or triviality in these paintings replete with worldly objects, still lifes always also alluded to the transitory nature of human life on earth. Suitable images included rotting fruit, wilting flowers, clocks proclaiming the passing of time, sputtering or extinguished candles or, more simply, skulls. Sometimes, the message was obscured, and at other times it was in plain sight, as in Christian Thum's *Vanitas Still Life* (fig. above).

A popular sub-genre of still-life painting were the so-called *quodlibet*, or letter-rack pieces, in which painters arranged various objects, hanging from a board, as convincingly as possible. Samuel van Hoogstraten (1627–78) took this one step further because his still life is not simply a trompe l'œil, but simultaneously a programmatic self-portrait (fig. pp. 118/119). For example, the quill and penknife point to his work as an author, which is underlined by the inclusion of the two small books, both of which are tragedies that he himself wrote. Hoogstraten seems also to have paid a lot of attention to his external appearance, as indicated by the comb and razor. Furthermore, a portrait medallion of the Habsburg emperor Ferdinand III is visible. It had been given to Hoogstraten in 1652 in recognition of his great skill as a painter. In the accompanying letter, he is compared to his colleagues

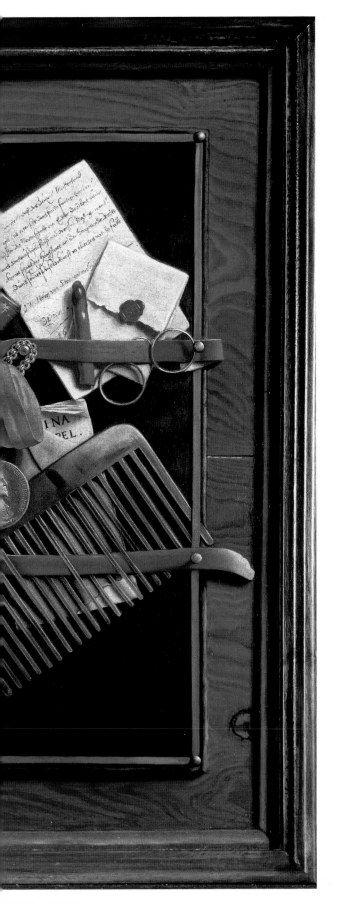

left——SAMUEL VAN HOOGSTRATEN, QUODLIBET STILL LIFE
c. 1668 | oil on canvas | 63 x 79 cm | Kunsthalle | Karlsruhe.

1689—Bill of Rights in England ··································· **1756**—Birth of Mozart ·······································

1712—Saint Petersburg becomes the capital of Russia ··········· **1769**—Invention of the steam engine·

1699–1779 Jean-Baptiste-Siméon Chardin 1741–1825 Johann Heinrich Füssli 1746–1828 Francisco de Goya

from Antiquity, Zeuxis and Parrhasius. Hoogstraten was therefore a man of many talents. The painter created a monument to himself as a writer—albeit one in which the painter remains in the foreground—not simply through the emperor's accolades but also through the painting itself. The booklet on the left points to the true subject of the painting for it is a copy of *Principia Philosophiae* by René Descartes, in which deception is a central concept.

In the academic hierarchy of the different genres, however, still life was on the lowest rung. The most respected genre was that of history painting, which dealt with biblical, mythological, historical, or literary themes, followed by portrait painting. This was followed by paintings of landscapes and animals, and in last place by still lifes. In the 18th century, the Frenchman Jean-Baptiste-Siméon Chardin (1699–1779) raised the still life to new heights. Although he was an autodidact and worked primarily within this "inferior" genre, he managed to gain admittance to the Académie Royale. Chardin no longer selected his objects according to their meaning, but according to form, composition, and color. Marcel Proust said of Chardin's still lifes: "From Chardin we have learned that a pear can be as full of life as a woman, that an ordinary clay jug is as beautiful as a precious stone." Chardin concentrated on a small number of objects, which he then proceeded to describe in a wide variety of different tones. Chardin achieves in his *Still Life with Pipes and Drinking Pitcher* of 1737 (fig. above) a relationship between the objects that is full of tension through the contrast between the fragile pipe and the solid clay jug, underlined by the horizontal and vertical accents. The blue—white harmony of the jug and the cup is framed by the silvery glint of the little bottle on the left and the reddish glass on the right. The little brown box behind the jug introduces a note of calm into the composition and color of the painting.

Chardin was not only thought of very highly by connoisseurs during his lifetime, but he also became a trailblazer for Modernism. It is no coincidence that Paul Cézanne (1839–1906) was one of his greatest admirers.

Cézanne, too, was more interested in the "how" than in the "what" in his art. His famous proclamation that "I will astonish Paris with an apple" essentially referred to Chardin, and it aimed to make clear that

above——**Jean-Baptiste-Siméon Chardin, Still Life with Pipes and Drinking Pitcher, or The Smoking Salon [La Tabagie]** | 1737 oil on canvas | 32.5 x 40 cm | Musée du Louvre | Paris.

right——**Paul Cézanne , Apples and Oranges** | *c.* 1899 | oil on canvas 74 x 93 cm | Musée d'Orsay | Paris.

1774—Goethe writes *The Sorrows of Young Werther* .. **1827**—First photographs.. STILL LIFE **120/121**

................**1776**—Declaration of Independence in the USA ..

..**1789–1799**—French Revolution ..

1774–1840 Caspar David Friedrich 1798–1863 Eugène Delacroix 1839–1906 Paul Cézanne

above——**RENÉ MAGRITTE, THE TREACHERY OF IMAGES (THIS IS NOT A PIPE)** | 1929 | oil on canvas | 60.3 x 81.1 cm | Los Angeles County Museum of Art | Los Angeles.

1861–1865—American Civil War 1933—Adolf Hitler seizes power STILL LIFE 122/123
1883—First petrol-engined automobile
1914–1918—First World War

1859–1891 Georges Seurat 1898–1967 René Magritte 1904–1997 Willem de Kooning

"Still lifes, as well as landscapes, were the ideal experimental ground for the painters of the rising modern art."

his painting would make an impact even if it depicted an entirely unimportant object within the "lowest" genre of painting (fig. p. 121). According to Cézanne's philosophy, color, surface, and form determine the painting. The dictates of perspectival pictorial space that had dominated art until then were thus overruled. Cézanne saw the painting for what it really is: a two-dimensional surface. He assumed that the viewer perceives only areas of color, which the painter must combine to form the appropriate shape. "A painting should represent only colors in the first instance," said Cézanne, who believed that one could not reproduce, but only represent, nature. Paintings are therefore not an image of nature, but rather the equivalent of nature: "Art is a harmony parallel to nature" (Cézanne). Still lifes, as well as landscapes, were the ideal experimental ground for the demonstration of his approach. Émile Bernard (1868–1941), who observed Cézanne at work, described it as follows: "His working method was peculiar, and completely different from the usual ones. He began with the areas of shadow and with a spot, upon which he made a second, larger one, then a third, until all of these color tones, arranged together, formed the objects." And yet Cézanne's philosophy of painting did not gain acceptance immediately. In 1907 a retrospective was held in Paris that made a great impression on Georges Braque and Pablo Picasso. They expanded on Cézanne's idea about two-dimensionality and developed Cubism (see also *Cubism*, pp. 172–179).

However, artists continued to concern themselves with the question of pictorial illusion and deception. René Magritte (1898–1967) asked this question in his famous painting *The Treachery of Images* (fig. p. 122). What we see is not a pipe although it looks very much like one. But Magritte has written very clearly underneath it that "This is not a pipe" and he is, of course, right. It is just oil paint on canvas, in other words it is a depiction of the object we call a pipe. In his work, Magritte repeatedly dealt with our perception of pictures. And the still life provided the best opportunity to do so.

Jm 1525 Jar noch dem pfingstag zwischen dem pfin Mitwoch vnd pfintztag Jn der nacht Jm schloff hab Jch
dis gesicht gesehen wij vil grosse wasser von Himl fielen vnd das rest traff das Erterich vngfer 4 miill von
mir Mit einer solchen grausamkeitt mit einem vber grossen rauschen vnd zersprützen vnd retrenktett
das gantz lant Jn solchem erschrack Jch so gar schwerlich das Jch doron erwachett ehe dij andern wasser fielen
vnd dij wasser dij do fielen dij woren fast groß vnd doe fielen etliche weit etliche neher vnd sy komen so hoch herab das sj
Jm gedunken glench longsam fielen aber do das rest das erste wasser erterich
solchen geschwindikeit wint vnd brausen das Jch also erschrack do Jch erwacht das mir all mein lichnam
zitert vnd long nit recht zu mir selbs kom Aber do Jch am morgen auff stund molet Jch sij oben dy Jch
geschen hett Got wende alle ding zu besten

 Albrecht durer

1555—Peace of Augsburg, ending religious struggles during Reformation··········· 1618–1648—Thirty Years' War···· **124/125**

1564—Birth of Galileo Galilei···········

1571—Birth of Johannes Kepler ···········

1560–1609 Annibale Carracci 1571–1610 Caravaggio 1599–1660 Velázquez 1606–1669 Rembrandt

DREAMS

"In the year 1525, during the night of Wednesday to Thursday after Whitsuntide, I had this vision in my sleep, and saw how many great waters fell from heaven. The first struck the ground about four miles away from me with such ferocity, great noise, and splashing that it drowned the entire countryside. I was so shocked by this that I woke up before the rest of the water came down from the sky. And the downpour that followed was enormous. Some of the waters fell far away and some fell nearby. And they came from such a height that they appeared to fall at an equally slow speed. But when the first water to hit the ground suddenly fell at such speed, and was accompanied by wind and blustering so frightening, my entire body trembled when I awoke, and I did not recover for a long time. But when I arose in the morning, I painted the above as I had seen it. May the Lord turn all things to the best. Albrecht Dürer." Albrecht Dürer wrote this when he awoke from a nightmare on the morning of June 8, 1525. The text complements a watercolor in which he depicts what he saw in his dream at night (fig. p. 124). Dreams have been recorded since Antiquity, both in writing and as pictures. But these dreams were always understood to be divine revelations. The content of such dreams consisted of political or religious messages. They never had personal content. Dürer's dream vision therefore represents something completely new: it is the first record of a personal dream. No document like this, created by an artist before or for a long time after him, survives. Dürer shows a frightening vision of an apocalyptic scenario. Great quantities of water gush from the sky onto a landscape with trees and a small village, flooding the land. If we imagine this scene and the noises described by Dürer, we can understand the alarming dimensions and powerful nature of the dream. And so it is not surprising that Dürer was trembling when he woke up.

On the one hand, the text is written in a fairly reserved, virtually scientific style. On the other hand, this record develops its impressive effect precisely through the combination of image and text. But just which aspect of the dream was it that alarmed Dürer so much? Sigmund Freud said that dreams provided the most direct access to the unconscious. So which of Dürer's fears are revealed here? And are they really his personal fears, or is this just a sort of general dream vision? The latter seems unlikely because at this point Dürer had not painted in watercolor for a long time. That he took up watercolors again indicates that it was important to him to put the dream

left——**ALBRECHT DÜRER, DREAM VISION** | 1525 | watercolor and ink on paper | 30 x 42.5 cm | Kunsthistorisches Museum | Vienna.

vision on paper as quickly as possible, before it could disappear from his memory. The imprecise and quick execution of the watercolor, unusual for Dürer, also suggests that this was not simply a "general" illustration of a dream.

There were plenty of things to worry about at the time, for Dürer personally too. It was the time of the Peasants' War in Germany. The uprising of the suppressed peasants escalated when Martin Luther justified all means for the suppression of the insurgents by the authorities in his essay *Against the Murderous, Thieving Hordes of Peasants*: "They should be smashed, strangled, stabbed, in secret and in public, whoever is able to, just as one has to batter a rabid dog to death." According to contemporary sources, more than 130,000 peasants were killed during the conflict. Dürer, who was a follower of Martin Luther, was very concerned about the unrest that had erupted in Germany. In addition, Dürer suffered from malaria and was plagued by repeated bouts of high fever. He was 54 years old at this time, and would die three years later. Of course it is impossible to verify whether one of these events gave rise to his nightmare. What is new and important in this context is Dürer's understanding of himself as an artist who expressed his subjective fears directly in his painting.

One cannot say that Dürer inspired many other artists to follow in his footsteps as very few people will have seen his dream painting—it was too private. Dreams and fears played an interesting and important part in the art of the 18th and 19th centuries, however, when they became quite fashionable. One of the most famous dream paintings shows not the content of the dream itself (as in the Dürer watercolor), but the cause of nightmares. The Swiss painter Johann Heinrich Füssli (also known as Henry Fuseli, [1741–1825]) created *The Nightmare* in 1781 (fig. above). A woman lies on a bed, obviously asleep. A troll-like creature known as a "mare" sits on her stomach, having ridden through the night on the back of the ghost-horse whose head with shining eyes pokes through the curtains. Mares are creatures from Nordic folklore that sit on top of people's

above——**Johann Heinrich Füssli (Henry Fuseli), The Nightmare**
1781 | oil on canvas | 101.6 x 126.7 cm | Detroit Institute of Arts | Detroit.
right——**Francisco de Goya, The Sleep of Reason Produces Monsters [El sueño de la razón produce monstruos]** | *c.* 1797/98
etching and aquatint | 32.5 x 24.7 cm.

1774—Goethe writes *The Sorrows of Young Werther*
1776—Declaration of Independence in the USA
1789–1799—French Revolution

1741–1825 Johann Heinrich Füssli 1746–1828 Francisco de Goya 1832–1908 Wilhelm Busch

chests as they sleep, inspiring bad dreams. This is the origin of the term "nightmare." At night, when we sleep, dream, and have nightmares, we are assailed by fears that are buried deep inside us, and of which we are not conscious. They make their presence felt and take possession of us. However, nighttime also brings to the fore our dark delight in feeling afraid. It is no coincidence that Füssli took inspiration for his nightmare-paintings from English ghost stories, amongst other things.

Francisco de Goya's (1746–1828) most famous etching, *The Sleep of Reason Produces Monsters* [*El sueño de la razón produce monstruos*] (fig. p. 127), looks quite different. It was originally intended as the frontispiece for a series of etchings entitled *Dreams*, but finally appeared in the *Los Caprichos* cycle, published in 1799. An artist, most likely Goya himself, has fallen asleep at his table. Frightening creatures of the night—owls, bats, and a lynx—assail him. One owl passes the artist a drawing implement as though prompting him to record his dreams. The Spanish term *sueño*, which Goya used in the title of the etching, means both "sleep" and "dream." In the 18th and 19th centuries, dreams were synonymous with fantastical pictures, which meant that they did not always represent personal dreams but were also sometimes invented. Goya consciously made use of his dreams and fears as a source of inspiration. He "presents to the eye

shapes and movements that had previously existed only in the human mind." The *Caprichos* are a powerful satire and attack on the condition of Spanish society. In his etchings, Goya accuses both those in power in the forms of state and clergy, and the stupidity and lack of reason of the common people. "The author, dreaming. His only intention is to banish harmful superstitions and in this work titled *Caprichos* to establish the lasting testimony of the truth," Goya wrote under his first drawing of a dream, which would serve as a model for *The Sleep of Reason*. Goya's etchings not only symbolize the loss of control of our thoughts and fantasies that we experience while sleeping and dreaming, but can also be understood as a warning by Goya, who was a friend of the Enlightenment: as soon as reason sleeps, humans are ruled by the powers of darkness and irrationality. The *Caprichos* would become an important source of inspiration for many artists who, like Goya, concerned themselves with the depths of the human soul and society. These include Max Klinger (1857–1920) and Alfred Kubin (1877–1959).

The monsters in Goya's etching can also be interpreted as representations of that which we call the subconscious. In this way, Goya anticipated the foundation of Surrealism. The Surrealists in the group around Salvador Dalí (1904–89) and Max Ernst (1891–1976) developed their pictorial worlds using a similar approach and access to dreams. Like Goya, the Surrealists tapped into their inner worlds

above——ALFRED KUBIN, MAN | *c.* 1902 | Museum Leopold | Vienna
right——SALVADOR DALÍ, DREAM CAUSED BY THE FLIGHT OF A BEE AROUND A POMEGRANATE A SECOND BEFORE AWAKENING [SUEÑO CAUSADO POR EL VUELO DE UNA ABEJA ALREDEDOR DE UNA GRANADA UN SEGUNDO ANTES DE DESPERTAR] | 1944 | oil on canvas | 51 x 41 cm Museo Thyssen-Bornemisza | Madrid.
far right——PABLO PICASSO, LE RÊVE [THE DREAM] | 1932 | oil on canvas 130 x 97 cm | Private collection.

····**1848**—Marx and Engels publish *The Communist Manifesto* ·· **1939–1945**—Second World War···· DREAMS **128/129**
······························· **1886**—Completion of the Statue of Liberty······························· **1914–1918**—First World War···
··· **1919**—Formation of the Bauhaus school···

1881–1973 Pablo Picasso **1904–1989 Salvador Dalí** **b. 1931 Bridget Riley**

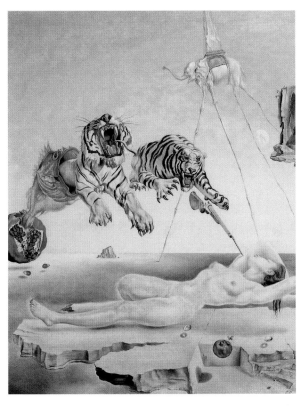

as sources of their art, but achieved very different results. Where Goya's "visions" adopt dark, nightmare-like features, this is seldom to be felt in the work of the Surrealists. Their approach is to make the subconscious and dreams visible through associations. They combine objects from different contexts in a seemingly haphazard way to form dream-like pictures (fig. above left), referring to the insights of Sigmund Freud's psychoanalysis and interpretation of dreams. They wanted to establish a connection with the subconscious in this way because they believed that true art could only be created when the rational conscious was "switched off."

Freud himself did not know what to make of the art of the Surrealists at first, and was of the opinion that they had not understood him correctly. In July 1938, however, he met Dalí in London and wrote: "Until then, I was inclined to consider the Surrealists, who appeared to have chosen me for their patron saint, to be absolute (let's say 95 percent, as with alcohol) idiots." Dalí was clearly able to convince him that the opposite was the case, or at least make him curi-

ous: "The young Spaniard with his loyal, fanatical eyes and indisputable technical mastery suggested a different appraisal to me. It certainly would be interesting to investigate the creation of such an artwork analytically." Sadly, no such Freudian investigation of a work by Dalí took place as Freud died two months after the meeting.

1599–1660 Velázquez 1601–1678 Jan Brueghel the Younger 1606–1669 Rembrandt

THE BAROQUE

Baroque "is a terrible epidemic that filled the brains of scholars with evil vapors and made their blood surge as though they had a fever," the German archaeologist Johann Joachim Winckelmann (1717–1768) said about the art style popular between 1600 and 1750. The term "Baroque" was not introduced in France until the middle of the 18th century, and in Germany as late as a century later. The word derives from the Portuguese word *barocco,* an irregularly shaped pearl. Baroque art was abhorred during the Neo-classical period. As late as 1904, the German reference book, *Meyers Konversationslexikon,* stated that "the term [Baroque] describes that which is nonsensically strange, faddishly bizarre, and tends towards the incomprehensible and idiotic." Opinion today is more nuanced; and yet one continues to associate Baroque art with the bombastic, and at the same time with the magnificent. Probably most people's minds immediately turn to the rather heavyset ladies of the Flemish painter Peter Paul Rubens when they think of Baroque painting. And for good reason.

The cliché of Baroque painting is only tenuously connected to what is nowadays regarded as the beginning of Baroque art. This was neither kitschy nor excessive. Quite the contrary: the movement that took place in what was at the time the center of art, Rome, was a reduction or reaction against Mannerism, an art that appeared to have lost all that is natural. Mannerism is the name for the late period of the High Renaissance, when the younger generation of painters attempted to surpass the great masters Raphael and Michelangelo. This younger generation distanced itself from the art of its predecessors and from the idealized image of humankind handed down from Antiquity. The typical figure of this time is the so-called *figura serpentinata,* the twisted, serpentine figure: it became fashionable to depict bodies in this winding manner. Perspective no longer conformed to logical relationships and coloring became more imaginative. In an attempt to outdo the masters, art became more artificial, exalted, or "mannered," hence the term Mannerism, which came into use from the 19th century onwards and described art produced between 1530 and 1600 (fig. p. 132). Two painters from northern Italy were the protagonists of the counter-movement that came into being in Rome in about 1600: Michelangelo Merisi, better known as Caravaggio (1571–1610)—after the name of his hometown near Bergamo—and Annibale Carracci (1560–1609) from Bologna.

left—Peter Paul Rubens, The Rape of the Daughters of Leucippus | 1618 | oil on canvas | 224 x 210.5 cm | Alte Pinakothek Munich.

1618–1648—Thirty Years' War .. 1632—Construction of Taj Mahal........................... 1644—Beginning of the Qing Dynasty in China

1627–1678 Samuel van Hoogstraten 1628/29–1682 Jacob van Ruisdael

Annibale Carracci arrived in Rome in 1595. He aspired to the art of Raphael, and the latter's classical aesthetic ideal. The intentionally original painting of Mannerism was anathema to him; he was in search of strict form and ideal composition. Together with his brother Agostino and his cousin Ludovico, he had founded in Bologna the painting school the Accademia degli Incamminati [Academy of the Progressives], a predecessor of modern-day art school. Carracci overcame Mannerism by harking back to the ideals of a time before what he considered to be the errors of Mannerism, thus "calming down" art (fig. p. 133). Agostino Carracci (1557–1602) described the painting of his brother Annibale as follows: "... the feminine grace of the line from Raphael, the muscular power from Michelangelo, the strong colors from Titian and the soft colors from Correggio." Carracci's painting style gave rise to a stricter form of painting, known as Baroque Neo-classicism. It may be considered a little bit too emotional and saccharine for present-day tastes.

Caravaggio, too, felt that the "excesses" of Mannerism went too far. He considered the contorted figures, the odd lighting, and the artifice to be too unnatural. In contrast to Carracci, he did not aspire to the ideal image of humankind, but to the representation of people in their natural state. Few painters had as profound an effect on later generations as Caravaggio has had. His influence was based in part on his dramatic *chiaroscuro* painting (see also *Shadow*, pp. 58–65) and in part on the unprecedented realism that made his paintings so unusual. Caravaggio grasped the climaxes of stories and accentuated them with his extraordinary use of light. The people in his paintings look as though they are illuminated by a concentrated spotlight on a stage, leaving the background in darkness. This is accompanied by the realism of his depictions: he does not represent model athletes such as those in the frescoes of Michelangelo. Caravaggio interpreted the Bible differently: for him, the Apostles were farmers, fishers, and customs officials. In other words, they were completely normal people. His models consisted of people from the street, including prostitutes. This also applies to *Judith Beheading Holofernes* (fig. p. 134), painted *c.* 1599. Judith, a Jewish widow, strategically acquiesced to an evening rendezvous with the general Holofernes, who was laying siege to her hometown. When the latter fell into an

above——JACOPO DA PONTORMO, JOSEPH IN EGYPT | 1517/18 oil on canvas | 93 x 110 cm | National Gallery | London.
right——ANNIBALE CARRACCI, THE DEAD CHRIST MOURNED (THE THREE MARIES) | c. 1604 | oil on canvas | 92.8 x 103.2 cm National Gallery | London.

1659/1664–1714 Andreas Schlüter

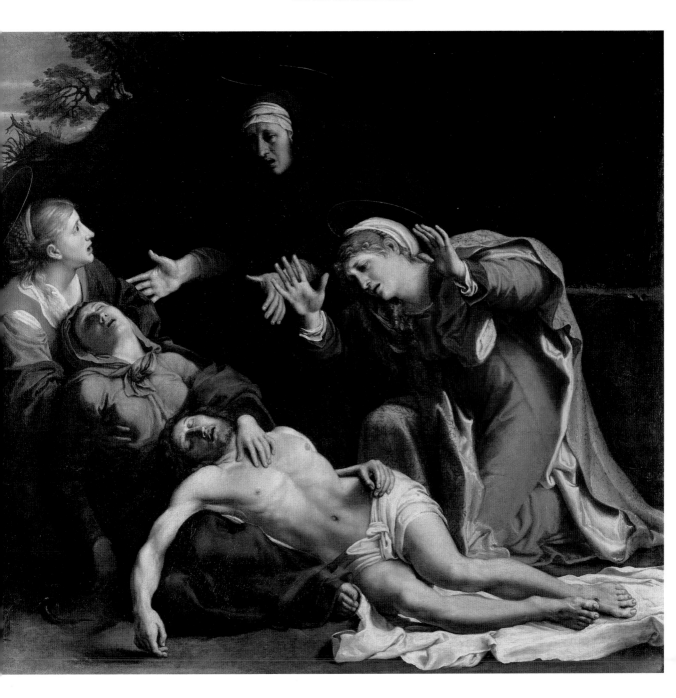

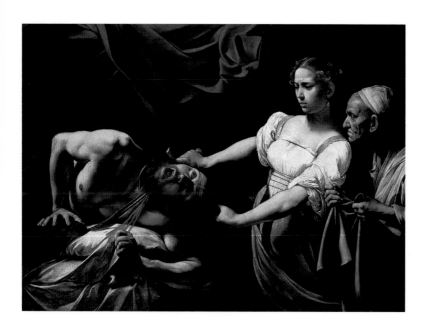

intoxicated asleep, she beheaded him and showed his severed head to the soldiers of the occupying forces the following morning, causing them to flee in horror. The moment in the Old Testament story in which the head is actually severed had never before been shown. Caravaggio succeeded in establishing a new narrative mode in his paintings, and this made his way of painting popular throughout Europe. The Flemish artist Peter Paul Rubens (1577–1640), who was in the service of the Duke of Mantua, was among the many painters who were drawn to Rome. During his time as a court painter of the Gonzaga from 1600 to 1608, he travelled through Italy and absorbed all of the developments of Italian art: the classical figure-composition of Michelangelo and Carracci, the coloring of Titian and, most notably, the innovations of Caravaggio—his naturalism and the drama of his use of light and of his pictorial narratives. All of this was combined in a grand, dynamically powerful style that made him one of the most productive and successful painters of the Baroque period. The artworks created in the studio he opened when he returned to his hometown of Antwerp in 1608 had an influence throughout Europe. His masterpiece *The Rape of the Daughters of Leucippus* (fig. p. 130), executed in 1618, is a prime example of his dynamic pictorial composition. Castor and Pollux abducted Hilaeira and Phoebe, the daughters of King

Leucippus of Argos, just before the women were to be married. Although Castor and Pollux were twins born of Leda, they had separate fathers. Castor was the son of the King of Sparta, and thus mortal, while Pollux was the son of Zeus, and thus immortal. The abduction had an unhappy end: Castor was killed in a battle with the future husbands. Pollux implored Zeus to make his brother immortal. After the request had been granted, they spent alternate days on Olympus and in Hades. Rubens's representation of this story is structured in a spiral, with the group of four people framed by two horses. The power of the movements is increased by the rearing horses and the women's dramatic gestures. The fullness of the composition further heightens and concentrates the dynamic nature of the composition. Furthermore, this painting exemplifies Rubens's ability to make a variety of surfaces appear almost palpable, such as the difference between the soft, light skin of the women and the sun-tanned skin of the muscular Pollux. The dramatic impact of Rubens's work became a symbol of Baroque art. However, his paintings sometimes feel as reserved and impersonal as they are overwhelming. The paintings of the artist Rembrandt (1606–1669) from Amsterdam, who was one generation younger than Rubens, have a very different effect on the viewer. Rubens was a master of luminous color; Rembrandt, on the other hand, reduced his

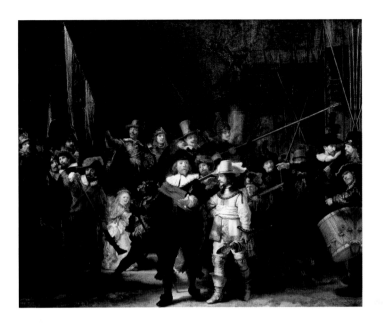

palette and in doing so increased the intensity of the color he used. His paintings may not have the might of those by Rubens, but they have a greater emotional power and feel more personal. While Rembrandt, too, engaged in history painting, his focus was on portrait painting. Rembrandt created masterpieces in the genre of group portraits in particular, transcending the usual forms of representation many times over. According to contemporary practice, the subjects of group portraits were arranged neatly in a row and then painted to look equal to one another and similar in size. Rembrandt, however, grouped the people in front of his canvas as a movie director might do, and in this way imbued the paintings with the semblance of an action in the process of unfolding. His most famous painting, *The Night Watch* of 1642, is an outstanding example of his method (fig. above). Rembrandt arranged his group portrait like a history painting. The group appears to be in the process of leaving, thus causing a well-calculated muddle. In addition to the militia members, Rembrandt paints other people into the painting, such as the drummer on the right and the young woman whose dress glows as though it were made of gold. This figure is seen as the mascot of the group and has been given the facial features of Rembrandt's wife, Saskia. The title *The Night Watch*, by which the painting has become commonly known, derives from the slowly advancing darkness engulfing the painting, the result of the varnish, staining, and restorations, rather than from the painting's subject. The original title was *The Shooting Company of Frans Banning Cocq* and refers not to a militia, but to an association of honorable citizens of the city of Amsterdam. The captain, Frans Banning Cocq, for example, was the mayor of Amsterdam from 1650 to 1655. Rembrandt was soon held in high esteem and had a large number of students. Although he had never been to Italy himself, he adopted the innovations that originated there and developed them further. He had acquired his knowledge of Italian art from his teacher Pieter Lastman (c. 1583–1633), who had studied contemporary art in Italy, and from his extensive collection of engravings and drawings, including artworks by Titian, Carracci, and Rubens. Rembrandt, like Rubens, had a tremendous influence on the following generations of painters.

left——CARAVAGGIO, JUDITH BEHEADING HOLOFERNES | *c.* 1599 oil on canvas | 144 x 195 cm | Galleria Nazionale d'Arte Antica Palazzo Barberini | Rome.
above——REMBRANDT, THE SHOOTING COMPANY OF FRANS BANNING COCQ (THE NIGHT WATCH) | 1642 | oil on canvas | 359 x 438 cm Rijksmuseum | Amsterdam.

1732–1806 Jean-Honoré Fragonard 1741–1825 Johann Heinrich Füssli 1755–1842 Élisabeth Vigée-Lebrun

"The art historian Heinrich Wölfflin differentiated between the painting of the Renaissance and the painting of the Baroque period by opposites, like graphic and painterly."

In 1628, Rubens was on a diplomatic mission in Madrid, where he met the young court painter Diego Velázquez (1599–1660). He suggested that the latter should travel to Italy to round off his artistic training by studying the local art. In 1630, Velázquez arrived in Rome as an unknown painter, and was overwhelmed by the city and the art that he discovered there. He already knew the work of Titian from the collections of the King of Spain, but was able to gain an entirely new perspective on painting in Rome, the center of the art world. He, too, was impressed by the art of Carracci and, more than anything, by that of Caravaggio, and applied these new inspirations to his own painting. Velázquez returned to Rome for a second visit in 1649, this time as a celebrated master. It was during this period that he painted his famous portrait of Innocent X (fig. p. 24) and, it is thought, *Venus at her Mirror* (c. 1650), the first nude in Spanish painting. Velázquez, like Rembrandt, did not adopt Peter Paul Rubens's vibrant colors. Velázquez's color palette is more reserved, but no less intense in the effect that it achieves. While Rubens's work is impressive as a result of its might and its size, the paintings of Velázquez are characterized primarily by an inner strength. This can be seen in *The Surrender of Breda* (fig. p. 137), for example which was painted in 1634/35. A victory, or capitulation, has seldom been staged in as effective, and simultaneously undramatic, a way as in this painting.

The Baroque period was the era of great painters, and their creations had an impact that reached far beyond the places in which they worked and the times in which they lived. They had both the opportunities and the skills necessary to liberate themselves from the "orderly" painting of the Renaissance. The art historian Heinrich Wölfflin differentiated between the painting of the Renaissance and the painting of the Baroque period by, among other things, opposing the "graphic" and the "painterly" in reference to the artistic approach to an artwork: while the painters of the Renaissance attempted to depict things as they are, the painters of the Baroque period show things as they appear. Individual details are dissolved into fine color gradations that become visible only at a certain distance from the painting. In other words, it is not necessary to paint everything in order to see everything, but it must look as though everything is present although in reality it all consists of nothing but a few impressively applied brushstrokes. It is no coincidence that painters such as Velázquez and Rembrandt had such a formative influence on Goya, Delacroix, or even the Impressionists.

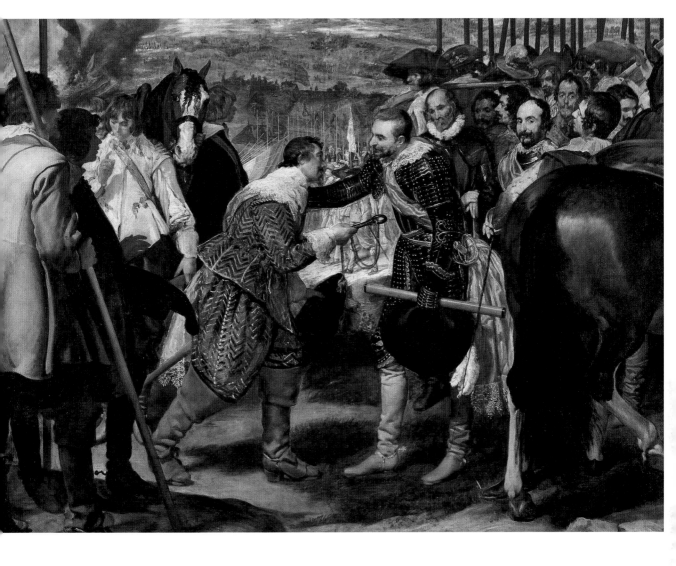

above——**Diego Velázquez, The Surrender of Breda** | 1634/35
oil on canvas | 307 x 367 cm | Prado | Madrid.

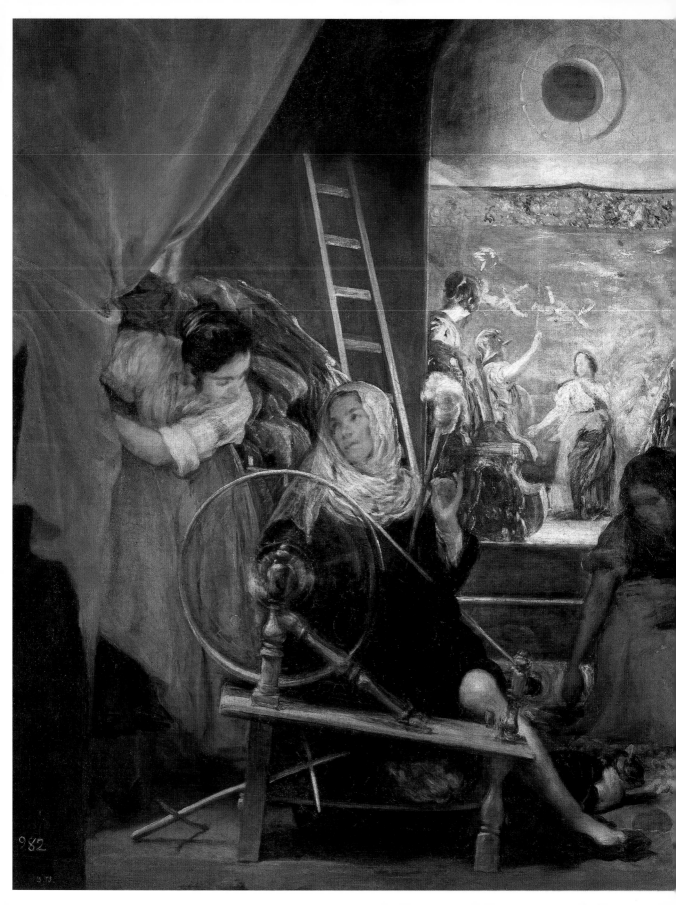

1659/1664–1714 Andreas Schlüter

SPEED

The depiction of movement in a single picture is quite a challenge. Painters "solved" this problem by simply counting on the cooperation of the viewer. Paintings are snapshots in which time appears to stand still. For example, we see a horse with two legs in the air and automatically realize that it cannot not stay in this position for a long time and so, in a moment, its legs will make contact with the ground again (see also fig. p. 42). This is not actually depicted, and yet it is clear to the viewer, as is the fact that all four of the horse's legs were on the ground before this frozen movement. As a viewer, one automatically imagines what came before and what will follow, and so the intended movement is created in the viewer's head. In order for this to be possible, the painter has to depict a position that is clearly transitory.

Paintings are therefore snapshots in which movement is created only in the virtual sphere, and this is only possible with bodies that can be adopt different positions. This raises the question: How can one show movement or even speed in a single picture,

and how do painters "move" objects whose exteriors are not altered through movement, such as wheels? Many painters were clearly aware of this problem, as is apparent from a statement in *In Praise of the Art of Painting* [*Lof der schilder-konst*] of 1642, by the Dutch painter Philip Angel (1616–83): "When a cartwheel or a spinning wheel turns very quickly, you will notice that as a result of this fast movement the individual spokes can no longer be seen, but are replaced by an unclear sheen. Although I have seen many depictions

right——Diego Velázquez, The Fable of Arachne [Las Hilanderas]
1657 | oil on canvas | 167 x 250 cm | Museo Nacional del Prado | Madrid.

left——Diego Velázquez, The Fable of Arachne [Las Hilanderas]
detail

of cartwheels, I have never seen one that shows it in the way that it really appears. Instead, each spoke is always painted as though the cart were stationary." Diego Velázquez, painter to the Spanish king Philip IV, realized the same thing that his Dutch colleague had noticed: the individual details of a moving object cannot be perceived when it is in rapid motion, as they appear to melt before the human eye. While they were still mulling it over in the Netherlands, Diego Velázquez presented the "solution" in his 1657 painting *The Fable of Arachne* [*Las Hilanderas*] (fig. p. 139), which tells the story of a competition between Arachne and Athena. Arachne was the best weaver in Antiquity. In her arrogance, she claimed that she was better at it than the goddess Athena, who had invented the weaving loom. When Athena heard of this, she visited Arachne, having adopted the form of an old woman, in order to challenge her: a competition would show who could weave the most beautiful tapestry. In his painting, Velázquez shows the different events at the same time: Arachne and Athena spin their wool in the foreground. The moment when Athena reveals her identity is depicted in the background. Wearing armor and a helmet, she stands in front of one of the tapestries woven by Arachne. It depicts the scene in which Zeus kidnaps the young girl Europa. The goddess had to acknowledge that Arachne was the better weaver. And yet

it was precisely this sort of scene that filled Athena with rage because humans were not entitled to mock the various amorous entanglements of the gods. In punishment, "Athena struck Arachne's forehead three and four times." Arachne could not bear it and wanted to hang herself. To prevent this from happening, Athena turned her into a spider, in which form she and her descendants were to practice the art of weaving. And thus we have the scientific name for spiders—*arachnida*.

In this painting, Velázquez shows us a spinning wheel in motion, and its spokes can no longer be made out. What we see instead are the light reflections on the spokes. Our experience tells us that this spinning wheel must be turning very quickly because the human eye is too slow to be able to perceive details above a certain speed. Velázquez was the first to put this

above—**WILHELM CAMPHAUSEN, NAPOLEON III CONDUCTED TO MEET WILLIAM I BY BISMARCK ON THE MORNING FOLLOWING THE BATTLE OF SEDAN** | 1877 | oil on canvas | 68 x 115 cm | Deutsches Historisches Museum | Berlin.
right—**J.M.W. TURNER, RAIN, STEAM AND SPEED – THE GREAT WESTERN RAILWAY** | 1844 | oil on canvas | 91 x 121.8 cm | National Gallery | London.

1769—Invention of the steam engine 1789–1799—French Revolution SPEED 140/141

1774—Goethe writes *The Sorrows of Young Werther*

1776—Declaration of Independence in the USA

1755–1842 Élisabeth Vigée-Lebrun 1775–1851 William Turner

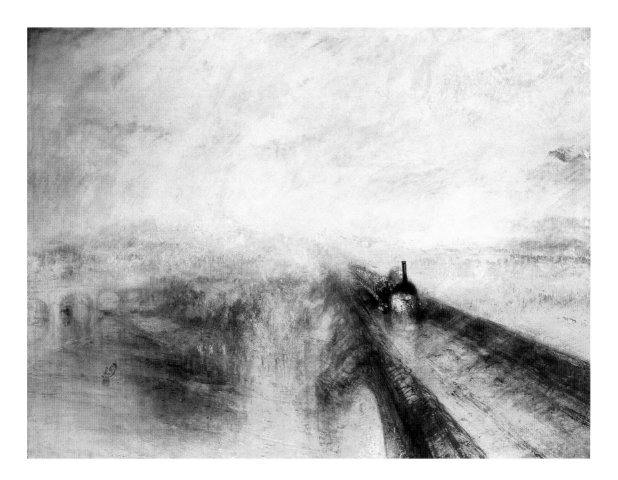

knowledge into practice in his painting. It was his brilliant idea to reduce the form so much that the wheel itself can still be recognized as a wheel, whereas the spokes cannot: he has depicted only their light reflections. The wheel appears to spin without the viewer having to imagine the "before" and "after."

Experience teaches us that the details of moving objects are observed less easily than the details of stationary objects. Velázquez recognized that one does not have to paint everything in order to show everything. He achieved a paradox with *The Fable of Arachne*: it is a snapshot in which all figures are frozen in motion. Time stands still for a moment. And yet the spinning wheel appears to continue to turn. Velázquez makes time stand still and run on simultaneously.

It took a long time before Velázquez's brilliant representation of movement caught on in painting. One reason for this was that his paintings were generally shown only at the Spanish court, which is why Carl Justi described Velázquez as a "painter without an audience." A painting of 1876 by Wilhelm Camphausen (1818–85) shows just how far ahead of his times Velázquez had been (fig. p. 140). The horses appear to be moving rapidly, and the carriage stirs up a lot of dust. It is clear that the company is moving at high speed. And yet all of the spokes can be seen individually. If one looks at the horses alone, one gains the impression of speed and velocity, but this is immediately dispelled when one concentrates on the wheel spokes.

The world changed rapidly in the 19th century as the age of industrialization began. Where the horse had been the measure of all things when it came to speed and dynamism, the steam engine now took its place. Although the speed of the first railroad engines was considerably slower than that of a galloping horse, this was soon to change.

1819—Carlsbad Decrees ... 1848—Revolution in Europe ...

1853–1856—Crimean War

1857–1859—First world economic crisis ····

1818–1885 Wilhelm Camphausen 1832–1908 Wilhelm Busch

Of course artists, too, were fascinated by this new technique and wanted to depict it in their paintings. Perhaps no other painter expressed this fascination more impressively in his work than the English artist Joseph Mallord William Turner (1775–1851). Turner was an exceptionally talented landscape painter and achieved new heights with the landscape watercolor, which Dürer had first used for landscape painting in 1500.

Turner used a different method from Velázquez to express his enthusiasm for the thrill of speed. In his painting *Rain, Steam and Speed—The Great Western Railway*, executed in 1844, the wheels are barely discernible, and the spokes not at all (fig. p. 141). The rain, the steam from the engine, and the light combine to form an atmospheric unity of unusual density out of which the train appears to speed past the viewer. This dynamic effect is increased by the strong perspective. Of course the expectation of a dynamic event is already conjured up by the title of the painting. If it were simply called *Rain on the Railway*, for example, the reception of the painting might have been different.

Despite all of these differences, Turner's technique is similar to that of Velázquez, however. The sense of speed results from the lack of precision and reduction of details: again, the eye is slower than the moving object. Instead of showing things clearly, Turner shows us only the moment as it appeared to him. This way of representing an observed moment made Turner one of the precursors of Impressionism. Where the illusionistic or impressionistic representation of movement and speed was still the challenge for Velázquez and Turner, dynamism and speed itself became the subject for the Futurists, who emerged onto the scene in 1910: "We declare that the splendor of the world has been enriched by a new beauty: the beauty of speed." But this applied not only to racing cars and trains, which were popular objects among the Futurists ("A racing automobile is more beautiful than the Victory of Samothrace"). It also applied to dachshunds, as one can see in Giacomo Balla's painting *Dynamism of a Dog on a Leash*, executed in 1912 (fig. above). The Futurists split the movement into its component parts and put it back together again to form a multi-stage movement (see also Futurism, pp. 180–185).

above——GIACOMO BALLA, DYNAMISM OF A DOG ON A LEASH [DINAMISMO DI UN CANE AL GUINZAGLIO] | 1912 | oil on canvas 90.8 x 110 cm | Albright-Knox Art Gallery | Buffalo.
right——WILHELM BUSCH, THE VIRTUOSO (DETAILS) | 1865 | first published as an illustration in the journal *Fliegende Blätter*, Munich, 1865.

........**1861–1865**—American Civil War .. **1914–1918**—First World War SPEED **142/143**

.. **1889**—Completion of the Eiffel Tower ..

.. **1900**—Sigmund Freud publishes *The Interpretation of Dreams*

1871–1958 Giacomo Balla **1883–1970 Erich Heckel** **1912–1956 Jackson Pollock**

13. Fortissimo vivacissimo.

14. Finale furioso.

15. Bravo-bravissimo.

This multi-stage movement in art was not as new, however, as Giacomo Balla (1871–1958) and the Futurists may have believed it to be. As early as 1865, Wilhelm Busch (1832–1908) made drawings that anticipated the work of the Futurists in a marvellous way. In the series of pictures entitled *The Virtuoso* (fig. above), he shows the energetic piano-playing of a pianist, and the reaction of somebody who must be one of his greatest fans. The pianist's fingers multiply from one frame to the next—in the *finale furioso* one can see more than 50 fingers—and the pianist himself appears to have been lifted from his stool by the dynamism of his playing.

The reaction of the avid listener is equally amazing: by the final bar, his head consists only of an eye and an ear. One can almost hear the wild piano sonata in the style of Franz Liszt, who may even have been the model for Busch's virtuoso. In this sense, one can certainly describe Wilhelm Busch as a father of the comic strip: it is precisely these techniques, invented

here by Busch, that are used to this day in comics to represent speed in what is actually a static medium. In addition to these techniques, comic strips use what are known as speed lines, which connect the presumed starting point and the drawn end point of a movement. But when wheels are supposed to turn rapidly in comics, illustrators continue to draw on Velázquez. His power of observation and the brilliant way in which he put it into practice remain a benchmark and the foundation for the representation of speed in art to this day.

1771–1834 Alois Senefelder 1774–1840 Caspar David Friedrich 1775–1851 William Turner

LITHOGRAPHY

It appears to be one of the characteristics of artistic printing techniques that their origins are unrelated to art, coming instead from different areas. This is true of the woodcut, copperplate engraving, and etching. And it is also true of lithography. Its purpose was originally to help the playwright and actor Alois Senefelder (1771–1834) to reproduce texts and scores more quickly and more cheaply. This aim, and more, was accomplished: with lithography, Senefelder provided artists with a new medium. It spread like wildfire and transformed many areas of art.

In 1797, Senefelder invented "chemical stone printing." The principle of this printing technique rests on the mutual repulsion of water and oil. Senefelder experimented with a variety of printing plates until he chanced upon Solnhofen limestone, a fine-grained limestone that absorbs water and oil equally.

The text or drawing is marked using chalk, a quill, pen, or paintbrush on the smoothed and degreased limestone plate, cut to a thickness of between 8 and

12 centimeters, as though it were paper. The surface is then "corroded" with a mixture of nitric acid and gum arabic so that the remaining, unmarked areas of the stone's surface are sealed and can absorb no more ink. The fat- or oil-based drawing alone remains absorbant. The stone is dampened and brushed with printer's ink. As this ink, too, is oil-based, it is absorbed by the drawing, but not by the unmarked areas. Once the printing paper has been put into place, printing can begin. Lithography is the first planographic printing technique: the areas to be

left——Henri de Toulouse-Lautrec, Mouln Rouge–La Goulue
1891 | color lithograph | 170 x 124 cm | Museum für Kunst und Gewerbe Hamburg.
right——Alois Senefelder, The Fire of Neuötting | 1797
lithograph | 17 x 20 cm | Bayerische Staatsbibliothek | Munich.

1789–1799—French Revolution .. **1797**—Invention of lithography .. **1804**—Napoleon becomes Emperor of the Frenc

1805—Battle of Trafalgar..........................

1798–1863 Eugène Delacroix 1808–1879 Honoré Daumier

> *"The term lithography stems from the Greek words lithos, meaning stone and graphein, meaning writing."*

printed and the unmarked areas of the printing plate are level. The advantage of this is that the plate is not subject to wear, as it is in relief and intaglio printing. The print run can therefore be virtually unlimited. Once printing is completed, the stone can be polished and used for a new design. The term "lithography" stems from the Greek words *lithos*, meaning "stone" and *graphein*, meaning "writing."

The first known lithograph was made by the inventor himself, and shows a sheet of music with a small drawing: *The Fire of Neuötting* (fig. p. 145), executed in 1797. The printing came about because of an appeal for donations after the small town of Neuötting had been destroyed in a fire. A book was produced for this purpose, and this plain sheet placed inside it. It already reveals all of the possibilities that the recently invented printing technique had to offer, and which made it such a great success: musical notes, texts, and pictorial illustrations could be printed, and all of this could be done at great speed.

Senefelder enjoyed his first breakthrough when, in 1799, he met the composer and music publisher Johann Anton André (1775–1842) from Offenbach in Germany. The latter had recently acquired Mozart's musical legacy from the Austrian composer's widow, Constanze. The publisher considered lithography to be the appropriate printing medium for the 273 musical scores, which included piano concertos,

Serenade no. 13 for strings in G major, and the opera *The Magic Flute.* Senefelder and André established a lithographic printing press, and so lithography experienced its first commercial application thanks to Mozart's compositions. Lithography became well known very quickly as a result of this success, and printing presses were opened in London, Paris, and Vienna. The simplicity of the method of lithography obviously corresponded to the requirements of the dawn of industrialization, and further printing presses were built throughout Europe by 1820. This meant that anything could be printed, from playing cards and layout drawings to maps for the military, passports, and forms such as those introduced in Bavaria in 1808.

Artists, too, accepted the new medium with enthusiasm. Senefelder convinced the painters Ferdinand Piloty (1786–1844) and Johann Nepomuk Strixner (1782–1855) to take part in a large-scale project: they reproduced 432 artworks from the collections of the Bavarian king Maximilian I. These were published in 72 instalments between 1810 and 1816, and demonstrated the entire gamut of lithography's technical and artistic possibilities. This series was about printing but, according to Gottfried von Schadow (1764–1850), "... most importantly, the first and original spirit of the artist remains in the first prints." This was the reason why artists were so

1815—Congress of Vienna · 1827—First photographs · · · · · · · · · · · · · · · · · · · LITHOGRAPHY 146/147
1817—Wartburg Festival ·
1819—Carlsbad Decrees ·

1818–1885 Wilhelm Camphausen 1832–1883 Édouard Manet 1834–1903 James McNeill Whistler

enthusiastic about the new method: its immediacy. One draws directly on the printing medium, and there is no need for an intermediate stage carried out by a block-cutter or engraver. Any artistic technique can be used, from drawing with a quill to drawing with pens, chalk, or painting with brushes. As one draws or paints directly onto the printing surface, every print could be said to be an original. And there was a further advantage, which should not be underestimated: unlike in copperplate engraving or etching, black appears as black and white appears as white. This means that the picture that will result from the printing process is already visible during the process of drawing. In intaglio printing techniques, the negative has to be carved away first, which requires greater experience.

The first established artists to realize the advantages to be gained in their art from the use of lithography were the French painters Théodore Géricault (1791–1824) and Eugène Delacroix (1798–1863), as well as the aged Francisco de Goya (1746–1828). Goya, who was always interested in new techniques, discovered lithography in Paris and Bordeaux, where he lived in exile. His little series *The Bulls of Bordeaux*, executed in 1828, is a masterpiece, and it was created not long after the introduction of the new medium.

Goya's younger colleague Delacroix also created early masterpieces of lithography. In addition to paintings, he made literary illustrations. The most famous are the 17 illustrations that accompany Goethe's *Faust,* a French translation of which was published in Paris in 1828 (fig. above). The greatest compliment Delacroix received was paid by the master himself: Goethe wrote that "the brilliance of these drawings makes all in its vicinity pale in comparison." Lithography revived an art form that had existed for a long time but did not make its breakthrough until after the invention of this technique: the caricature

above——Eugène Delacroix, Mephistopheles Flying Over Wittenberg, from the French edition of Goethe's Faust
1828 | lithograph | 27 x 23.8 cm.

1848 Revolution in Europe·· 1857–1859 First world economic crisis ····
1849 Death of Chopin·········
1853–1856 Crimean War ···

1839–1906 Paul Cézanne **1848–1894 Gustave Caillebotte** **1859–1891 Georges Seurat**

(from Ital. *caricare*, "overload, exaggerate"). This had been a popular medium for satirical comments on political and social events and for the exposure of human weakness in general and that of power brokers in particular. One of the oldest well-known caricatures is also the first representation of Jesus on the Cross. The engraved drawing was discovered in 1857 on the Palatine Hill in Rome. It features Jesus with an ass's head, and underneath it is the inscription "Alexamenos prays to his god" (fig. above).

Artists such as the Carracci brothers (see also *The Baroque*, pp. 130–137) and the famous Roman baroque architect Gianlorenzo Bernini (1598–1680) created caricatures in which they poked fun at their employers. But caricature could not develop its full satirical potential until lithography had been invented and the mass-circulation of newspapers had become possible. The most significant protagonist in this respect was the Parisian painter and graphic artist Honoré Daumier (1808–79). Daumier was a brilliant illustrator and created more than 4,000 lithographs for various newspapers, such as

La Caricature and *Le Charivari*. Honoré de Balzac (1799–1850) called him the "Michelangelo of his time." In 1832, he drew the last French king, Louis Philippe I (1773–1850), as a greedy, gluttonous exploiter with a head the shape of a pear (fig. p.149). As a result of this caricature, Daumier was imprisoned for six months for *lèse-majesté*. He made his drawings on lithographic plates, which were then processed by specialists. After printing, these sheets were placed in the newspapers. Nobody was safe from Daumier's lithographic caricatures. Members of parliament, lawyers, and the bourgeoisie, too, were subject to his mockery. His drawings occasionally had a touch of the visionary about them. In *Dream of the Inventor of the Needle-Gun on All Saints Day* of 1866, Daumier shows the diabolical grin of the inventor who delights in the "success" of his invention in a field of dead bodies (fig. p. 150).

In 1837, Senefelder's pupil Gottfried Engelmann (1788–1839) applied for a patent for a process that made it possible to print lithographs in color. Several stones or plates were required for what became

1861–1865—American Civil War · 1883—First petrol-engined automobile · · · · · · · · · · · · · · · · · · LITHOGRAPHY 148/149

1876—Invention of the telephone ·

1864–1901 Henri de Toulouse-Lautrec 1871–1958 Giacomo Balla 1872–1944 Piet Mondrian 1884–1950 Max Beckmann

left——**Alexamenos graffito** | 2nd century AD | Palatine Hill | Rome.

above——**Honoré Daumier, Gargantua** | 1832 | lithograph.

known as chromolithography. They were printed consecutively after a different color had been applied to each stone.

The combination of this technique and artists who knew how to take advantage of it meant that the poster turned from a plain written announcement into a new form, between fine art and commercial art. How successful posters were can be seen in the fact that the Berlin resident and printer Ernst Litfass (1816–74) asked himself how one could counter the "unruly assault" of mass-distributed posters. In 1854, he invented the "advertising column." By the following year, 100 of them had been erected and diligently pasted up. He was granted a monopoly for setting up advertising columns, which became known as Litfass columns in Germany.

The first artists to take an interest in poster lithography were Jules Chéret (1836–1932) and Henri de Toulouse-Lautrec (1864–1901). Chéret, a trained lithographer, worked in London for many years before opening a lithographic printing press in Paris in 1866. In 1889 and 1890, he created two posters for the famous nightclub the Moulin Rouge, as well as for other music halls and dance venues. He is considered the real father of poster-art, and created approximately 1,200 posters. The better-known and more popular artist in this field was, however, Toulouse-Lautrec. His simpler, more striking style attracted the public's attention more strongly and had a greater impact and legacy. His poster *Ambassadeurs—Aristide Bruant dans son Cabaret* of 1892 is considered an icon of early poster art (fig. p. 151).

above——Honoré Daumier, Dream of the Inventor of the Needle-Gun on All Saints Day | 1866 | lithograph.

right——Henri de Toulouse-Lautrec, Ambassadeurs – Aristide Bruant dans son Cabaret | 1892 | color lithograph 133.8 x 91.7 cm | Museum für Kunst und Gewerbe | Hamburg.

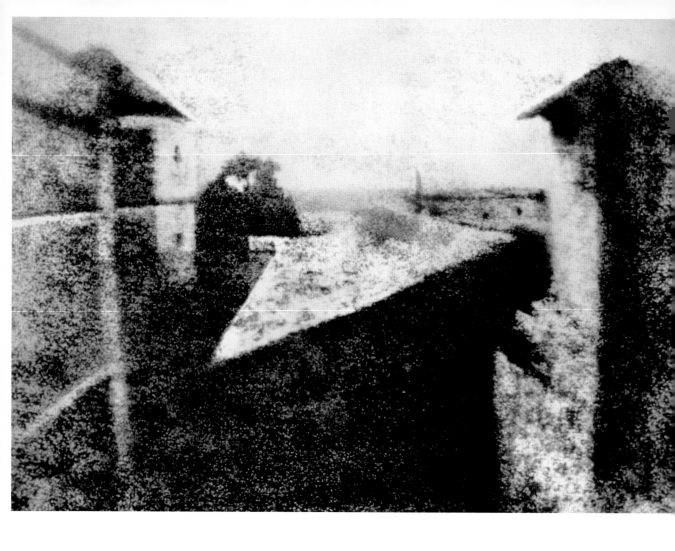

1765–1833 Joseph Nicéphore Niépce

PHOTOGRAPHY

In June 1827, a picture was created in the French commune of Le Gras that had never before existed in this form. For the first time, a picture was made using neither pencil nor brush nor paint. It was made by the Sun and the objects themselves. This was the first photograph, created by the French inventor Joseph Nicéphore Niépce (1765–1833), who was thus the first photographer (fig. p. 152).

The tools Niépce used had been around for quite a long time: light-sensitive material and a camera. The principle of the camera was already known from the camera obscura ["dark chamber"], in which light enters through a small opening in one side of a darkened room, and projects an image from outside onto the opposite wall. The Arabs had already used the camera obscura at the turn of the millennium for observing the stars, and in 1558 the Italian Giovanni Battista della Porta provided the first description of such a device in Europe. The first devices were actually the size of a room, but soon they also existed in transportable formats that were used as drawing aids. The light entering the box was directed to a

glass pane using a mirror construction; the image created in this way could be easily copied. A lens was inserted into the hole to create a more focused picture.

Many painters used the camera obscura to work on their paintings. The Dutch painter Jan Vermeer (1632–75) made use of one, as did the Venetian painter Canaletto (1697–1768). The camera obscura was a suitable aid in the creation of his precise city views, which he made of Venice (fig. p. 154), London, and the country estates of his wealthy English clients. He transposed the relatively small images supplied by the camera onto the canvas and used this basis to paint his paintings. The Museo Correr in Venice exhibits a camera obscura that was probably in Canaletto's possession.

The use of the camera obscura triggered the desire to capture the camera image itself, without the intermediate step of drawing. This could only be achieved through a chemical process, the groundwork for which had already been carried out: in 1727, the German scientist Johann Heinrich Schulze had discovered the light-sensitivity of silver salts. This discovery was given an entirely new significance by its association with the camera obscura. The invention of photography must have been in the air, because a number of men worked on it independently of one another at the same time. Niépce's experiments

left—JOSEPH NICÉPHORE NIÉPCE, VIEW FROM THE WINDOW AT LE GRAS | 1827 | heliograph | 16.5 x 20 cm | Gernsheim Collection | University of Texas | Austin.

1774—Goethe writes *The Sorrows of Young Werther* ··· **1804**—Napoleon becomes Emperor of the French ··················

············· **1776**—Declaration of Independence in the USA ···············

························· **1789–1799**—French Revolution ·················

1774–1840 Caspar David Friedrich **1787–1851 Louis Jacques Mandé Daguerre** **1808–1879 Honoré Daumier**

were initially focused on replacing the heavy stones needed for lithography with metal plates to which a light-sensitive coating had been applied. The difficulty lay not in the light-sensitivity of the plates and their exposure, but in the fixing of the images: they turned black straight after exposure. In 1816 Niépce achieved his first breakthrough: he created a copy of a copperplate engraving and was also able to fix it. The next step consisted of capturing the pictures from the camera obscura on a metal plate. It was not until 1827 that he succeeded in creating the first photograph, for which he used an asphalt coating and a substance containing iodine. To this end, Niépce positioned a camera he had constructed himself at the window on the first floor of his house, and exposed the plate for eight hours. Various parts of buildings and the hazy outline of a tree, none of which is very clearly visible on the original photograph today, can be seen. Niépce called the pictures heliographs ["sun writings"].

Louis Jacques Mandé Daguerre (1787–1851) was carrying out his own experiments at the same time. He used silver plates to which iodine had been applied. They were developed using mercury vapor after exposure, and then fixed in salt water. His plates were of considerably higher quality that Niépce's pictures, but were unique pieces from which it was not possible to make copies. Niépce and Daguerre

met through their shared lens manufacturer and collaborated in order to improve their inventions. Niépce died in 1833, and Daguerre continued to develop his method by himself. In 1839, he presented the eponymous Daguerreotypes to the French Academy of Sciences, whereupon the French state bought the rights to the process in order to make it freely available to the public without patents because of its great importance. Daguerre published a book in which he discussed not only Niépce's invention and his own, but even included construction plans for the camera and developing equipment. The book was on sale worldwide, and soon everybody was trying to construct a Daguerreotype camera. Photographic cameras made according to Daguerre's plans became a great success overnight.

One of the first Daguerreotypes exemplifies both the high degree of faithfulness to detail of this type of photography, and its greatest weakness—the long

above——**Canaletto, Campo SS. Giovanni e Paolo** | Venice | 1726 oil on canvas | 125 x 165 cm | Gemäldegalerie Alte Meister | Staatliche Kunstsammlungen | Dresden.

right——**Louis Jacques Mandé Daguerre, View of the Boulevard du Temple, Paris** | *c.* 1838 | Daguerreotype | 16 x 21 cm | Bayerisches Nationalmuseum | Munich.

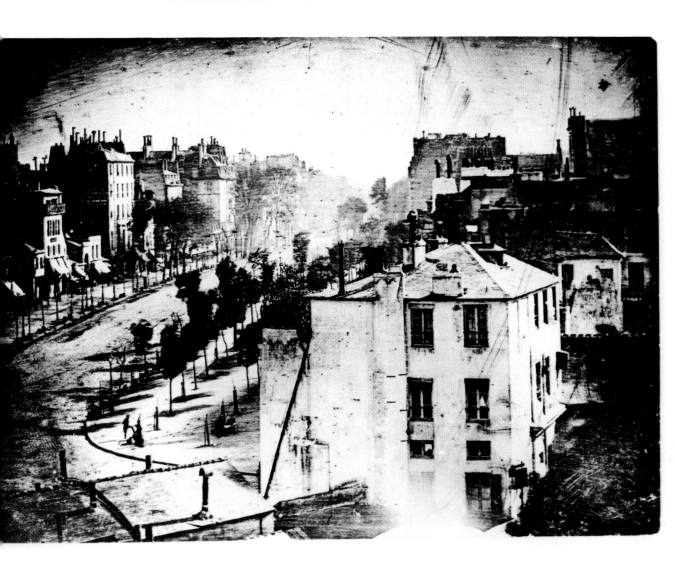

1861–1865—American Civil War ... 1876—Invention of the telephone ...

1883—First petrol-engined automobile

1889—Completion of the Eiffel Tower ·······

1853–1890 Vincent van Gogh 1879–1935 Kasimir Malevich 1888–1978 Giorgio de Chirico

"The British astronomer and natural scientist Sir John Herschel was the first to introduce the term photography after its development by inventors like Daguerre and Niépce."

exposure time. Daguerre appears to have taken a picture of the lively Boulevard du Temple in Paris as early as 1838 (fig. p. 155). No people can be seen on this picture, however. As a result of the long exposure time, which lasted several minutes, the people essentially eradicated themselves through their own movement. Only a shoe-black and his client stay in the same place for long enough to leave their imprints on the Daguerreotype. They are thus the first people ever to have been captured in a photograph. The exposure time could only be gradually shortened following the development of more light-sensitive emulsions in the 1860s.

The many developments in photography that followed one another in rapid succession, leading to the first digital photograph in the year 1975 are too numerous to list here. Photography was, in the end, an invention which took many individual steps and was achieved by a number of different creative minds. Several other inventors, in addition to Niépce and Daguerre, contributed to making photography what it is today. The Englishman William Fox Talbot (1800–77), for example, developed the positive–negative process upon which modern photography is primarily based. He called his pictures "photogenic drawings." The Frenchman Hippolyte Bayard (1801–87) developed the direct-positive process. The terms, too, developed gradually: every inventor gave

his pictures a different name. The British astronomer and natural scientist Sir John Herschel (1792–1871) was the first to introduce the term "photography." For our purposes, however, the reaction of painters to photography and the direct and indirect effects of photography on painting are of far greater importance. There was both considerable enthusiasm and considerable irritation about the detailed and precise way in which these early photographs depicted their subjects. As a contemporary put it, "photography is characterized by its immediacy and its authenticity, as well as by the remarkable fact that its eye sees more than does the human eye. The camera sees everything." In other words, just about everybody could now produce perfect pictures. While before the invention of photography, the representation of reality had been the exclusive domain of those who had labored to learn to paint and draw, it was now possible for everybody in possession of a camera to capture their subjects on paper with much greater precision. Some details on photographs were so small that one needed a magnifying glass in order to perceive them: this was a degree of precision that could not be achieved in painting.

The initial enthusiasm about the "pictures that painted themselves" gave way to the criticism that they could do no more than depict lifeless objects in a soulless fashion. For this reason, many relegated

········1900—Sigmund Freud publishes *The Interpretation of Dreams* ·················· **1931**—Completion of the Empire State Building··· **PHOTOGRAPHY** 156/157

·········· **1914–1918**—First World War··········

1919—Formation of the Bauhaus school ·········

1898–1967 René Magritte **1910–1962 Franz Kline** **1922–2011 Lucian Freud**

photography to the role of an aid for the improvement of drawings. In 1859, Charles Baudelaire took an unambiguous stand: "It [photography] should be the humble servant of science and art, like printing and shorthand, which have not created or replaced literature, either."

Eugène Delacroix (1798–1863) used photography as just such a "humble servant": together with the photographer Eugène Durieu (1800–74), he took photographs of male and female models (fig. above right), from which he later drew. Delacroix was responsible for the composition, while Durieu was responsible for the photographic technique. *Odalisque,* of 1857, is one of the paintings based on this collaboration

(fig. above left). "I look at these photographs of nude people with passion and without fatigue …" said Delacroix, who did not ascribe artistic potential to photography itself, however.

"From this day onwards, painting is dead!" declared the French painter Paul Delaroche when he heard of Daguerre's process. Delaroche was not the only person to raise this concern, and yet soon after news of Daguerre's process had spread, a French newspaper opined that "You will recognize how far crayon and paintbrush are removed from the truth of the Daguerreotype. But those who draw and paint need not despair; M. Daguerre's results differ from theirs, and cannot, in many respects, replace them." The author of this article was right: despite the fact that photography was faster and more precise than painting with respect to the most faithful reproduction of nature possible (to which painting had aspired since the Renaissance), photography was not able to displace painting.

It was precisely because of photography that painting gained the freedom and the mission to concentrate

above left——**Eugène Delacroix, Odalisque** | 1857 | oil on canvas 38.5 x 30 cm | Niarchos Collection.

above right——**Eugène Durieu, Female Nude** | 1853/54 | salt print 14 x 9.5 cm | Bibliothèque nationale de France | Paris.

1939–1945—Second World War ············· **1948**—Founding of the State of Israel ······································· **1969**—Neil Armstrong lands on the Moon ·······
··· **1949**—Founding of the Federal Republic of Germany ································

b. 1932 Gerhard Richter **b. 1938 Georg Baselitz** **b. 1960 Walton Ford**

on other subjects and on other forms of representation. Painters started to concern themselves with their own emotional worlds, and experimented with new approaches to color, which remained unconvincing in photography for many years, despite concerted efforts and gradual improvement. And so it is perhaps no coincidence that Impressionism developed during this period. It is interesting to note that the first exhibition of the Impressionists was held in the atelier of the Parisian photographer Nadar in 1874. Nowadays, photography is well established as an independent art form. And the use of photographs as a starting point for paintings is no longer frowned upon. Andy Warhol (1928–87), Gottfried Helnwein (1948–), David Hockney (1937–) and many others make use of them in their art in a wide variety of

ways. Gerhard Richter (1932–) may be the most famous painter whose paintings can often be traced back to photographs. He uses press photos as well as photographs he has taken himself for his large-scale paintings. Richter transforms the photographs through the very act of enlarging them, thus making them slightly blurry, and lending them a very distinct aesthetic and a special aura (fig. p. 159).

right——**GERHARD RICHTER, MOTOR BOAT (1ST VERSION)** | 1965
oil on canvas | 170 x 170 cm | Galerie Neue Meister | Staatliche Kunst-
sammlungen | Dresden.

.............**1984**—The Apple Macintosh is introduced .. **2008**—Beginning of the Global Financial Crisis··· **PHOTOGRAPHY** 158/159

..**1989**—Fall of the Berlin Wall ...

..**2001**—Terrorist attacks on World Trade Center (9/11)

b. 1974 Anri Sala

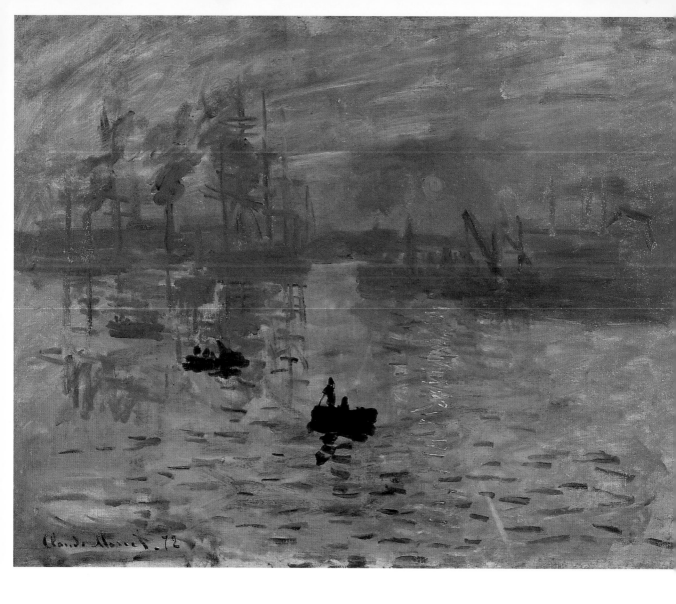

1832–1883 Édouard Manet 1840–1926 Claude Monet 1841–1919 Auguste Renoir

IMPRESSIONISM

"One day, one of us ran out of black—and so Impressionism was born." Auguste Renoir's casual remark about the birth of Impressionism certainly has a kernel of truth, and yet this is not precisely how it came about.

In the 18th century, Salons—the official art exhibitions of the Académie Royale—were held every year in Paris. As the selection criteria for these exhibitions were very conservative, the number of rejected paintings grew continuously. In 1863, the Salon des Refusés was set up, allowing rejected artists to exhibit their work; some private art schools at the time propagated a more modern style than the Royal Academy. In 1874, an exhibition was held in the atelier of the Parisian photographer Nadar. It was met with comprehensive rejection by the critics, but also marked the beginning of a monumental change. It was the first exhibition to take place without an official jury. Auguste Renoir (1841–1919), Edgar Degas (1834–1917), Camille Pissarro (1831–1903), and many others took part. It was here that Claude Monet

(1840–1926) showed a painting created in 1872, which was met with widespread derision among the critics: *Impression, Sunrise* (fig. p. 160). The painting greatly enraged the critic Leroy. His agitated statements certainly had consequences, but not the consequences he must have imagined. "Impression: I was certain of it. There had to be impression in it. And what freedom, what audacity in its execution! Wallpaper in its embryonic state is more carefully made than this painting!" What had discomposed Leroy to this degree? All that can be seen in Monet's painting is a hazy view of a harbor at sunrise, which looks as though one were peering at it through scrunched-up eyes. This in itself was like a slap in the face for a conservative critic. Not one of the elements that was considered to constitute a good painting according to academic rules was to be seen here. The painting consists of individual dots and lines of color, which appear to have been placed next to one another arbitrarily. The precise drawing that was so important to the dominant academic style did not play a role here. Contour and surface were suspended in favor of optical appeal. And the subject was not a proper subject, either, because Monet was not painting a religious, mythological, or in some other way edifying scene. But Monet was not interested in such things. To him, it was important to commit spontaneous impressions to the canvas. And he was successful in doing so with

left——CLAUDE MONET, IMPRESSION, SUNRISE [IMPRESSION, SOLEIL LEVANT] | 1872 | oil on canvas | 48 x 63 cm | Musée Marmottan Monet | Paris.

1849—Death of Chopin ... **1857–1859**—First world economic crisis ...

1853–1856—Crimean War ... **1861–1865**—American Civil War ...

1848–1894 Gustave Caillebotte **1859–1891 Georges Seurat** **1864–1901 Henri de Toulouse-Lautrec**

the methods we see here. In Monet's painting, things are depicted in a blurred way because his real subject was the light, air and, more than anything else, the atmosphere. He wanted to capture this moment of a sunrise on a hazy morning in Le Havre. The painting was originally titled *Harbor of Le Havre*. Because Edmond Renoir, brother of Auguste Renoir, considered the title to be too lacking in expressive power for the catalogue, Monet said: "Why don't you write *Impression, Sunrise*." In subsequent exhibitions the group referred to themselves as the "Impressionists" after this painting, not least to cause some irritation to their great critic Leroy.

One would be justified in claiming that the work of the Impressionists brought about one of the most important developmental steps in the history of art. Pointillism, Cubism, Futurism, and finally abstract painting were built upon this foundation. Today, the paintings of Monet, Renoir, and the other Impressionists are among the most popular paintings in museums, and among the most expensive at auctions. However, the beginnings of Impressionism did not indicate that it would be such a success story.

An apparently insignificant invention played a not insignificant part in the development of Impressionist painting. John Goffe Rand (1801–73), an American painter working in London, was tired of his paint drying up so quickly when he was not using it. He

had the idea of putting the paint into zinc tubes, and thus invented the paint tube in 1841. This innovation gave painters the ability to paint outdoors and to close their paint tubes when they were not using them to stop them from drying up. Renoir had his own theory about this, too: "The paint tubes have allowed us to paint in the open air. Without them, there would have been no Cézanne or Manet, no Sisley, and no Pissarro. There would, in other words, have been no Impressionism." This was accompanied by a new form of paintbrush. While it had been common practice to manufacture round paintbrushes, the idea now emerged of attaching the bristles in a flat arrangement. This paintbrush shape allowed artists to apply paint to the canvas in short, strong strokes, typical of many Impressionist painters. Auguste Renoir was one of the first Impressionists. In 1876 he created the painting *Dance at Le Moulin de la Galette* (fig. p. 163), one of the key works of Impressionism. The Moulin de la Galette was an establishment very close to his atelier, and so he could carry the canvas there time and again in order to paint it *in situ*. Most of those depicted are Renoir's friends and acquaintances. It is a luminous painting that draws its charm from the joyful group of people and, primarily, from the flickering play of light and shadow, with which Renoir captured the atmosphere of a summer afternoon superbly. The critic Georges

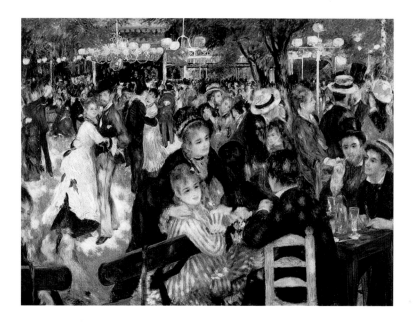

Rivière, who is also shown as a member of the group at the table, wrote about this painting: "This is a history painting [...] nobody in the past would ever have considered representing a random everyday scene on such a large canvas." And it is true that this was one of the Impressionists' innovations: leisure time became a subject of art for the first time, and its depiction gave the content of Impressionist paintings a light, joyful tone, too.

In 1877, Renoir invited Gustave Caillebotte (1848–94) to take part in the third Impressionist exhibition. Caillebotte had until then worked for the Impressionists in a supporting role. As a result of the early death of his wealthy parents, the trained lawyer was financially independent and supported his friends by frequently paying for their materials and the rent for their ateliers. Most importantly, however, he bought many of their paintings. His collection would later form the foundation of the Impressionist collection of the Musée d'Orsay in Paris. His own enormous

painting *Paris Street, Rainy Day* (fig. p. 164) was the main attraction at the exhibition of 1877, although a critic remarked: "Monsieur Caillebotte is an Impressionist in name only," because everything that had characterized the Impressionist painting style until then is not to be found in this painting. Caillebotte shows people strolling along the boulevards of modern Paris. The critic looked in vain for the typically spontaneous and easy style. Caillebotte depicts the scene in great detail and had prepared the painting with numerous studies. The snapshot feeling of the painting is both modern and Impressionistic, and in this way Caillebotte positioned everyday haphazardness on the same level as academic art through his detailed painting style. The idea of the moment, which characterizes Impressionism, is further accentuated here. It prompted Émile Zola to judge that Caillebotte was the most courageous of the Impressionists because he showed the truth as it was. Georges Seurat (1859–91), on the other hand, did not. He was interested in the scientific foundations of painting, and he was particularly interested in color. The Impressionists had long worked with simultaneous contrasting and complementary colors and they were certainly aware of the fact that the inherent colors of objects are not constant but are in fact dependent upon light, air, and the environment. Seurat wanted to find a scientific foundation for this

left——**CLAUDE MONET, POPPIES AT ARGENTEUIL** | 1873 | oil on canvas 50 x 65 cm | Musée d'Orsay | Paris.
above——**AUGUSTE RENOIR, DANCE AT LE MOULIN DE LA GALETTE** [**BAL AU MOULIN DE LA GALETTE**] | 1876 | oil on canvas | 131 x 175 cm Musée d'Orsay | Paris.

1886—Completion of the Statue of Liberty .. 1900—Sigmund Freud publishes *The Interpretation of Dreams*

1889—Completion of the Eiffel Tower ..

1884–1950 Max Beckmann 1887–1968 Marcel Duchamp 1899–1968 Lucio Fontana

"Georges Seurat developed the method of Divisionism, in which he positioned pure colors in tiny dots next to one another."

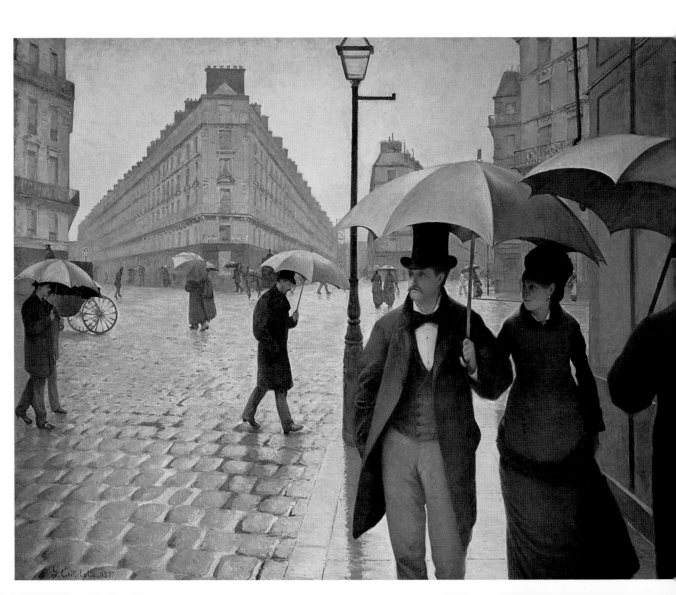

1904–1989 Salvador Dalí 1910–1962 Franz Kline 1917–2009 Andrew Wyeth

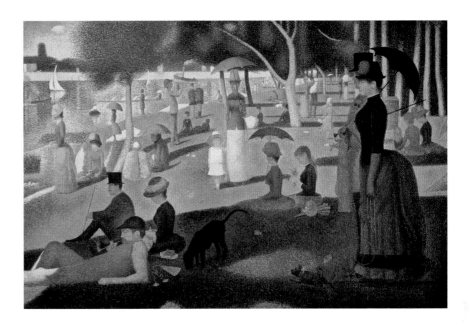

realization. He developed the method of Divisionism, also known as Pointillism or Neo-Impressionism, in which he positioned pure colors in tiny dots next to one another in the hope that this would make them appear even more radiant. *A Sunday Afternoon on the Island of La Grande Jatte* of 1884 (fig. above) should therefore also be regarded as a programmatic painting, with which Seurat wanted to create a pictorial corroboration of his method. In 1886, Camille Pissarro invited Seurat to take part in the last Impressionist exhibition. This time, however, the harsh criticism came from within. Monet and Renoir were strongly opposed to Seurat's participation because in this painting the freedoms they had fought for were again subjugated to a strict form, and because none of the liveliness that characterizes their work remains in Seurat's painting. Edgar Degas spoke of "poorly assembled wax figures" in this context. It was said

that there was no subjective feeling, no temperament, and no individual signature in this "confetti painting." Pissaro insisted on Seurat's inclusion, whereupon Monet and Renoir withdrew their paintings. And so the last exhibition of the Impressionists, who had revolutionized art, was held without the painter whose painting had given this style its name.

left—**Gustave Caillebotte, Paris Street, Rainy Day [Rue de Paris, temps de pluie]** | 1877 | oil on canvas | 212.2 x 276.2 cm | Art Institute of Chicago | Chicago.
above—**Georges Seurat, A Sunday Afternoon on the Island of La Grande Jatte [Un Dimanche après-midi à l'Île de la Grande Jatte]** | 1884–86 | oil on canvas | 207.5 x 308.1 cm | Art Institute of Chicago | Chicago.

1848—Marx and Engels publish *The Communist Manifesto*
1857–1859—First world economic crisis
1861–1865—American Civil War

166/167

1839–1906 Paul Cézanne 1840–1926 Claude Monet 1866–1944 Wassily Kandinsky

ABSTRACT PAINTING

Today abstract painting has become considered "normal." At the beginning of the 20th century, however, creating a painting without a recognizable subject would have been unthinkable. Any painter doing so would have been accused of charlatanism.

Until then, painting had been tied to the concrete, although it was simultaneously moving further and further away from the traditions of painting. The Impressionists liberated it from "important" subject matter and their successors, such as Paul Gauguin (1848–1903) and Vincent van Gogh (1853–90), started to express their feelings in their paintings. Gauguin also asked the trend-setting question "Why should we not be able to create color-harmonies that correspond to our emotional states?" At this time, it would have been unthinkable just to start painting in any old way. While artists were tied to concrete objects, however, they could not make progress—and painting was not at liberty to conquer new ground.

The Russian Wassily Kandinsky (1866–1944) dealt with these questions in depth, but from a different angle. He was not so much concerned with expressing his feelings, but wanted instead to elicit feelings from the viewer in the same way that music can. During a performance of Richard Wagner's opera *Lohengrin*, he formulated his aim: his painting was to be like music, and should trigger emotions in its viewers as music does in its listeners: "I could see all of my colors, I became aware of the fact that painting has the same power as music." In other words, Kandinsky knew what he wanted, but did not know exactly how he could achieve this goal. Another experience put him on the right track: he saw Claude Monet's (1840–1926) haystack paintings (fig. p. 168) in an exhibition of works by the Impressionists. At first, he did not actually recognize the subject depicted, but was fascinated by the way in which it had been painted. Monet's painting style made the object itself uninteresting to him.

Kandinsky did not become a painter until the age of 30, having graduated from his degree in law. In 1896, he went to Munich to study with Franz von Stuck (1863–1928) and came to know the painting of the Fauves in Paris (see also *Cubism*, pp. 172–179). In their work, too, the focus was on color rather than the subject itself. But Kandinsky felt that even the Fauves did not go far enough. He thought that his aim—to touch the viewer's soul, to "make it resonate"—could not be achieved with their methods. He

left——KASIMIR MALEVICH, BLACK SQUARE ON A WHITE GROUND | 1915 oil on canvas | 79.5 x 79.5 cm | Tretyakov Gallery | Moscow.

was convinced that the only way to do this was to use the "physical power of color."

In 1908, Kandinsky moved to Murnau, where he lived and worked together with his former student Gabriele Münter (1877–1962). It was here that he brought together the experiences and influences he had gathered over the course of the previous years: Impressionism, which gave a new function and freedom to color, and the two-dimensionality and simplification of objects that he had seen in the work of the Fauves in the group surrounding Matisse (1869–1954) in Paris. Kandinsky also remembered the ornamental iconography of his native land of Russia.

A coincidence was helpful to Kandinsky during his period of searching: one evening, he walked into his atelier and saw a painting that he did not recognize, and was delighted by it. He saw only colors and shapes, which appeared to be "saturated by an inner glow." He immediately realized that he had found the solution here: in order to speak to the soul and turn painting into something that was equal to music, he had to relinquish nature as his model. Painting had to be liberated from the object and become independent. As he approached the extraordinary painting, he realized that it was one of his own, which had been placed the wrong way up. In his painting, Kandinsky detached himself increasingly from the world of objects, and created his own poetry of lines and colors. With his painting *First Abstract Watercolor*, created in 1910, Kandinsky finally overcame a boundary that had until then seemed insurmountable (fig. p. 169).

The Russian Kasimir Malevich (1878–1935), too, was fascinated by the metaphysical power of color. He was influenced both by the Fauves and by Cubism and its reduction of shapes to geometric elements. Malevich wanted to liberate art from the "ballast of the concrete world." In 1913, he founded a new painting style called Suprematism. It was supposed to express the primacy of new art over tradition, while restricting itself to "purely painterly" forms. The artist was to concentrate on geometric shapes such as squares, rectangles, triangles, and circles, painting them with primary colors. Malevich's most radical painting, and one of the most famous artworks of the 20th century, is *Black Square on a White Ground*, which he first showed at the "Last Futurist Exhibition: 0,10" in Saint Petersburg (fig. p. 166).

above—**Claude Monet, Haystacks in the Sunlight** | 1891 oil on canvas | 73 x 92 | 5 cm | Museum of Fine Arts | Boston
right—**Wassily Kandinsky, First Abstract Watercolor** | 1910 pencil | ink | watercolor on paper | 49.6 x 64.8 cm | Musée National d'Art Moderne | Centre Georges Pompidou | Paris.

1905—Formation of the expressionist group Die Brücke

1941—Pearl Harbor attack··· ABSTRACT PAINTING **168/169**

1914–1918—First World War

1939–1945—Second World War

1910–1962 Franz Kline

b. 1931 Bridget Riley

b. 1937 David Hockney

"Kandinsky wanted paintings to be like music, to make it resonate the soul of the viewer."

1949—Founding of the Federal Republic of Germany ················· **1961**—Construction of the Berlin Wall ··
··· **1968**—Assassination of Martin Luther King ······························
··· **1969**—Neil Armstrong lands on the Moon ·············

b. 1958 Julian Opie **b. 1960 Walton Ford**

The positioning in a corner just below the ceiling of the exhibition room alone made the viewer think of icons, which were hung in exactly the same way in homes. Malevich himself claimed that "I have painted the naked icon of my time." His art and his art theory, which he recorded in 1915 in his manifesto, *From Cubism to Suprematism*, form the foundation of the artistic styles based on geometry that would develop later in the 20th century.

While Kandinsky tried to evoke emotions with his paintings, Malevich was interested in content-related problems. The Dutchman Piet Mondrian (1872–1944) posed structural questions in his art. He, too, used Cubism as a reference and reduced his pictorial elements in several developmental steps, until he reached the pictorial constructions for which he is known nowadays (fig. above left). Mondrian constructed them with the elemental contrasts of color

and form. The primary colors red, blue, and yellow, as well as the "non-colors" black, white, and gray were put in a grid made up of verticals and horizontals. To prevent any association with objects and spatial illusion, he divided the rectangular areas of color with black lines, which provided the basic pattern for his paintings. Mondrian wanted to reduce painting to its "zero-point" and permit nothing natural or individual anymore. The complex art theory behind his paintings is often overlooked because of the decorative power of his art, however. It is no coincidence that Yves Saint Laurent (1936–2008) selected Mondrian's iconic constructions as a model for his clothes in 1965 (fig. p. 170 right).

After World War II, new impulses from the US were incorporated into abstract painting. Jackson Pollock (1912–56) established a new form of expression with his "Action Paintings" (see also *Action*

far left——**PIET MONDRIAN, COMPOSITION II WITH RED, BLUE AND YELLOW** | 1930 | oil on canvas | 172.6 x 54 cm | Christie's Images Ltd. © 2012 Mondrian/Holtzman Trust c/o HCR International.

left——**MODEL IN "MODRIAN DRESS" (1965) BY YVES SAINT LAURENT**

above left——**FRANZ KLINE, WHITE FORMS** | 1955 | oil on canvas 188.9 x 127.6 cm | Museum of Modern Art | New York.

above right——**BRIDGET RILEY, FALL** | 1963 | acrylic on hardboard 141 x 140 cm | Tate Modern | London.

Painting, pp. 186–191). His art was also referred to as "Abstract Expressionism," which was an inspiration to many artists in many different ways.

Franz Kline (1910–62) was one of the protagonists of Abstract Expressionism. His most important artworks are large paintings that use only black and white. Large forms take shape on the canvas through powerful brushstrokes. Kline did not want to express himself in his art as Pollock did, but wanted to establish a relationship with the viewer. The paintings are reminiscent of Japanese calligraphy, but are nothing but form. In the painting reproduced here, one first sees broad, black lines on a white canvas (fig. above left), but the title is *White Forms*. If one considers the title and looks at the painting again, one senses that the white forms push themselves into the foreground while the black shapes form the ground. The painting is reversed. "I paint the white just as I paint the black, and the white is equally important," Kline himself said, playing with the audience's viewing habits, partly with the help of the painting's title, in this work of art.

The paintings of British artist Bridget Riley (1931–) are confusing in a different way. Riley experiments with lines and surfaces and creates optical frequencies that appear to make the painting vibrate through the highly accurate painting technique, with nothing but black lines on a white ground: the viewer's every movement makes the painting "move" (fig. above right). "I try to organize a field of visual energy that accumulates until it reaches maximum tension," Riley says about her work. Riley is a so-called "Op art" artist, experimenting with effects that cause optical illusions. One could almost say that it is a modern form of the Dutch trompe-l'œil painting of the 17th century.

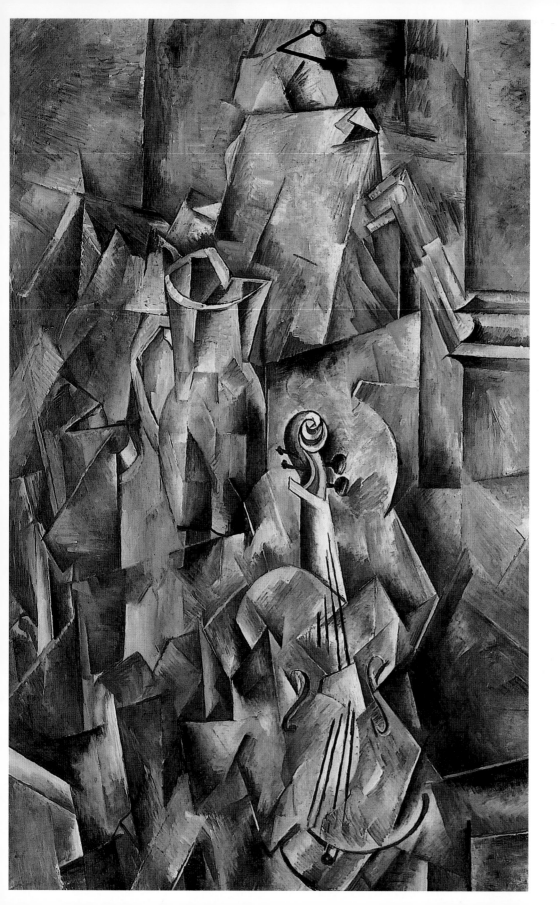

1879–1935 Kasimir Malevich 1881–1973 Pablo Picasso

CUBISM

At the end of the 19th century, painting was "liberated" from what had until then been its most important task the accurate depiction of nature. This function was now fulfilled by photography. The fear that photography might come to replace painting was unfounded. Painting stepped up to the challenge and adopted a new approach to the problems of artistic representation. How something was painted was considered more important than what was painted. The Impressionists had put an end to the rule that only important and noble subjects should be painted, and applied their minds to the use of color instead. The Pointillists in the circle around Georges Seurat (1859–91) focused on the scientific foundations of color. Paul Cézanne (1839–1906) attempted to combine the new freedom achieved by the ideas of the Impressionists with the clarity and solidity of classic painting. For him, the canvas was a two-dimensional surface that he covered with his colors and forms, splintered into their component parts, thus putting an end to the illusion of three-dimensionality. According to him, painting did not have to recreate nature; for Cézanne art was "a harmony parallel to

nature." During his lifetime, Cézanne's painting was understood only by few, and his fellow-artist Camille Pissarro (1830–1903) feared that "... centuries would pass before one takes account of it." But this fear was, it transpired, baseless. In 1907, a year after Cézanne's death, a big retrospective of his work was held in Paris, and it was a great success. Many, including a large number of his young colleagues, were fascinated by Cézanne's approach. Two young painters in particular took his ideas several steps further: Georges Braque and Pablo Picasso.

Georges Braque (1882–1963) was at this time a member of the Fauves, or "wild ones." This group, centred around Henri Matisse (1869–1954), created paintings in bright colors, which the artists applied to their canvases in large sections, without concern for perspective. After he had seen the big Cézanne retrospective in 1907, Braque's painting style changed. In the summer of 1908, he painted in the southern French village of L'Estaque, where he had already created Fauvist paintings in 1906 (fig. p. 174). But these new paintings had an entirely different character. When he wanted to exhibit these landscapes in the autumn salon in Paris, they were rejected. However, Daniel-Henry Kahnweiler (1884–1979), a young gallery owner from Germany, took charge of them. He showed these paintings, including *Houses and Tree* (fig. p. 175), in the gallery in Paris, which he had

left——**GEORGES BRAQUE, VIOLIN AND PITCHER** | 1909/10 | oil on canvas
117 x 73.5 cm | Kunstmuseum Basel.

1883—Friedrich Nietzsche publishes *Thus Spoke Zarathustra* 1887—First Sherlock Holmes novel is published

1884—Mark Twain publishes the *Adventures of Huckleberry Finn* 1889—Completion of the Eiffel Tower ...

1882–1963 Georges Braque **1885–1941 Robert Delaunay** **1887–1927 Juan Gris**

opened in 1907 and where he had already exhibited artworks by Picasso.

The painting is a plain-looking landscape with a very muted color scheme, making it quite different from Braque's colorful Fauvist paintings. It may look innocuous, but it could be said to contain the seeds of the greatest revolution in art since Brunelleschi and Masaccio had introduced central perspective. Henri Matisse, one of the members of the jury for the autumn salon, noticed the "small cubes," and the critic Louis Vauxcelles (1870–1943) declared that Braque "disregards form and reduces everything, places, people and buildings, to geometric schemata, to cubes."

It is certainly true that each of the pictorial elements is reduced to what is essential: a house is transformed into a cube, the roof becomes a pyramid, and the tree is made of several cylindrical shapes. Braque dispensed with all details such as leaves, windows, and doors for the sake of clarity of the geometric shapes. The objects are therefore not only formally reduced, but also robbed of their practical functions and characteristics. The concentration on form is amplified by the reduction in color. The color palette of the former Fauve Braque now featured only muted colors such as ocher, brown, and green. Here, color was no longer tasked with the description of the materiality of objects, as had been the case until then. Instead, it now

served to emphasize form. The painting *Houses and Tree* marks the beginning of Cubism, and its reverse was even inscribed with the words "Rejected by the Salon d'Automne, the first painting to be described by the painter Matisse, member of the jury of the salon, as 'Cubist'."

Pablo Picasso (1881–1973), too, was searching for new forms of representation, and had been working on a painting since the autumn of 1906 that, like Braque's paintings of this period, would demonstrate the new direction he would take. A group portrait, *Les Demoiselles d'Avignon* (fig. p. 176) has a traditional subject. But what Picasso made of it marked a radical departure from traditional forms of representation. The name of the painting came from a friend of Picasso's and refers to the Carrer d'Avinyó in Barcelona, a street on which there were several brothels. The painting features five female nudes in two groups, assembled in front of and between two curtains. Picasso reduced the form and brightness of color here too, and the illusionistic pictorial space is no longer relevant. The bodies, in different positions, are partially abstracted, and the color is reduced to a few shades. Picasso struggled with this painting for a long time: more than 800 preparatory studies and drawings are known to have been made.

Braque's *Houses and Tree* and Picasso's *Les Demoiselles d'Avignon* were in some respects the starting

1892—Premiere of *The Nutcracker* ··· CUBISM 174/175

1895—Discovery of X-rays ···

points for an artistic adventure. The two artists, though they approached it from very different directions, developed a strange symbiosis from what both of them had already begun on their own. The new art style was called Cubism. They increased the plasticity of objects through the radical simplification of all pictorial elements. Illusionistic pictorial space was abandoned, and the two-dimensionality of the canvas was emphasized.

Beginning in 1909 Braque and Picasso took the next step. Once objects had been reduced to their basic geometric elements, the painters also abandoned the notion of a fixed viewpoint in relation to the object, and essentially walked around it while painting: they showed objects simultaneously from different angles. Although the first Cubist paintings were landscapes, the still life was found to be the ideal experimental area for Cubism because it allowed ideas to be implemented and developed under controlled conditions. Braque and Picasso often chose easily recognizable objects, such as musical instruments, whose shapes were known to the viewer, as subjects. During the early stages, this was the only way that they could make their paintings comprehensible. In *Violin and Pitcher,* painted in 1909/10, Braque demonstrates the process in textbook fashion (fig. p. 172).

Although the violin in Braque's painting is clearly recognizable, it has in fact been taken apart into its various component parts: the spiral of the pegbox is shown in profile while the sound holes have been

left——**Georges Braque, Paysage de L'Estaque [Landscape at L'Estaque]** | 1906 | oil on canvas | 59 x 72,4 cm | Musée d' Orsay | Paris.
above——**Georges Braque, Maisons et arbre [Houses and Tree]** 1908 | oil on canvas | 40.5 x 32.5 cm | Musée d'Art Moderne | Villeneuve d'Ascq.

1896—First modern Olympic Games ·· **1900**—Beginning of the Boxer Rebellion in China ··

·· **1903**—First powered flight by the Wright brothers··

1898–1967 René Magritte **1899–1968 Lucio Fontana**

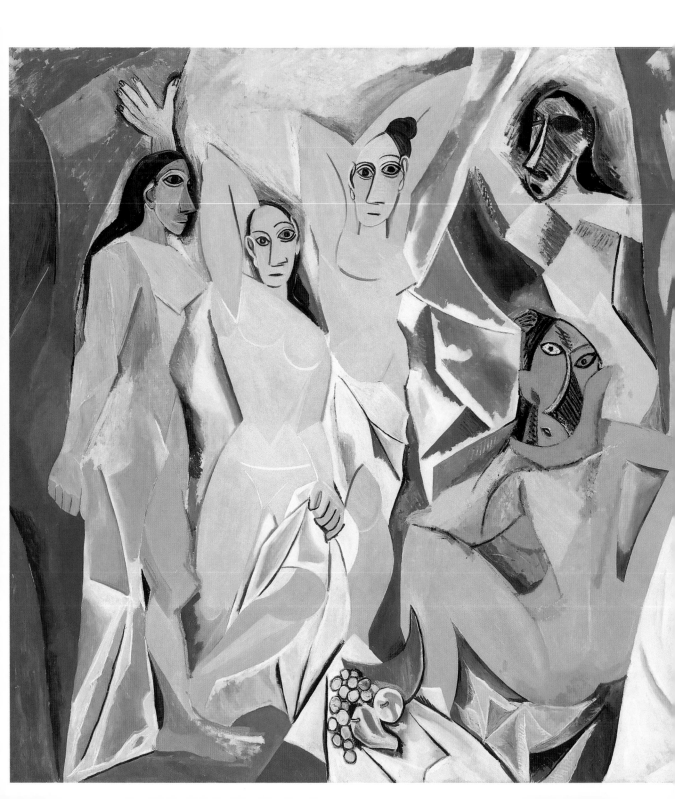

1904–1989 Salvador Dalí 1907–1954 Frida Kahlo 1910–1962 Franz Kline

depicted from the front. Different facets of the body of the violin are shown from different sides. There is a pitcher to the left of the violin. This, too, appears to have been disassembled into its individual parts. All of the objects have been chopped up and therefore look as though they are interwoven with the room itself, so that one can no longer detect a boundary between the foreground and the background, or between the objects and the room they are in. In this phase of Cubism, known as Analytical Cubism, the focus is on the penetration of bodies and spaces, as well as on the simultaneous depiction of different sides of objects. This is supplemented by the reduction of color, almost to the point of being monochrome, which negates the materiality of the objects. This gave rise to a paradox: on the one hand, Analytical Cubism eschews the simulation of three-dimensionality, and on the other hand, it reveals an enhanced spatiality through the reduced form of the pictorial elements. Only a nail, which casts a trompe-l'œil-style shadow in *Violin and Pitcher*, is reminiscent of the traditional, illusionistic painting style.

The viewer was thus faced with an entirely new challenge. While it had in the past been possible to recognize the erotic nature of a representation of Venus even without any knowledge of mythological characters, the viewer now had to learn to understand the thought processes of the painter in order to decode the painting.

Braque and Picasso engaged in a unique form of collaboration during this period. This was encouraged by the visionary owner of the gallery that displayed their paintings, Daniel-Henry Kahnweiler, who agreed to take everything they produced. This allowed them to concentrate on their ideas. The two artists' styles converged so closely that one can barely discern which painting was painted by whom, a matter further complicated by the fact that they sometimes failed to sign them. Braque described this period as follows: "Picasso and I said things to each other that nobody will ever say to anybody else again; things that nobody could possibly say again; that nobody could understand anymore [...] things that would be incomprehensible and that gave us so much pleasure [...] and it will end with us [...] It was a little bit like being roped together in the mountains."

But it was not over yet, for in 1912 Picasso and Braque were to transcend the traditional boundaries of painting. They stuck materials such as pieces of wallpaper, playing cards, and newspaper cuttings onto their

left——PABLO PICASSO, LES DEMOISELLES D'AVIGNON | 1906/07
oil on canvas | 244 x 234 cm | Museum of Modern Art | New York.

paintings and in this way created the first collages (French: *coller*, to stick) in the history of art. This step had a significant impact on the appearance and function of painting in the art of the 20th century. The phase that followed Analytical Cubism is called Synthetic Cubism.

Materiality, which had been pushed entirely to one side in Analytical Cubism, was reintroduced in Synthetic Cubism, and this was done even more realistically than if it had been painted: it was real. Picasso's *Still Life with Chair Caning* (fig. above) of 1912 is one of the first collages. The chair is not painted in a realistic manner, but its caning is inserted directly into the painting and is thus even more realistic than would have been possible through painting alone. In this way, the painting not only represents the object, but becomes the object itself. Picasso supplemented it with a Cubist still life and encircled the entire paint-

ing with a piece of string. In addition to being part of the painting, the string is its frame, emphasizing the painting's status as an object.

There is another important aspect: painting, which had been described since the Renaissance as a view through a window, and in which the action could be described as taking place in the illusionistic space behind the pictorial surface, was "inverted" here. The canvas became the foundation from which the painting develops forwards, or towards the viewer. The painting's surface is therefore located behind the objects. In Juan Gris's (1887–1927) *Still Life with Bordeaux Bottles*, painted in 1915, this paradigm shift can be easily recognized (fig. left). The background is a picture frame upon which a tabletop, a newspaper fragment, and a wine bottle move from the canvas towards the viewer.

Painters such as Juan Gris, Fernand Léger (1881–1955) and Robert Delaunay (1885–1941), who subscribed to

1917–2009 Andrew Wyeth 1922–2011 Richard Hamilton 1923–1997 Roy Lichtenstein

Picasso and Braque's ideas, provided new lifeblood. Color was assigned a more important role once again, and with it the materiality of objects, almost entirely abandoned during the Analytical phase, was reintroduced.

The continuous dissolution of the object, which is virtually unrecognizable in some of the paintings, borders on abstraction in some cases. And a stream of abstract painting did indeed develop from the ideas of the Cubists. Braque and Picasso always remained loyal to figurative painting as it was only the figurative that allowed them to achieve this dissolution of form and their manipulation of space and object. How they manipulated the figurative was new, however. Braque put it like this: "Writing does not mean describing, and painting does not mean copying."

left——PABLO PICASSO, STILL LIFE WITH CHAIR CANING [NATURE MORTE À LA CHAISE CANNÉE] | 1912 | oil, oil cloth and paper on canvas surrounded by string | 29 x 37 cm | Musée Picasso | Paris.
above——JUAN GRIS, STILL LIFE WITH BORDEAUX BOTTLES | 1915 | oil on canvas | 50 x 61 cm | Pinakothek der Moderne | Munich.

1883—First petrol-engined automobile

1886—Completion of the Statue of Liberty

1889—Completion of the Eiffel Tower

180/181

1882–1916 Umberto Boccioni

1887–1968 Marcel Duchamp

FUTURISM

"We declare that the splendor of the world has been enriched by a new beauty: the beauty of speed. A racing automobile with its steel body adorned with thick tubes like serpents with explosive breath [...] a roaring motor car which seems to run on machine-gun fire, is more beautiful than the Victory of Samothrace." The *Futurist Manifesto*, published in the Parisian newspaper *Le Figaro* on February 20, 1909 by the Italian poet Filippo Tommaso Marinetti (1876–1944), is studded with this and similar declarations. Belief in the future and enthusiasm for technology are the cornerstones of this manifesto, which polemically and aggressively opposes all forms of tradition and culture rooted in the past. The movement of Futurism was to affect all areas of cultural life, not just poetry but also theater, music, fashion and, later, even the Church—not to mention painting, of course. For Marinetti, museums were "graveyards [...] public dormitories in which one sleeps forever beside hated and unknown creatures." He went on to describe them as "absurd abattoirs of painters and sculptors, who butcher one another wildly with colors and lines along the contested exhibition walls." Marinetti's martial theses culminate in the statement "We want to glorify war—the sole hygiene of the world." This manifesto clearly had an impact on the Italian painter Umberto Boccioni (1882–1916). He met Marinetti in 1909 and was infected by the latter's enthusiasm. Boccioni and his fellow painters Giacomo Balla (1871–1958), Gino Severini (1883–1966), and Carlo Carrà (1881–1966) put together the *Manifesto of Futurist Painting*, which was proclaimed on February 11, 1910, in a theater in Turin. It is just as polemic and provocative as Marinetti's founding Futurist manifesto: "We rebel against the blind admiration of old paintings and against the enthusiasm for all that is worm-eaten, dirty, and corroded by time." This was followed in April 1910 by the *Technical Manifesto of Futurist Painting*, which describes its most important point: universal plastic dynamism. "Plastic dynamism is the simultaneous action of the motion characteristic of an object (absolute motion), and the transformation undergone by the object in relation to its mobile and immobile environment (relative motion)." Boccioni, who was the driving force behind this manifesto, assumes that the materiality and form of bodies and objects is deformed and destroyed by light and movement. Visions of lines, light, and color were to be created in these paintings. Optical sensation was the starting point. Modern technology, speed,

left——UMBERTO BOCCIONI, RIOT IN THE GALLERY [RISSA IN GALLERIA] 1910 | oil on canvas | 76 x 64 cm | Pinacoteca di Brera | Milan.

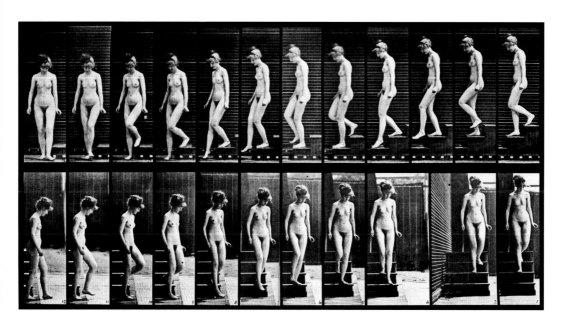

noise, and agitation are the subjects of Futurist painting. In contrast to Velázquez, the Futurists did not want to show the illusion of movement, but the movements and dynamisms themselves. Painting titles such as *Speeding Train*, *The Street Enters the House*, and *The City Rises* set the tone. The first programmatic painting was created by Umberto Boccioni and its title is typical of Futurist painting: *Riot in the Gallery* (1910) (fig. p. 180). It depicts a fistfight between two women in a gallery in Milan, and the excited mob that rushes towards them. The real subject is not so much the fistfight, but rather the sensation of movement and light. The crowd is represented in surges of movement leading diagonally from all sides towards the center of the action. Boccioni employs several strategies to heighten the feeling of agitation and the turbulence of the scene. The most obvious of these is the contrast between the confused movement of the crowd and the calm, vertically positioned walls. This contrast is amplified and strengthened by the depiction of light: the top is bathed in bright light, which is splintered and made to undulate in the lower part of the painting by the different groups and figures, their colorful clothes, and hard shadows. The people become arrows shooting towards the center of the painting, the fighting women. The space is still depicted in a traditional, illusionistic manner, while the diagonal composition contributes to the ampli-

fication of the dynamism. The painterly techniques draw on the Neo-Impressionism of Georges Seurat (1859–91) (see also *Impressionism*, pp. 160–165). The Futurist painters were also influenced by the photographic studies of movement of Étienne-Jules Marey and Eadweard Muybridge (both 1830–1904). These two photographers managed to record animals and humans in motion (fig. above), which made it possible to analyze the sequence of motions of people and situations (see also *Animals*, pp. 42–49). When the Futurists came into contact with Analytical Cubism in 1911, this had an immediate effect on their painting. They combined the Cubist multi-angle approach that had until then been applied primarily to still lifes and portraits with their feel for movement and dynamism. They brought together the states occupied at different times in one painting, while simultaneously permeating the objects with the inherent energies of their environments (fig. p. 185 right). Simultaneity and permeation are the key concepts that characterize Futurist art. In summary, one could say that Futurism feels like a more colorful version of an Analytical Cubism that has been expanded to include the dimension of time. How far removed and simultaneously close Futurist paintings are to Cubism can be seen in Boccioni's painting *Elasticity*, created in 1912 (fig. right). A galloping horse and its rider can only just be made out,

but one senses the propulsive power of the movement. The horse appears to be broken down cubistically into its component parts by the forces inherent in it and those exerted upon it. The dynamism that Boccioni and the Futurists wanted to show in their paintings was not the actual movement, as captured by chrono-photography, or its illusion. Instead, the Futurists wanted to show the forces exerted by the movement in and on bodies and their environments.

Futurist ideas spread rapidly throughout Europe's metropolises because of the prodigious activity of its protagonists. As painting was only one aspect of the Futurist program, Futurists having a wide variety of possible means of expression. And they created a stir wherever they appeared. It is said that theaters sold more tickets than there were available seats just to create agitation and movement in the audience. The first Futurist exhibition was held in Berlin in 1912. The "Blue Rider" Franz Marc (1880–1916) was among the visitors, and an increased dynamism can be detected in the paintings he created afterwards. In Russia, Futurist ideas were adopted with enthusiasm, and it was melded with Cubism to create what came to be known as Cubo-Futurism, which is characterized by the use of primarily geometric forms. In France, the art of the Futurists was considered to be a variation on Cubism, and little attention was paid to it. French artists, too, reacted to the ideas of Futurism, however: in 1912, Marcel Duchamp (1887–1968) created *Nude Descending a Staircase no. 2*, which was at first met with widespread rejection (fig. p. 184). Its relationship with Futurist ideas is immediately apparent, as is the connection to the photographic studies of motion of Marey and Muybridge. Duchamp's painting caused a sensation, in particular at the 1913 Armory Show in New York, the first large-scale exhibition of European avant-garde art in the US. There was a seemingly endless stream of negative reviews. One critic saw an "explosion in a shingle factory" in the painting, and a caricaturist used it as a model for a cartoon about the rush hour on New York's subway (fig. 185 left). Cubism, Kandinsky's abstract art, Malevich's Suprematism, and Futurism changed art for the viewer

left——**Eadweard Muybridge, Woman Walking Downstairs** | 1887 chronophotography from *The Human Figure in Motion*, 1901.
above——**Umberto Boccioni, Elasticity** | 1912 | oil on canvas 100 x 100 cm | Riccardo Jucker Collection | Museo del Novecento | Milan.

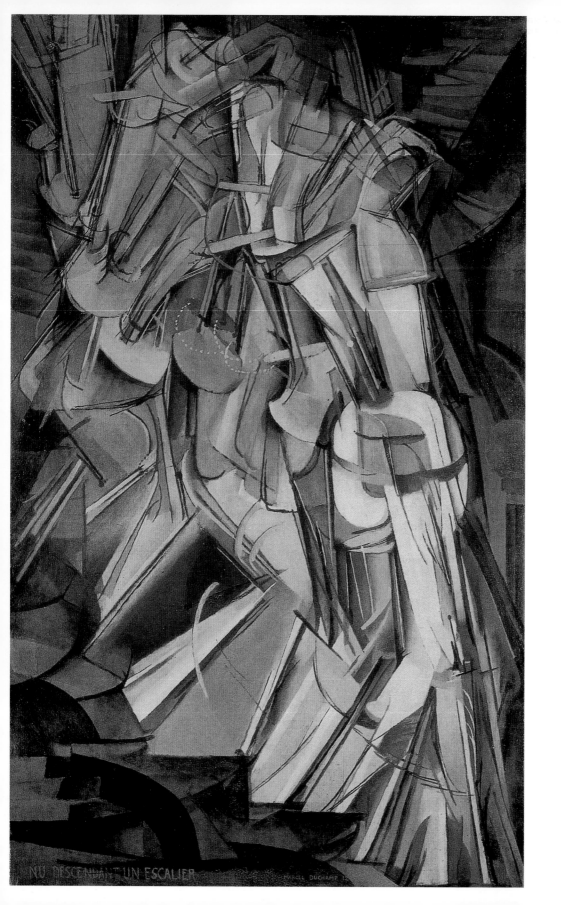

NU DESCENDANT UN ESCALIER MARCEL DUCHAMP 12

1911—Roald Amundsen reaches the South Pole ·· FUTURISM **184/185**

1912—Sinking of the *Titanic* ··

1914–1918—First World War ·· **1919**—Founding of the Weimar Republic ·······················

1910–1962 Franz Kline 1912–1956 Jackson Pollock 1917–2009 Andrew Wyeth

in that it forces us to think about the artist's ideas and concepts in order to decode and understand the paintings. Futurism considered itself to be more than an aesthetic concept. In fact, it believed itself to be a new world view, which differentiates it from other avant-garde concepts of this time. The formative period of Futurism ended with World War I. In 1916, Umberto Boccioni died as a result of a riding accident during a military exercise. The other protagonists moved on to new challenges. The original initiator of the Futurist movement, Filippo Tommaso Marinetti, became the minister of culture in Italy's Fascist government of 1933.

left——MARCEL DUCHAMP, NUDE DESCENDING A STAIRCASE NO. 2 [NU DESCENDANT UN ESCALIER NO. 2] | 1912 | oil on canvas 147 x 89 cm | Philadelphia Museum of Modern Art | Philadelphia.
above left——J.F. GRISWOLD, THE RUDE DESCENDING A STAIRCASE (RUSH-HOUR AT THE SUBWAY) | 1913 | published in *The New York Evening Sun*, March 20, 1913.
above right——LUIGI RUSSOLO, DYNAMISM OF AN AUTOMOBILE 1912/13 | oil on canvas | 104 x 140 cm | Musée national d'art moderne Centre Georges Pompidou | Paris.

1900—Beginning of the Boxer Rebellion in China 1909—Opening of Queensboro Bridge in New York 186/187

1903—First powered flight by the Wright brothers

1906—San Francisco earthquake

1904–1997 Willem de Kooning 1910–1962 Franz Kline 1912–1956 Jackson Pollock

ACTION PAINTING

The history of painting is dominated by European art. Although inspiration was taken from Japanese woodcuts *c.* 1900, and African tribal art made quite an impression, no significant influence on European art by non-European art took place. America's art, too, was largely irrelevant until the middle of the 20th century. The American public was exposed to the European avant-garde for the first time in 1913. Everything that was of importance in the contemporary art of Europe around the turn of the century was represented at the Armory Show: from the Impressionists to the Fauves, from van Gogh to Edvard Munch. The Cubist paintings of Braque and Picasso and Kandinsky's abstract improvisations in particular made a lasting impression on American painters. A large number of European artists emigrated to the US during World War II. Here, they met a new generation of artists who were searching for new ways and possibilities of artistic expression and who sought to emancipate themselves from the excessive European influence.

In the 1940s, a number of painters united by these aims gathered in New York. They were no longer satisfied with merely describing their feelings, but wanted instead to express them in as direct a manner as possible. They wanted to articulate themselves spontaneously and without being restricted by tradition. Franz Kline (1910–62; see also *Abstract Painting*, pp. 166–171), Willem de Kooning (1904–97) and Jackson Pollock (1912–56) were among the most important thinkers in this respect. This group did not form a homogenous movement, and there was no theoretical programme because the artists and their works were too different from one another for that. But all of them attempted to make completely new paintings.

In 1952, the critic Harold Rosenberg used the term "Abstract Expressionism" to give a collective label to the art of these painters. As they searched, they brought together two important streams of 20th-century modern painting: Kandinsky-style abstract art and an idea from Surrealist painting known as "automatic drawing." Based on the theories of Freud and Jung, the Surrealists saw in the latter a way to direct the unconscious onto the canvas in a direct and unfiltered way.

Jackson Pollock, who fought for the greatest degree of artistic freedom—not just from Europe, but also from traditional painting—was accorded special

left——JACKSON POLLOCK, FULL FATHOM FIVE | 1947 | oil on canvas, nails, drawing pins, buttons, keys, coins, cigarettes, matches 129.2 x 76.5 cm | Museum of Modern Art | New York.

1919—Formation of the Bauhaus school·····1925—Invention of television·····1931—Completion of the Empire State Building·····

1933—Adolf Hitler seizes power·····

1923–1997 Roy Lichtenstein····1928–1962 Yves Klein····b. 1932 Gerhard Richter

status among the Abstract Expressionists. Pollock, who had had a fairly conventional education, said of himself that he was not particularly skilled at traditional painting and drawing techniques. When he arrived in New York in the early 1940s, he came to know the work of the German émigré Hans Hofmann (1880–1966). Hofmann experimented with a variety of techniques in his art school, and these included the process of dripping paint from the paintbrush onto the canvas. Pollock wanted to have more direct control over his paintings: an interest in the material and the canvas was at the forefront of his work. In contrast to his European colleagues, he felt that the process of painting rather than the resulting artwork was the great event. Gradually, figurative elements disappeared from his paintings. In 1943, he created—in the course of one night, it is said—the painting titled *Mural* (fig. above) for patron of the arts Peggy Guggenheim. It is a large-scale painting whose composition has no center and which appears to have neither a beginning nor an

end. Instead, it shows an abstract web of colors and lines. *Mural* was one of Pollock's first successes, but he was not yet satisfied. He experimented a lot before daring to take the radical step that was would signify a rupture with all tradition. With *Full Fathom Five* (fig. p. 186) Pollock finally achieved what he had been looking for: he placed the canvas on the floor and put the paintbrush to one side. He made holes in the paint cans and let the paint drip directly onto the canvas in this way. Harold Rosenburg coined the term "drip painting" for this technique. Furthermore, Pollock poured the paint onto the canvas in rhythmic movements and manipulated it with sticks, spatulas, and all sorts of other tools. The painting was created as a direct eruption of his energy and expression of his psyche. *Full Fathom Five*, executed in 1947, was the first dedicated drip painting: a tangle of line-like forms, areas of color, and marks. If most paintings list materials as "oil on canvas" or "watercolor on paper," Pollock's are labelled "oil on canvas, nails, drawing pins, buttons, keys, coins, cigarettes,

1939–1945—Second World War .. 1949—Founding of the Federal Republic of Germany ·· **ACTION PAINTING** 188/189
1941—Pearl Harbor attack ..
1948—Founding of the State of Israel ..

b. 1937 David Hockney b. 1938 Georg Baselitz

matches." Pollock wanted to emphasize the unity of art and life through the inclusion of such everyday objects. At first, one sees a chaotic confusion of surfaces, lines, and forms. It essentially defies any attempt at description as nothing remains recognizable. A statement by another Abstract Expressionist, Frank Stella (1936–), sums it up: "What you see is what you see."

The photographer Hans Namuth captured Pollock as the latter "danced" on and around his paintings like a dervish. These photographs became almost as famous as Pollock's artworks, and they make it clear why Harold Rosenberg referred to this form of painting as "Action Painting." No artist is more strongly associated with this painting technique than Jackson Pollock. Namuth's photographs show how important the very act of painting is in Pollock's art. "When I am in my painting, I'm not aware of what I am doing," Pollock said about his working style. The critic Clement Greenberg commented that Pollock's art was ugly, but "all profoundly original art looks ugly at first." There is actually a method to what looks chaotic in Pollock's paintings and comes across as a fairly arbitrary and random pouring of paint onto the canvas. As Pollock said, contradicting his first statement: "When I am painting I have a general notion as to what I am about. I can control the flow of paint; there is no accident ..."

Two aspects of Pollock's art were new. The first was the radical way in which he freed himself of all tradition. For him, painting no longer consisted of defined subjects. This gave him the inner freedom to draw only on himself in the process of painting, and to express his feelings. The second aspect is the media attention he gained through his "dripping" (*Life* magazine called him "Jack the Dripper") and Namuth's photographs was entirely new to the art world.

above—**JACKSON POLLOCK, MURAL** | 1943 | oil on canvas | 247 x 605 cm
University of Iowa Museum of Art | Iowa City.

190/191 ACTION PAINTING **1959**—Completion of the Solomon R. Guggenheim Museum **1969**—Neil Armstrong lands on the Moon

.. **1961**—Construction of the Berlin Wall ...

.. **1968**—Assassination of Martin Luther King

b. 1958 Julian Opie **b. 1960 Walton Ford**

"With Abstract Expressionism, Action Painting, and Pollock's drip painting, New York became the center of American art."

Jackson Pollock and the Dutch-American artist Willem de Kooning met in New York as early as 1942. They formed a friendship, although this soon crumbled under the pressure of their artistic rivalry. De Kooning had entered the US illegally in 1926 and kept his head above water with numerous odd jobs. At this time his pictorial language was still strongly aligned with Surrealism and with Picasso's Cubist paintings. This changed when he met Franz Kline. Under the latter's influence, de Kooning started on his Black Paintings, which are reminiscent of Japanese calligraphy despite their size. De Kooning found his gesturally expressive style, oscillating between the abstract and the figurative, as a result of many attempts. In comparison with Pollock, de Kooning's painting technique was positively traditional, involving the use of paintbrush and spatula. Despite all the abstraction and distortion, he did adhere to the figurative, however. "Even abstract shapes must have a likeness," de Kooning said.

His most famous, and at the same time most powerful paintings are a series of monumental paintings of women. The first painting in this series, *Woman, I*, which appears at first sight to be a rapidly painted emotional outburst, took 18 months to paint (fig. p. 191). The woman appears to bare her teeth like one of the Furies, and her eyes are fixed in a wild-eyed stare. De Kooning set new standards in painting that continue to be felt to this day with the explosive wildness with which this woman is let loose on the viewer from a "hullabaloo crammed with physical matter" (Norbert Wolf).

With Abstract Expressionism, Action Painting, and Pollock's drip painting, American art freed itself from Europe for ever. New York, whose significance for the development of art became similar to that of Paris in the early 20th century, became the center of American art.

right——**WILLEM DE KOONING, WOMAN I** | 1950–52 | oil on canvas 129.7 x 147.3 cm | Museum of Modern Art | New York.

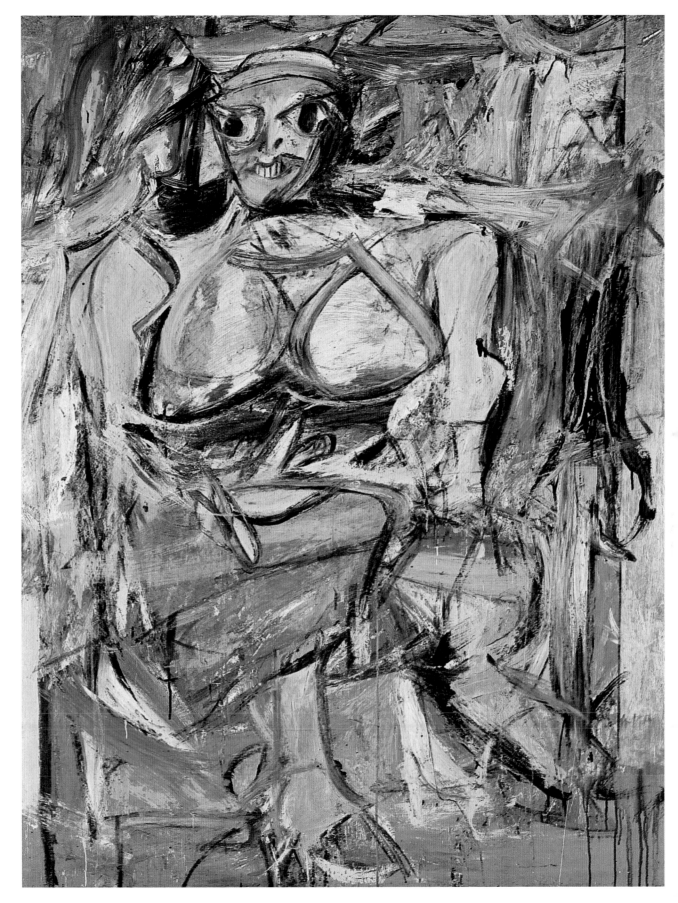

1919—Formation of the Bauhaus school······ **1922**—Discovery of Tutankhamun's Tomb···

192/193

1925—Invention of television···

1931—Completion of the Empire State Building

1922–2011 Richard Hamilton 1923–1997 Roy Lichtenstein 1928–1987 Andy Warhol

POP ART

While the critics were still recovering from the shock of Abstract Expressionism and Action Painting, a new direction was already being mapped out on the art horizon: Pop Art. It was in every respect the opposite of Abstract Expressionism. Because Andy Warhol (1928–87) and Roy Lichtenstein (1923–97) were the most popular proponents of this new direction, and because of its proximity to the typical, clichéd understanding of the American Way of Life, it is easy to mistake it for an entirely American "invention." This is only partially true. Of course it became well known primarily through these protagonists in the US, but its roots actually lie in the United Kingdom. In 1956 the exhibition *This is Tomorrow* was held in London on the subject of the cultural developments of the new era, characterized by the influence of technology. For the posters and the catalogue, the exhibition organizers used a picture, or rather a collage, by the British artist Richard Hamilton (1922–2011), with the long title *Just what is it that makes today's homes so different, so appealing?* (fig. p. 192). While there is no "official"

or uniform concept for Pop Art, Hamilton's collage can be understood as a sort of programmatic seminal work because it features just about everything that would become a subject for Pop artists in later years. We are shown a view of a living space that is equipped with what were at the time the most modern of consumer goods, and decorated with the products of everyday culture: in a room furnished with ready-made sofas are a tape recorder, a vacuum cleaner with an extra-long suction tube, and a television showing what appears to be a soap opera or advertisement. A small table, on top of which is a large tin of ham, is positioned between the sofas. A photograph of a throng of people on a beach acts as a carpet and the company logo of the Ford corporation adorns the living-room lamp. The poster on the wall is an oversize comic print and one can make out a cinema advertisement for *The Jazz-Singer,* the first sound film, outside the window. While the housewife carries out her daily chores on the steps, a pin-up girl (who, strangely enough, wears a lampshade as a headdress) and a body-builder (who holds a gigantic lollipop in his hand as though it were a tennis racket) lounge around in her living room.

Hamilton's collage has an ironic feel to it, with its references to trivial everyday culture and its "summary" of the American Way of Life. Co-organizer of the exhibition Lawrence Alloway accordingly took

left——RICHARD HAMILTON, JUST WHAT IS IT THAT MAKES TODAY'S HOMES SO DIFFERENT, SO APPEALING? | 1956 | collage | 26 x 25 cm Kunsthalle | Tübingen.

194/195 POP ART ·················· **1933**—Adolf Hitler seizes power ·················· **1939–1945**—Second World War··················

1941—Pearl Harbor attack··················

1946—First computer

"Richard Hamilton wanted a new art that is popular, transient, expendable, low-cost, mass-produced, young, witty, sexy, gimmicky, glamorous, and Big Business."

his cue from the inscription "POP" on the lollipop and spoke about "Pop Art" long before Warhol or Lichtenstein concerned themselves with these things. Hamilton saw his work not as an attack on American popular culture, but as a manifesto: he wanted "a new art that is popular, transient, expendable, low-cost, mass-produced, young, witty, sexy, gimmicky, glamorous, and Big Business." In other words, he wanted it to be everything that Pop Art would become in the years that followed.

While Abstract Expressionist artists focused on the expression of their feelings and increasingly eschewed the figurative, it is the figurative that is the foundation of Pop Art. The basis of the art of Andy Warhol, the most famous Pop Artist, for example, was the soup can. Warhol had begun with comics of Mickey Mouse and Superman, copying individual panels in large-format paintings. But another artist was already doing that—Roy Lichtenstein. When Warhol and Lichtenstein were to exhibit their paintings in New York's Leo Castelli Gallery in 1962, the gallery did not want to present two "comic-strip artists." Warhol acknowledged that Lichtenstein had been the first to come up with the idea and decided to choose a subject that he would, without a doubt, be the first to paint: Campbell's soup cans (fig. p. 195). However, this was only the beginning. Warhol also "painted" dollar bills, Coke bottles, and other objects

from the world of mass-produced consumer products, and turned them into art. To be precise, this was not actually new at all as the painters of still lifes in the 17th century had already depicted everyday objects. In the past, these had consisted of bottles, fruit, weapons, and dead animals, and in Warhol's time, these were replaced by Coke bottles, soup cans or tinned ham, as in Hamilton's collage.

Marcel Duchamp (1887–1968), too, turned everyday objects into art. In 1917 he took a urinal, turned it upside down, signed it, and exhibited it. Viewers were nonplussed and shocked by such banality. For Duchamp, the act of selecting the object was in itself artistic. Until then, the expression of meaningful ideas behind objects had been the function of art in general, and of still lifes (which is, essentially, what Duchamp's ready-mades are) in particular. Duchamp rejected this. In his work, the object refers only to itself. In Pop Art, too, this search for meaning appears to be absent. And this, paradoxically, means that its presence is felt. But are the representations of

right——**ANDY WARHOL, CAMPBELL'S SOUP CAN** | 1968 | silkscreen print on canvas | 38.1 x 25.4 cm | José Mugrabi Collection.

1948—Founding of the State of Israel ... **1959**—Completion of the Solomon R. Guggenheim Museum

.........**1949**—Founding of the Federal Republic of Germany .. **1961**—Construction of the Berlin Wall

trivial objects and the mass reproductions of pictures of famous people such as Marilyn Monroe and Elvis Presley really a criticism of the culture of mass consumerism? Or is this actually the extremely cunning marketing of an idea that, after a short period of teething problems, developed just as Hamilton had hoped it would into a style that is "popular, mass-produced and Big Business"?

Warhol was a master of both self-promotion and the production of his artworks. In his work, he combined the aesthetic of advertising with the world of art. He reproduced images, which were often based on photographs, using the relatively new technique of silkscreen printing. Individual objects and portraits no longer satisfied him. Instead, he worked according to the motto that "30 are better than one" and created tableaus with as many as a hundred pictures of the same motif. In his studio, significantly known as The Factory, he tasked his employees with the production of the pictures. He did not incorporate an individual message, and removed himself further and further from the process of production: "I want to be a machine."

Roy Lichtenstein is the other star of Pop Art. Following a period of experimentation with Abstract Expressionism, Lichtenstein developed and perfected the idea of "comic-strip art." He did not use existing comics as models, however, but created fictitious scenes that had absolutely no narrative context. He drew on the clichés of day-dreaming young women who appear to think only of their lovers (fig. p. 197) and of chiseled hero-types who also live up to their own clichés. Lichtenstein painted these individual panels in the format of museum exhibits, imitating the printing-screen technique that is used for halftones in real comic strips. The dots became Lichtenstein's trademark. With this style he not only took on the subject of mass culture, but also art itself. He was well acquainted with the history of art, having taught at university for three years, and experimented with various art styles in his own way. In his typical printing-dot style he makes reference to the work of Cézanne and Matisse, and creates his own Cubist and Futurist "comic-strip artworks." Lichtenstein's *Brushstrokes* series, which was executed in the 1960s (fig. p. 198), is an ironic commentary on the significance of Drip Painting and of the gestural brushstroke of Abstract Expressionism, which he abandoned early on: "Nowadays, people will even hang a paint-soaked rag on the wall." But Warhol and Lichtenstein were certainly controversial, especially because of the apparently trivial way in which they made art. *Life* magazine, which had declared Jackson Pollock to be America's greatest painter in 1949, asked in 1964: "Is Lichtenstein America's worst painter?"

b. 1970 Jonathan Meese

above——**ROY LICHTENSTEIN, M-MAYBE** | 1965 | oil and synthetic resin on canvas | 152 x 152 cm | Museum Ludwig | Cologne.

Another Pop Artist has created a stir in recent years with an unusual painting technique. British resident of Los Angeles David Hockney (1937–) became famous in the 1960s as a result of his sun-drenched paintings of swimming-pool scenes and his photographic collages. He is one of the most universal representatives of Pop Art, but also transcends this genre. Hockney has used smartphones to turn them into miniature digital canvases with Apps such as

"Lichtenstein painted his works in the format of museum exhibits and imitated the printing-screen technique of Comics by painting dots."

"Brushes" for a new series. The artist uses his fingers to "paint" and can change the thickness of the brush and the colors at will. Within a short period of time, Hockney created hundreds of paintings, landscapes, and still lifes, in which his intensely colorful style always remains recognizable. Hockney himself said of the series: "It's a real privilege to make these works of art through digital tools which mean you don't have the bother of water, paints, and the chore of clearing things away. You know, sometimes I get so carried away, I wipe my fingers at the end, thinking that I've got paint on them." The pictures are not printed for exhibitions, but shown directly on smartphones and tablet computers. These paintings could be considered a new form of Pop Art both because of their style and, even more significantly, because of their technique.

Whether Pop Art criticizes or caricatures the mass culture, from which it draws its subject matter, can-not be definitively settled. The nature and motifs of Pop Art have their roots in everyday life. Some works certainly appear to take a critical stance with respect to it. The question is whether the depiction of one, or of a hundred, soup cans is sufficient as a possible criticism of the system of mass culture. Whatever the answer, Pop Art is much more complex than its apparent superficiality may suggest at first glance.

left——**ROY LICHTENSTEIN, BRUSHSTROKES** | 1965 | oil and synthetic resin on canvas | 121.9 x 121.9 cm | Private collection.

1900—Sigmund Freud publishes *The Interpretation of Dreams* ······································

1914–1918—First World War ·······································

1919—Formation of the Bauhaus school ····· **1931**—Completion of the Empire State Building ···············

200/201

1899–1968 Lucio Fontana

1928–1962 Yves Klein

ART AND TRADEMARKS

Changes from one art style and direction to the next took place at an ever-increasing speed around the turn of the last century. Impressionism gave way to Expressionism, Cubism, Futurism, and Surrealism. Art became more and more multifaceted and it became less and less easy to maintain an overview of its developments. In the US, developments that emerged after World War II included Abstract Expressionism and Pop Art. In the second half of the 20th century, all stylistic and technical possibilities in painting appeared to coexist, from traditional painting via Cubist experimentation to abstract art, not to mention painting without paintbrushes, in the form of Drip Painting. Artists now had freedoms, both in terms of style and in terms of content, that had never before existed in the history of art. They were largely liberated from the religious, social, and political restrictions of earlier societies. In addition, artists were presented with an unprecedented selection of paint media. The new challenge for artists therefore consisted of managing these freedoms and asserting themselves. The result was a plethora of highly personal styles that the artists developed for themselves in order to dif-

ferentiate themselves from one another in this time of "anything goes." Of course all the painters of the past also had their own styles, but these were more variable in earlier times. What now emerged was the "trademark" that allowed viewers to identify artists and their artworks immediately: a private style that was not adopted by any other artist. There were no more grand stylistic unities, followed and developed further by several artists. Instead, there were niches, each of which was occupied by just one artist. Pop Art could be described as the last "official" style of the 20th century, bringing together several artists under the auspices of an idea, albeit an idea that was not fixed by a set of aims or manifestos. But even Pop Art was already characterized by these sorts of trademarks, such as Lichtenstein's halftone dots. Such trademarks belonging to individual artists were the products of a search for a form of artistic expression, as well as of the necessity to be successful in the art market and to become recognizable.

These types of trademarks have become commonplace, and a number of artists became famous precisely because of their trademarks. In 1958 Lucio Fontana (1899–1968), for example, began to use a knife to slash his canvases, which were coated in monochrome paint. The idea behind it was to expand the paint surface and to open up a dimension "behind the paintings," thus moving beyond traditional forms

left——**Georg Baselitz, The Wood on its Head** | 1969 | oil on canvas 250 x 190 cm | Museum Ludwig | Cologne.

........ **1939–1945**—Second World War .. **1959**—Completion of the Solomon R. Guggenheim Museum in New York
.. **1961**—Construction of the Berlin Wall
.. **1969**—Neil Armstrong lands on the Moon

b. 1937 David Hockney **b. 1938 Georg Baselitz** **b. 1958 Julian Opie**

of painting. He referred to this as a *concetto spaziale* (Ital. spatial concept) (fig. above). Most of the paintings created by Fontana feature cuts to the canvas in one form or another—and the viewer therefore knows exactly who made them.

By contrast, when one comes across classically painted artworks populated by excessively heavily proportioned figures and objects, one immediately associates them with the Colombian Fernando Botero (1932–), who occupies this particular niche. The French artist Yves Klein (1928–62) took this to extremes: color became his trademark. Klein developed his own color, in collaboration with a chemist. In 1960, he patented this type of ultramarine blue as his personal IKB, International Klein Blue (fig. p. 203). During this period, he used this special shade of blue for everything he created, from monochrome paintings to artworks that he made with the help of men and women to whose skin he applied his IKB pigment before they rolled around on white canvases, leaving imprints of their bodies.

However, there are also disadvantages for artists who have such strong trademarks: they are often reduced to their trademarks, and viewers do not pay as much attention to artworks that do not conform to their expectations.

Georg Baselitz (1938–) created a highly unusual trademark when he turned paintings upside down

for the first time in 1969. *The Wood on its Head* is the first painting he inverted (fig. p. 200). Since then, he has never again presented his work "the right way up." When he first showed this and other paintings at an exhibition in Cologne in 1970, the paintings were not the only ones to be turned around: the critics and audience, too, were disoriented. Baselitz's work was greeted primarily with laughter because the viewers were not able to relate to this step. With the idea of turning the paintings upside down he took a very individual stance between the twin poles of 20th-century painting. At one extreme, there was figurative painting, which was not (with the exception of Pop Art) particularly fashionable in the 1960s and repeatedly subject to the criticism of artistic conservatism. At the other, there was abstract painting, with which Baselitz did not want to ally himself either, however. The idea of the upside-down painting provided Baselitz with a new way to approach artistic challenges. He wanted to "liberate representation

above——**LUCIO FONTANA, CONCETTO SPAZIALE – ATTESE (SPATIAL CONCEPT – EXPECTATIONS)** | 1966 | acrylic on canvas | 115 x 190 cm
Teresio Monina Collection | Casale Monferrato.
right——**YVES KLEIN, ANTHROPOMETRIE ANT SU 13** | *c.* 1960
IKB blue on cardboard | 125 x 85 cm | Private collection.

b. 1974 Anri Sala

from content" as objects do not in themselves express anything at all, according to Baselitz. By being turned on their heads, objects lose their meaning and the viewer's attention is drawn to the painting itself. Through the inversion, Baselitz imparts his paintings with the appearance of abstraction and is able to paint figurative paintings without being considered conservative. No high-ranking artist could imitate this without exposing themselves to charges of a lack of personal creativity or even of plagiarism. The only one to imitate this kind of painting is Baselitz himself: in 2005 he created a series in which he painted his best works again. He called these new takes on his old "hits" *Remix*, a reference to the same practice in the music business.

In previous centuries, art had more time to allow styles to develop. Recent technical advances mean that the dissemination of new ideas and trends, and the international exchange of ideas, take place much more rapidly today than they did in the past. Photography, computer and video art, and the Internet have a tremendous impact on painting which, even 30,000 years after art began, will continue to produce new masterpieces from this cornucopia of diverse artistic possibilities.

LIST OF ARTISTS

13th/14th century

GIOTTO di Bondone: born *c.* 1266 in Vespignano near Florence; died January 8, 1337 in Florence

Taddeo **GADDI**: born *c.* 1290 in Florence; died 1366 in Florence

Ambrogio **LORENZETTI**: born *c.* 1290 in Siena; died 1348 in Siena

MASTER WENCESLAS: born mid-14th century in Bohemia; died probably 1410 in Trento

Robert **CAMPIN**: born *c.* 1375 in Tournai, Belgium; died April 26, 1444 in Tournai, Belgium

Filippo **BRUNELLESCHI**: born 1377 in Florence; died April 15, 1446 in Florence

LIMBURG BROTHERS: Herman born *c.* 1385, Paul born *c.* 1386, Johan born *c.* 1388 in Limburg; all died 1416 in Paris

Jan **VAN EYCK**: born *c.* 1390 in Maaseyck; died 1441 (buried July 9 in Bruges)

PISANELLO (Antonio di Puccio Pisano): born 1395 in Pisa; died 1455 in Rome

Paolo **UCCELLO** (Paolo di Dono): born 1397 in Florence; died December 10, 1475 in Florence

15th century

Konrad **WITZ**: born *c.* 1400 in Rottweil am Neckar; died *c.* 1446 in Geneva

MASACCIO (Tommaso di Ser Giovanni Cassai): born December 21, 1401 in San Giovanni Valdarno; died 1428 in Rome

Andrea **MANTEGNA**: born 1431 near Padua; died September 13, 1506 in Mantua

Jacopo **DE' BARBARI**: born *c.* 1440 in Venice; died 1516 in Brussels or Mechelen

LEONARDO da Vinci: born April 15, 1452 in Anchiano near Vinci; died May 2, 1519 in the château of Clos Lucé near Amboise

Albrecht **DÜRER**: born May 21, 1471 in Nuremberg; died April 6, 1528 in Nuremberg

MICHELANGELO Buonarroti: born March 6, 1475 in Caprese near Arezzo; died February 18, 1564 in Rome

Albrecht **ALTDORFER**: born *c.* 1480 in Regensburg; died February 12, 1538 in Regensburg

TITIAN (Tiziano Vecellio): born *c.* 1488 in Pieve di Cadore near Belluno; died August 27, 1576 in Venice

CORREGGIO (Antonio Allegri): born *c.* 1489 in Correggio near Modena; died March 5, 1534 in Correggio near Modena

16th century

PARMIGIANINO (Girolamo Francesco Maria Mazzola): born January 11, 1503 in Parma; died August 24, 1540 in Casalmaggiore near Parma

Paolo **VERONESE** (Paolo Caliari or Cagliari): born 1528 in Verona; died April 19, 1588 in Venice

Annibale **CARRACCI**: born November 3, 1560 in Bologna; died July 15, 1609 in Rome

CARAVAGGIO (Michelangelo Merisi): born September 28, 1571 in Caravaggio near Bergamo; died July 18, 1610 in Porto Ercole

Peter Paul **RUBENS**: born June 28, 1577 in Siegen, Westphalia; died May 30, 1640 in Antwerp

Adam **ELSHEIMER**: born 1578 (christened March 18) in Frankfurt am Main; died 1610 (buried December 11) in Rome

Frans **HALS**: born between 1580 and 1585 in Antwerp; died August 1666 in Haarlem

Gerrit **VAN HONTHORST**: born November 4, 1592 in Utrecht; died April 27, 1656 in Utrecht

Pieter **CLAESZ**: born 1596/97 in Berchem near Antwerp; died before January 1, 1661 in Haarlem

Diego Rodríguez de Silva y **VELÁZQUEZ**: born 1599 (christened June 6) in Seville; died August 6, 1660 in Madrid

17th century

JAN BRUEGHEL THE YOUNGER: born September 13, 1601 in Antwerp; died September 1, 1678 in Antwerp

REMBRANDT Harmenszoon van Rijn: born July 15, 1606 in Leiden; died October 4, 1669 in Amsterdam

Samuel **VAN HOOGSTRATEN**: born August 2, 1627 in Dordrecht; died October 19, 1678 in Dordrecht

Jacob **VAN RUISDAEL**: born 1628/29 in Haarlem; died 1682 (buried March 14) in Haarlem

Giambattista **TIEPOLO**: born March 5, 1696 in Venice; died March 27, 1770 in Madrid

CANALETTO (Giovanni Antonio Canal): born October 7, 1697 in Venice; died April 19, 1768 in Venice.

William **HOGARTH**: born November 10, 1697 in London; died October 26, 1764 in London

Jean-Baptiste-Siméon **CHARDIN**: born November 2, 1699 in Paris; died December 6, 1779 in Paris

18th century

Pietro **LONGHI**: born November 5, 1702 in Venice; died May 8, 1785 in Venice

Giovanni Battista **PIRANESI**: born October 4, 1720 in Mogliano Veneto near Treviso; died November 9, 1778 in Rome

George **STUBBS**: born August 25, 1724 in Liverpool; died July 10, 1806 in London

Jean-Honoré **FRAGONARD**: born April 5, 1732 in Grasse; died August 22, 1806 in Paris

Johann Heinrich **FÜSSLI**, or **HENRY FUSELI**: born February 6, 1741 in Zurich; died April 16, 1825 in Putney Hill near London

Francisco de **GOYA** y Lucientes: born March 30, 1746 in Fuendetodos near Saragossa; died April 16, 1828 in Bordeaux

Élisabeth **VIGÉE-LEBRUN**: born April 16, 1755 in Paris; died March 30, 1842 in Louveciennes

Joseph Nicéphore **NIÉPCE**: born March 7, 1765 in Chalon-sur-Saône; died July 5, 1833 in Saint-Loup-de-Varennes

Alois **SENEFELDER**: born November 6, 1771 in Prague; died February 26, 1834 in Munich

Caspar David **FRIEDRICH**: born September 5, 1774 in Greifswald; died May 7, 1840 in Dresden

Joseph Mallord William **TURNER**: born April 23, 1775; died December 19, 1851 in London

John **CONSTABLE**: born June 11, 1776 in East Bergholt, Suffolk; died March 31, 1837 in London

Louis Jacques Mandé **DAGUERRE**: born November 18, 1787 in Cormeilles-en-Parisis; died July 10, 1851 in Bry-sur-Marne

Eugène **DELACROIX**: born April 26, 1798 in Paris; died August 13, 1863 in Paris

19th century

GRANDVILLE (Jean Ignace Isidore Gérard): born September 13, 1803 in Nancy; died March 17, 1847 in Vanves near Paris

Honoré **DAUMIER**: born February 26, 1808 in Marseille; died February 10, 1879 in Valmondois

Wilhelm **CAMPHAUSEN**: born February 8, 1818 in Düsseldorf; died June 18, 1885 in Düsseldorf

Alexandre **CABANEL**: born September 28, 1823 in Montpellier; died January 23, 1889 in Paris

Édouard **MANET**: born January 23, 1832 in Paris; died April 30, 1883 in Paris

Wilhelm **BUSCH**: born April 15, 1832 in Wiedensahl; died January 9, 1908 in Mechtshausen

James Abbott McNeill **WHISTLER**: born July 10, 1834 in Lowell, Massachusetts; died July 17, 1903 in London

Paul **CÉZANNE**: born January 19, 1839 in Aix-en-Provence; died October 23, 1906 in Aix-en-Provence

Auguste **RENOIR**: born February 25, 1841 in Limoges; died December 3, 1919 in Cagnes

Gustave **CAILLEBOTTE**: born August 19, 1848 in Paris; died February 21, 1894 in Gennevilliers

Vincent **VAN GOGH**: born March 30, 1853 in Groot-Zundert, Noord Brabant; died July 29, 1890 in Auvers-sur-Oise

Georges **SEURAT**: born December 2, 1859 in Paris; died March 29, 1891 in Paris

Giacomo **BALLA**: born July 18, 1871 in Turin; died March 1, 1958 in Rome

Pablo **PICASSO**: born October 25, 1881 in Málaga; died April 8, 1973 in Mougins

Rockwell **KENT**: born June 21, 1882 in Tarrytown, New York; died March 13, 1971 in Plattsburgh, New York

Edward **HOPPER**: born July 22, 1882 in Nyack, New York; died May 15, 1967 in New York City

Erich **HECKEL**: born July 31, 1883 in Döbeln; died January 27, 1970 in Radolfszell, Lake Constance

Max **BECKMANN**: born February 12, 1884 in Leipzig; died December 27, 1950 in New York City

Giorgio **DE CHIRICO**: born July 10, 1888 in Volos, Greece; died November 20, 1978 in Rome

René **MAGRITTE**: born November 21, 1898 in Lessines, Belgium; died August 15, 1967 in Brussels

Henri de **TOULOUSE-LAUTREC**: born November 24, 1864 in Albi; died September 9, 1901 in Château Malromé, Gironde

Piet **MONDRIAN**: born March 7, 1872 in Amersfoort, Netherlands; died February 1, 1944 in New York City

Kasimir **MALEVICH**: born February 23, 1878 in Kiev; died May 15, 1935 in Saint Petersburg

Georges **BRAQUE**: born May 13, 1882 in Argenteuil-sur-Seine; died August 31, 1963 in Paris

Umberto **BOCCIONI**: born October 19, 1882 in Reggio Calabria; died August 17, 1916 near Verona

Juan **GRIS**: born March 23, 1887 in Madrid; died May 11, 1927 in Boulogne-sur-Seine

Marcel **DUCHAMP**: born July 28, 1887 in Blainville-Crevon; died October 2, 1968 in Neuilly-sur-Seine

Lucio **FONTANA**: born February 19, 1899 in Rosario, Argentina; died September 7, 1968 in Comabbio, Italy

20th century

Willem **DE KOONING**: born April 24, 1904 in Rotterdam; died March 19, 1997 in Springs, Long Island, New York

Salvador **DALÍ**: born May 11, 1904 in Figueres, Spain; died January 23, 1989 in Figueres, Spain

Franz **KLINE**: born May 23, 1910 in Wilkes-Barre, Pennsylvania; died May 13, 1962 in New York City

Jackson **POLLOCK**: born January 28, 1912 in Cody, Wyoming; died August 11, 1956 near East Hampton, Long Island, New York

Andrew **WYETH**: born July 12, 1917 in Chadds Ford, Pennsylvania; died January 16, 2009 in Chadds Ford, Pennsylvania

Richard **HAMILTON**: born February 24, 1922 in London; died September 13, 2011 in London

Lucian **FREUD**: born December 8, 1922 in Berlin; died July 20, 2011 in London

Roy **LICHTENSTEIN**: born October 27, 1923 in New York City; died September 29, 1997 in New York City

Yves **KLEIN**: born April 28, 1928 in Nice; died June 6, 1962 in Paris

Andy **WARHOL** (Andrew Warhola): born August 6, 1928 in Pittsburgh; died February 22, 1987 in New York City

Bridget **RILEY**: born April 24, 1931 in London

Gerhard **RICHTER**: born February 9, 1932 in Dresden

Fernando **BOTERO**: born April 19, 1932 in Medellín, Colombia

David **HOCKNEY**: born July 9, 1937 in Bradford, Yorkshire

Georg **BASELITZ** (Hans-Georg Kern): born January 23, 1938 in Deutschbaselitz

Julian **OPIE**: born 1958 in London

Walton **FORD**: born 1960 in White Plains, New York

SELECTED BIBLIOGRAPHY

BASTIAN, HEINER (ed.). *Andy Warhol: Retrospective* (exh. cat. Tate Modern, London, February 7 to April 1, 2002), London, 2002.

BELL, JULIAN. *What is Painting? Representation and Modern Art.* London, 1999.

BEYER, ANDREAS. *Portraits: A History.* New York/London, 2003.

CALABRESE, OMAR. *Artists' Self-portraits.* New York/Enfield, 2006.

CHILVERS, IAN. *Dictionary of 20th-Century Art.* Oxford, 1998.

EBERT-SCHIFFERER, SYBILLE. *Still Life: A History.* New York, 1999.

EDGERTON, SAMUEL Y. *The Renaissance rediscovery of linear perspective.* New York/London, *1976.*

EMMERLING, LEONHARD. *Jackson Pollock: 1912–1956.* Cologne/London, 2003.

FEIST, PETER H. *French Impressionism: 1860–1920.* Köln/London, 1995.

GOMBRICH, ERNST H. *Art and illusion: A Study in the Psychology of Pictorial Representation.* London, 1972.

HEINE, FLORIAN. *The First Time: Innovations in Art.* Munich, 2007.

HEINE, FLORIAN, *Mit den Augen der Maler.* Munich, 2009.

HONOUR, HUGH AND JOHN FLEMING. *A World History of Art.* Upper Saddle River, N. J., 2005.

LIVINGSTONE, M. (ed.). *Pop Art.* London, 1989.

NEWHALL, BEAUMONT. *On Photography: A Source Book of Photo History in Facsimile.* Watkins Glen, N. Y., 1956.

PÄCHT, OTTO. *Van Eyck and the Founders of Early Netherlandish Painting.* London, 1994.

POESCHKE, JOACHIM. *Italian Frescoes: The Age of Giotto, 1280–1400.* New York/London, 2005.

Prestel Dictionary of Art and Artists in the 20th Century. Munich/London/New York, 2000.

ROETTGEN, STEFFI. *Italian Frescoes: The Early Renaissance, 1400–1470.* New York/London, 1996.

SCHNEIDER, NORBERT. *The Art of the Portrait.* Cologne, 1994.

TESCH, JÜRGEN AND ECKHARD HOLLMANN. *Icons of Art: The 20th Century.* Munich/London/New York, 1997.

WALTHER, INGO F. (ed.). *Art of the 20th Century.* Cologne, 1998.

WALTHER, INGO F. AND NORBERT WOLF. *Codices illustres: The World's Most Famous Illuminated Manuscripts, 400–1600.* Cologne, 2001.

ZÖLLNER, FRANK ET AL., *Michelangelo, 1475–1564: Complete Works.* Cologne, 2010.

INDEX

Numbers in *italics* refer to images.

PHOTO CREDITS

The illustrations in this publication have been kindly provided by the museums, institutions, and archives mentioned in the captions, or taken from the Publisher's archives, with the exeption of the following:

IMPRINT

© Prestel Verlag, Munich · London · New York, 2012

© for the works reproduced is held by the artists, their heirs or assigns, with the exception of: Giacomo Balla, Max Beckmann, Georges Braque, Giorgio de Chirico, Richard Hamilton, Wassily Kandinsky, Yves Klein, Franz Kline, Roy Lichtenstein, Rene Magritte with VG Bild-Kunst, Bonn 2012; Salvador Dalí with Salvador Dalí, Fundació Gala-Salvador Dalí / VG Bild-Kunst, Bonn 2012 ; Marcel Duchamp with Succession Marcel Duchamp / VG Bild-Kunst, Bonn 2012; Lucio Fontana with SIAE / VG Bild-Kunst, Bonn 2012; Willem de Kooning with The Willem de Kooning Foundation, New York / VG Bild-Kunst, Bonn 2012; Pablo Picasso with Succession Picasso / VG Bild-Kunst, Bonn 2012; Jackson Pollock with Pollock-Krasner Foundation / VG Bild-Kunst, Bonn 2012; Georg Baselitz with © 2012 Georg Baselitz; Walton Ford with courtesy of the artist and Paul Kasmin Gallery; Lucian Freud with © The Lucian Freud Archive; Erich Heckel with Nachlass Erich Heckel, Hemmenhofen; Edward Hopper with Photography © The Art Institute of Chicago; Piet Mondrian with Mondrian/Holtzman Trust c/o HCR International Washington DC; Gerhard Richter with ©Gerhard Richter 2012; Bridget Riley with ©Bridget Riley 2012. All rights reserved, courtesy Karsten Schubert, London; Andy Warhol with ©2012 The Andy Warhol Foundation for the Visual Arts, Inc. / Artists Rights Society (ARS), New York; Andrew Wyeth with © Andrew Wyeth.

Front cover: Pablo Picasso, *Le Rêve* [*The Dream*] | 1932 | oil on canvas | 130 x 97 cm | Private collection, see page 29
Back cover: Leonardo da Vinci, *Mona Lisa*, see page 27
Vincent van Gogh, *Café terrace at night*, see page 39
Juan Gris, *Still life with Bordeaux bottles*, see page 179
Frontispiece: Franz Marc, *Fighting Forms* (detail) | 1914 | oil on canvas | 91 x 131 cm | Bayerische Staatsgemäldesammlung, Munich

Prestel Verlag, Munich
A member of Verlagsgruppe Random House GmbH

Prestel Verlag
Neumarkter Strasse 28
81673 Munich
Tel. +49 (0)89 4136-0
Fax +49 (0)89 4136-2335
www.prestel.de

Prestel Publishing Ltd.
4 Bloomsbury Place
London WC1A 2QA
Tel. +44 (0)20 7323-5004
Fax +44 (0)20 7636-8004
www.prestel.com

Prestel Publishing
900 Broadway, Suite 603
New York, NY 10003
Tel. +1 (212) 995-2720
Fax +1 (212) 995-2733
www.prestel.com

Library of Congress Control Number is available; British Library Cataloguing-in-Publication Data: a catalogue record for this book is available from the British Library; Deutsche Nationalbibliothek holds a record of this publication in the Deutsche Nationalbibliografie; detailed bibliographical data can be found under: http://dnb.d-nb.de

Prestel books are available worldwide. Please contact your nearest bookseller or one of the above addresses for information concerning your local distributor.

Translated by: Jane Michael, Munich
Editorial direction: Claudia Stäuble and Julie Kiefer
Copyedited by: Philippa Hurd, London
Picture editor: Franziska Stegmann
Timelines and index: Andrea Jaroni
Cover design: Joana Niemeyer, April
Design: LIQUID Agentur für Gestaltung, Augsburg
Layout: Stephan Riedlberger, Munich
Typesetting: Wolfram Söll, Munich
Production: Astrid Wedemeyer
Art direction: Cilly Klotz
Origination: Reproline Mediateam, Munich
Printing and binding: Druckerei Uhl GmbH & Co. KG, Radolfzell

ISBN 978-3-7913-4569-7
(German edition: ISBN 978-3-7913-4568-0)